The Legacy of Ibo Landing

Gullah Roots of African American Culture

edited by
Marquetta L. Goodwine
&
The Clarity Press Gullah Project

Clarity Press, Inc.

ISBN: 0-932863-25-6

Front Cover photo: from *Daughters of the Dust*
written & directed by Julie Dash
Back Cover painting: *Tales,* by Jonathan Green, 1988.
Oil on masonite, 24 x 36"
Back Cover photo: Scott Hansen

In-house Editor: Diana G. Collier

Cataloguing in Publication Data:

The legacy of Ibo Landing " Gullah roots of African-American
culture / edited by Marquetta L. Goodwine & The Clarity Press
Gullah Project -- 1st ed.
p. cm.
Includes bibliographical references and index
ISBN: 0-932863-25-6

1. Gullahs--Literary collections. 2. Afro-Americans--Sea
Islands--Literary collections. 3. Sea Islands--Literary
collections. 4. Gullahs in art. 5. American literature --
Afro-American authors. I. Goodwine, Marquetta L. II.
Clarity Press Gullah Project

PS509.N4L44 1998 810.8'0896073'075799
QB198-323

CLARITY PRESS, INC.
Ste. 469, 3277 Roswell Rd. N.E.
Atlanta, GA. 30305
Toll free order: 1-800-533-0301
Bulk order: 1-800-626-4330
http://www.bookmasters.com/clarity
clarity@islandnet.com

◆ Table of Contents ◆

Acknowledgments

Clarity Press, Inc. wishes to thank those whose participation and assistance has been invaluable in the production of this book. We also thank the following publications for the right to reproduce materials which appear herein.

Artists Leroy Campbell, Jonathan Green and Joseph Pinckney, for the right to reproduce their paintings.

Cornelia Bailey, for permission to reprint material appearing at her website at http://www.gacoast.com/navigator/iamsapelo.html.

Cool Grove Press, 174 Prospect Park West, Ste. 4R, Brooklyn, New York, N.Y. 11215, website: http://www.coolgrove.com for fiction reprinted from *Ibo Landing* by Ihsan Bracy.

Julie Dash & Kino International for permission to use the cover photo taken from *Daughters of the Dust.*

Gender & Society for permission to reprint "We Got Our Way of Cooking Things: Women, Food and Preservation of Cultural Identity," by Josepine Beoku-Betts.

Kitty Green, for cuisine and basketweaving photos.

Scott Hansen, photographer, for photo of The Gullah Connection (back cover)

Historical Methods, for permission to reprint "The Relationship of the Gullah-Speaking People of Coastal South Carolina and Georgia to Their African Ancestors" by William S. Pollitzer.

Sherman Pyatt, Archivist, Avery Research Center, for unflagging assistance.

Earl Ijames, Archivist, North Carolina Dept. of Cultural Resources.

List of Illustrations

Memorial at Ibo Landing

Another boatload of captured Africans reached the Georgia coast. Those around them did not yet know that the cargo they were to unload were Ibo. These captives were warriors, and would not toil this land. Instead, the entire group walked into the water with the chains yet on their bodies. They are said to have walked on the water right back to Africa.

To this very day, no marker or shrine celebrates the site where the indomitable Ibo are said to have disembarked. In fact, Gullahs and Geechees can only look at the site from a distance, since it has been fenced off as private property. The owner's failure to cooperate and other disputes concerning the landing have prevented a marker even being placed at the road outside the property line where the landing is thought to exist: on St. Simon's Island, off the main road.

The heroic resistance of the Ibo at what is now called Ibo Landing forms a cherished part of the heritage, not only of the Gullah, but of all African Americans. That this site remains unmarked, or indeed that any might feel a private entitlement that unduly restricts public access is truly unconscionable.

Persons wishing to join the campaign to memorialize this heritage site should contact:

The Gullah/Geechee Sea Island Coalition
P.O. Box 1207
St. Helena Island, S.C. 29920
Toll-free: (888)TRY-ISLE
E-mail: GullGeeCo@aol.com.

Preface

Similar to indigenous peoples, Gullahs and Geechees have long been the object of outside study, whether by linguists, folklorists, or cultural anthropologists and archaeologists. This has fostered the impression that the primary interest of their culture lies in the archives, while those who practice Gullah traditions are remnants soon to be obliterated by the weight of mainstream culture.

While the Gullah and Geechee communities of today number some 500,000 speakers of the Gullah language, their influence extends to much larger numbers who, however territorially dispersed, yet remain ethnically tied through the extended lines of Gullah kinship. Though presently deprived of the international minority right to early education in their language and culture, and encroached upon territorially by communities which imperil their economic self-sufficiency, the Gullah still reflect that spirit of resistance to domination which marked their heritage (see Y.N. Kly, "The Gullah War, 1739-1858"). Indeed, those who practice Gullah culture today might be viewed as the dogged protectors of what is distinctly African in African American ethnicity, putting up a heroic resistance to cultural assimilation (ethnocide).

The Legacy of Ibo Landing seeks both to illustrate and to contribute to the many efforts now underway for the protection and development of Gullah and Geechee culture. The vibrant artwork of Jonathan Green, Joseph Pinckney and Leroy Campbell, and the English-language fiction of Ihsan Bracy attest to ongoing inspiration of Gullah roots. The Gullah language, heretofore the province of linguists, has now been recognized as a language in use, through the efforts of the Sea Island Translation and Literary Team (their Gullah translation of the Beatitudes is provided here) and those of Virginia Geraty, author of a forthcoming Gullah dictionary. Her Gullah tale in English and Gullah is included here. The recollections provided in "Gawd Dun Smiled Pun We" offer but a taste of what Gullah traditions have meant to so many, both near and far. "De Ones Ya'll Kno' 'Bout" commemorates Gullah notables, then and now. The threat to Gullah cultural survival is discussed, and an overview of institutions, organizations and individuals working for cultural preservation and development is provided.

Should the Gullah/Geechee culture vanish from this earth, it may be due not to their desire to forsake their traditions, but rather to the failure to empower socio-economic and political institutions to ensure their collective survival. Who can foresee how African American ethnic identity and African American efforts to exert their internationally protected minority right to be equal but different might be affected by such a loss?

The Clarity Press Gullah Project

Introduction

Rebuilding the African American Community by Returning to Traditions

Marquetta L. Goodwine

We are currently faced with what has been deemed a crisis in our communities, which are marked by destructive youths and people with low self-esteem. Many have come to ask themselves, "What are we going to do in the future?" As African people in America, we have witnessed the tearing down of the things that we have built up and seen our communities practically fall apart before our eyes. We want and need to combat this and rebuild our families, our organizations and our institutions. We need to recapture the interest and respect of our youth and pay attention to and care for our elders as our foreparents did. The blueprint for how this is done lies in our traditions.

My focus on the Gullah and Geechee cultures of the Sea Islands stems from personal experience. I am a product of a South Carolina Gullah upbringing and I am a member of two families that have a long history in the Sea Islands. My life has been unique in that I have lived the Gullah lifestyle as it is represented in the city or an urban environment and I have lived and worked on the soil of my home on St. Helena Island. As has occurred elsewhere in the African American community, there has been a departure from traditions in the Sea Islands which would be helpful to us now. Only recently have people come to accept and admire the things that were done in the south in order to maintain the family and to be self-sufficient. This new acceptance and admiration has only come because over time people have become intrigued by the fact that despite all that Gullahs and Geechees have been through, they have been able to preserve and maintain their own cultural practices, rituals, and language. As Dr. Na'im Akbar states in *Community of Self*:

> We still listen only to the ideas, interpretations, explanations, and directions that are given to us from outside of our communities... It is not easy to hear the inner community voice, but freedom does not come until we hear it.

I agree with his premise that:

> Every community has an independent voice. It is the independent voice of a people that is expressed in their culture. Once this voice is heard, then and only then will they gain respect from other cultural groups. The

independent voice does not require us to dominate anyone
else, but it does require us to dominate (or control) ourselves.

Given the history of exploitation of various African and African
American peoples and cultures, there is some apprehension to research
and open dialogue concerning traditional practices. Thus, many do not
feel that people have "a right" to start "digging up" certain things. If we
can make clear that our motivation for research and discussion is the
elevation and preservation of the community, the discussion begins to
become easier and more open. The core of African American survival
mechanisms are the traditions or the "old ways." When we were more
consistent in these traditions as a community, we had more control of
ourselves and our views. The culture cannot be properly elevated by
those who do not understand it for there are many nuances which will
be misinterpreted. These can only be clarified if the community that is
being studied is actively a part of the study process and not just treated
as a voiceless specimen to be viewed with a magnifying glass.

Those who do not understand the unique community that has
been formed in the Sea Islands by the Gullahs and Geechees often
regard its members as ignorant, barbaric, and backwards in their speech
and practices. Only recently through the work of scholars, researchers,
linguists, and folklorists are people realizing the value of the Gullah
language and culture. As a result of the respect that has begun to
grow for this culture, more interest is gradually growing in other aspects
of southern African American culture. People are beginning to realize
that there were many things that were overlooked that can now be
drawn upon to change present negative trends in our society.

One might ask, if our traditions had so much to offer us then why
did we leave them in the first place? Part of the answer lies in what
Carter G. Woodson pointed out in *The Miseducation of the Negro:* how
the "traditional curricula of the times...did not take the Negro into
consideration except to condemn or pity him."

This condemnation and pity of Gullah-speaking Sea Islanders had
an overwhelming and almost devastating impact. These people were
taught that "ef oona tak likka disyah, den ting backwad" and if you
wanted to "make something of yourself" then you needed to "correct"
the way that you spoke. This correction came in the form of changing
the intonations of the words and then beginning to take on "standard"
English as a first language and leaving Gullah as a secondary language.
As time went on, Gullah began to be eliminated from certain people's
communication altogether. This slow change in language also brought
a slow change in how to view the world. As one's world view changes,

one's values and value system change as well. We then want to get away from that which we feel is seen in a negative light and to get closer to what is "acceptable."

For generations, the speech pattern of African American southerners was not seen as acceptable to "mainstream" American society. Gullah was especially seen as barbaric and backwards. Many scholars are only now beginning to realize that the speech patterns and behaviors of people of the south were not "backward" for the most part, especially when it comes to Gullah. In fact, as Joyner and others have noted, the continuation of the language and certain practices surely points to its importance as a potent symbol of cultural unity among those (the enslaved Africans) who developed it and passed it on to posterity. The unfortunate thing is that the descendants of this culture often do not value what has been passed on to them. A major difficulty comes in trying to explain this to many African Americans who used to speak Gullah, Geechee, or in a similar fashion before they migrated to northern cities and felt that they had "made it" by arriving there and obtaining a job and an apartment. Many of them have had to struggle with the fact that by departing from the land and turning their backs on their native tongue and the practices in which they had been raised, they have in essence turned their backs on their own culture and history. As Joyner noted, "Speech communities imply a shared culture and world view." Thus, the break from the language is also a break from the culture which is formed through the traditional practices.

Joyner also dealt with this when he stated:

> Not the least of the ironies of Afro-American history is that aspects of Black speech related to Gullah are now stigmatized by many blacks as well as whites as illiterate or associated with field hands, in contrast to the high prestige of 'proper' English. In retrospect, one should be more impressed with the success of the slaves, a people of diverse linguistic backgrounds and limited opportunities, in creating a creole language and culture than appalled at their 'failure' to adopt in toto the language and culture of their masters."

Whether they are Gullah-speaking or speak a particular "Black English dialect," many southerners have done all they can to eliminate the way they spoke in the south from their present system of communication. Many times this was done because they were ostracized by teachers and other students who did not speak that way or they felt that they had "risen above" such a way of speaking. Many who made

a conscious choice to "eliminate" their Gullah way of speaking have also altered how they view the "old ways." They tend to see island and/or old southern traditions and practices as ignorant or at minimum, not useful. These traditions include crafts, use of healing herbs, religious rituals, "communalness," and more.

These displaced Sea Islanders and other southerners prefer to blend into the "mainstream" and/or "mainland" culture. Thus, they also tend to adopt the world views of the group with which they now prefer to associate. More often than not, these views are not conducive to rebuilding the African American community. However, the rebuilding of the African American community can only be to the benefit of the American community as a whole.

Currently, there is a breakdown in American society due to the extreme emphasis on the individual and the comforts of the individual. There is no appreciation and respect being cultivated for other peoples and the cultures attached to these peoples. Instead, the latest buzz word is "tolerance" for each other.

In the Sea Islands, there has been an onslaught of land takeovers which has led to a further breakdown of the cultural base and traditions. As the decades passed, more Euro-Americans began to come into the area and buy land in order to build summer homes and resorts. These newcomers did not come into the area with a respect for the people or the culture that was already there.

This continuing trend is not discussed on any large scale basis because it is seen as a local problem or a Sea Island problem. Why isn't it seen as the problem of all of us? Is it because we are not Gullah? Or we live in the city and have no intention of moving down there? Or is it simply because we have allowed ourselves to drift from the tradition of communalness?

If we begin to look at the term "community" as meaning "common unity" then maybe we will also begin to see that issues like this do and should go beyond the 10 mile radius of the geographic location that is the center of it. When we begin to look at how everything affects everything else within the universe as our ancestors did, then we will be able to truly begin to start to work towards correcting some of the negative trends that we are faced with.

People begin to unify or come together due to the things that they have in common. Understanding community in this basic way is the foundation of Sea Islanders' ability to survive and develop and maintain most of their language, culture, and traditions in spite of the oppression that they faced and the threat to their self-sufficiency brought on by land takeovers and land taxes, and compounded by zoning and

licensing acts to this very day. This understanding has stemmed from the faith and spirituality that Sea Islanders developed and continue to cultivate. The praise tradition of Gullah Sea Islanders extends beyond the history of the churches that were built there. Although the "praise service" is now conducted in edificies such as the church and the praise house for the most part, the praise process is ongoing and the spiritual connections are evident in day-to-day activities. These activities still include field work, i.e. farming and sea work. These and crafts are the means through which many Sea Island families have remained self-sufficient.

Many have been displaced from their land and have not been able to remain as self-sufficient as they would have chosen to be. There are also a number of problems that face the entire country that are being dealt with in the Sea Islands, including drug use and violent crimes. However, they too can begin to be counteracted by a return to teaching our children at all times and having them be a part of what we are doing as opposed to allowing them to learn their world view from what the television puts out.

African American history has been put in writing largely from oral tradition. We used to sit with our children, speak to them and tell them stories. This was a way of instilling morals in them, educating them, and passing on traditions. The children now are amazed at some of the things that they hear about the history of their own people because we no longer teach them. There are even many adults who are also amazed because they have forgotten a lot of what was passed down to them, having taken it for granted when it was being presented by someone in their community.

The traditions, the crafts, the entire society — all are breaking down because we have stepped away from sitting together and sharing with one another our ideas, views, and life experiences. If we return to this tradition and begin to rebuild communication between us so that we can dialogue about what is going on in our minds, in our households, in our community, and in the world, we can then begin to set a plan in order to rebuild our community as African Americans. As each ethnic group does this, then the global picture will become less bleak.

When we look at the way things are now and we begin to try to go back and find out what went wrong, it is likely that we are going to find that things are not continuous and smooth, but that there are jagged edges where pieces that have fallen off may not be replaceable. For example, Sea Islanders may never be able to regain the land that they have lost. But do we simply let go of what is left or do we fight to preserve what is left and make an effort to regain that which was long since put aside yet still has value?

In the process of evolution we must take the old and build on it to fit the new circumstances and environment. Any old structure needs to be examined and analyzed before it is added to. There may be reinforcements that are necessary before any additions can be made. If the structure is too faulty, then it may have to have parts removed or be completely torn down and rebuilt.

Many have realized or are realizing that there are cultures that are hundreds of years old which can provide guidelines to teaching a number of things including self-sufficiency and respect. Community respect is often the driving force behind those that realize the value of their native languages and traditional practices and they are proud to present them in any setting. These individuals have learned the value of language not as a commodity, but as a mode of survival — survival of culture, traditions, heritage, ancestral ties, education, and community. Thus, they are willing to work to preserve and build up the community.

As mi people dem sey, "empty sak cyan stan upright 'lone."

We present this book as part of our ongoing efforts in this line. We have not sought, in *The Legacy of Ibo Landing: Gullah Roots of African American Culture*, to capture facts, artifacts and archival remnants of Gullah culture, but rather to celebrate its dynamic, compassionate, and spiritual essence. We have sought to portray its joyousness, as well as its resilience, its pride, its courage and indeed, its heroism. Is it too much to say that what we allow to become of the Gullah in America will speak to what we will have allowed to become of ourselves? For after all, of all African people in America, it is the Gullah who have clung most dearly to what we once were, who have suffered and endured ignominy, deprivation and even death to preserve it. The Gullah have much to teach us still. If we allow what they have preserved to perish from this earth, the loss will also be our own.

Cum toggedda wid we people
fa hold on ta de tings wa wi peopol lef wi.

Mus' tek cyear a de root fa' heal de tree.

ibo landing[*]

Ihsan Bracy

for ivor

they would not remove themselves from his mind.

he dreamt of them, of her, every night. they all did.

the mass of human flesh lay beached upon the shore. in the pale early dawn they were indistinguishable.

they were poured upon the sands, fished out of nets like pounds of shrimp.

as his eyes adjusted to the light, he could make out land. he wondered, as he watched the ghosts move about, to what special hell he had been brought.

he would never forget the sound of teeth gnashing as she gave herself to the sea.

she gave herself to the sea. there was no struggle. she sensed him behind her. she reached back as his hand found hers. she squeezed it tight. she had only time to grab him before being engulfed by water.

he heard the unloading all night. as the sun began to rise, razzberry could make out the mound of black human flesh on the shore and the shadow of the ship beyond.

he could feel people all around him. he had grown used to this communal body. he had lost the parameters of his own body, just as he had given

[*] Reprinted from *ibo landing* by Ihsan Bracy, Cool Grove Press, 1998. More about *ibo landing* on website http://www.coolgrove.com

up the designs of his soul. it took all his effort to open his eyes. for so long it had seemed so useless, confined to the shadows and darkness as he had been.

the ghosts moved about freely, unconcerned for their cargo. there was the sense of exhilaration and completion that came at the end of each journey. satisfaction, having delivered over half of their cargo safely. they waited for the auction and the payment of their money.

as the sun rose, the mound began to move. warmed as they were by the sun, they no longer clung to each other. as the thaw of the journey and last night's unloading set in the cold subsided. they each began to take back their limbs.

they all remembered kiobe's screams, among those of the other women the ghost had chosen.

kiobe had been taken for the longest, passed around as she was. no one had seen her for two risings of the moon. they had begun to think of her as lost when she returned; bloody, taken, wet with the pollution of many ghosts. she cried until she fell asleep, then she screamed until she woke herself to cry.

atiba saw her from one corner of the vessel. she saw him. he saw it in the look in her eyes. she knew it in his. by the time he reached the railing she had already leaped. he focused on where the waters had withdrawn her. he eluded the many hands of ghosts reaching. he jumped after.

sharks that followed the ship of death continued in the process of their evolution, cleaning the waste and filth, drawn as they were by the blood of her taking and the remains of the communal blood in which they had lain.

they all remembered. it would not escape their dreams.

slowly they returned to life. scared. scarred by the passage. they had

crossed. they were the bridge. generations would cross through their collective womb.

each in their own way understood the distance. they would never again be home.

there were many tongues, many peoples among them. most were still chained. slowly they were released into a pen, washed, clothed, then given some gruel to eat, passed by ladle, by ghosts, from one communal pail.

as they were released they drifted together in the communal pen. it was here that for the first time many of them were able to find the sister tongues they had heard in the darkness.

that darkness. lying one upon the other. barely breathing. constant endless shifting, in the struggle for room. all would not survive. it had seemed an eternity before the one voice called out. a son. a warrior calling for silence. those of his tongue indicated this to each who was near. in this way slowly the silence had been achieved.

calling the name of a people, those of that tongue would cry out searching for information: a sound, a name, a place, anything familiar, any vestige of the ever distancing home.

it was on that day, when a young warrior son urged the people to learn the sounds of the one in bondage beside them that resistance was born. resistance which gave birth to survival.

so many died. so many gave themselves to the sea.

amazingly the eyes adapted to the darkness, to whatever little light surrendered itself through the virtually non-existent openings in the belly of the wooden ship.

next had come the arduous task of moving. each day at least one shift. as the voyage continued there had been more room.

there had been death, left to rot amongst them. they had lost so many.

fluids everywhere, from every opening of the living, the dying and the dead. this was the constant in which they survived.

one quarter of the cargo was brought above each day. fed. drenched in the waters of the sea, made to move, dance, then returned to the constant. the methodology developed by the success of many crossings.

among them were a people who did not speak.

the people of silence could hear the thoughts of one another. they alone knew the fate in each cargo hold.

atiba had known each of kiobe's thoughts, through every scream. they all had.

they waited until the washing was complete. the morning moon watched. silently they turned and began walking back toward the water.

movement was undetected for several minutes. their guard was down. they had passed the night. the cargo had been washed, fed, clothed and penned. auction was set for high sun.

the pens were guarded heaviest on the sides near the woods, near where the auction would take place. the slavers held the hill overlooking their prized cargo. it was a while before they noticed the thirty or more moving without hesitation toward the waters.

as they reached the limits of the pen they jumped it as one. they turned not a head, even as the sounds of agitation grew behind them. they quickly crossed the distance of the natural harbor.

the slavers were stunned. cautious, they sprang into action. quickly they realized they could cut off every path except the one which led to the water. they reached for their guns, but were confused, fearful to

injure even a single piece of cargo if it could be helped. suddenly angry, they contemplated their loss.

as if breaking out of a dream state, the slavers suddenly broke into a panicked run, each cursing non-stop, blaspheming their god and their luck. then they suddenly stopped, silenced by what they saw but could not comprehend.

as they reached the place of waves, each one would reach to grab the hand of the one before.

razzberry watched from the hill. it was through him the story was remembered and the truth told. stepping over wave after wave, they strode confidently, unhurriedly, past the ship lying in the sunrise.

nearly everyone in the vicinity of ibo landing that day came to see, before the silent band was lost from sight.

The Gullah War
1739-1858

*Y. N. Kly**

This presentation attempts to acquaint the reader with a war whose true nature has remained largely unacknowledged despite its decisive influence on U.S. historical development. It seeks to respond to the numerous questions that arise when one reviews existing data pertinent to the gamut of events, encounters, skirmishes, battles and wars that occurred in the South Carolina/Georgia/Florida region between 1739 (the Stono Rebellion) and 1858 (the ending of the "third Seminole War") in order to demonstrate that these events should be viewed as an important but seldom discussed war against slavery and colonization. Occuring on an ongoing basis through uprisings, military skirmishes and battles which took place over the period of a century, the Gullah War[1] marked the resistance of enslaved Africans to the institution of slavery in the U.S. colonies. For the length of its duration, this war[2] continued to pose a substantial threat to the successful maintenance and operation of the enslavement system, a threat acknowledged in historical writings,[3] historical data, and evident in the implacability with which, on the U.S. colonist and later federal side, it was pursued.

The fact that the true nature of a war occurring in the United States for over a period of a century has as yet to be fully acknowledged for what it was, suggests a socio-political manipulation of history that renders recovery possible only through a socio-political and historical analysis. The socio-political reasons why the prolonged Gullah resistance to enslavement was largely unreported and unacknowledged during its historical period, was due to the threat that widespread knowledge of a largely successful (insofar as it was never fully quelled) Gullah insurgency might have posed to the stability of a plantation system run on the labor of enslaved Africans, and thereby to the entire institution of slavery in the U.S. colonies. Whether acknowledgment of this war failed to surface in ensuing periods due to ongoing active suppression of information, the paucity of original sources, the unquestioning acceptance of biased earlier documentation and established parameters for viewing this phenomena or lack of courage remains a topic for further research. This article seeks, indeed, not to resolve these questions, so much as to initiate an uncorrupted investigation of the

* Assisted by Diana Kly.

period which views African involvement not merely as a constituent factor in what has been called the Seminole* Wars (the word "seminole" being incorrectly given the connotation of Indian instead of exile), but rather as the most significant one. Given the political delicacies, deceptions, and misinterpretations (intentional or resulting from ethnic bias) which continue to abound, our research leads us to believe that to completely untangle this web of historical distortion will require volumes of investigation beyond this slender exploratory article. What we seek to do here is to break through the conceptual distortion and provide a clear orientation based on acknowledged facts and sound historical analysis.

Located today primarily in the Lowcountry and Sea Islands of South Carolina and Georgia, Gullahs and Geechees exemplify in their purest form the African cultural attributes of African Americans. In the early 18th century, their forebears were the only blacks in South Carolina in significant numbers. Their forefathers were the African population who led the successful and unsuccessful revolts against enslavement. For the period of the 18th and early 19th century, we can use the term "Gullah" to represent the whole of the imported African population in the regions of South Carolina, Georgia and Florida. This definition holds, although they could also be (and often are) divided into categories such as maroons, Africans (born in Africa of different ethnicites), and African Americans (born in the U.S.); or Africans who escaped to Florida and those who didn't; or Africans who were pushed by the U.S. military into Mexico and those who remained in Oklahoma, Texas, etc..

The African peoples brought to the U.S. through the enslavement process came from numerous African nations, both as individuals and in groups. While some worked in colonists' homes and interacted most frequently with Euro-Americans, thus assimilating a form of Euro-American values and culture, for the masses who worked in the fields, this assimilation process was much slower and less governed by Euro-American values than by values rooted in Africa. However, the cultural pool over time evolved into the ethnicity now known as African American (in a process of melting of diverse yet similar cultures, as happened with the Euro-Americans' stabilization into Anglo-Americans or, as popularly called, "white" Americans). Whatever ethnic differences were ultimately to exist between those now known as Gullah and other more assimilated African Americans after the mid-1800s were due to the greater extent of the former's resistance to Anglo-Americanization.[4] To introduce nomenclature which divides the early imported African population on

* The word "seminole" meant "exile" or "runaway"; it never referred to an Indian tribe.

the basis of where they had been born (the U.S. or Africa), or whether they had successfully fled to Florida, tends to introduce separations which obscure an acknowledgment of the extent of their collective resistance to enslavement. To distort and conceal the true nature of this war, the technique used was to channel those efforts of enslaved Africans which were successful into efforts of new identities viewed as separate from the collective as a whole, resulting in the creation of such bizarre entities as "black Indians," (black reds).

The Gullah War (or the African role in what is popularly called the Seminole Wars) can most accurately be said to have begun around the time of the Stono Rebellion in South Carolina, and to have included the aborted Denmark Vesey revolt in Charleston, as well as other numerous skirmishes and battles which took place in South Carolina and Spanish Florida. All these can be viewed as part of an ongoing resistance of captured and enslaved Africans to the institution of slavery imposed by U.S. colonists. When writing about U.S. history of this period, however, most historians and social scientists usually highlight the revolutionary war of 1776 and the conflicts of 1812; the purchase of Florida (including what is now called Georgia) from the Spanish; the purchase of the Louisiana territory from the French; and the U.S. Civil War. While the anti-enslavement revolts and later military campaigns of the Gullah "exiles" of Florida were undeniably of equal socio-political, economic, demographic and military significance, historical records of this significant African American war were originally suppressed or omitted from print, and consequently usually ignored by succeeding generations of historians and scholars, who mistakenly represented a significant part of this conflict as yet another Indian war.[5]

The reasons for this are relatively easy to understand. The original suppression of information was first and foremost an effort to keep Gullah insurgency from becoming better known and more popular among other enslaved Africans and their potential allies among Indians and the indentured servants. It also seems reasonable to suggest that insofar as the U.S. at the time was successfully projecting its revolution as one motivated by the same principles as those of the earlier French and English revolutions — the cry of the popular masses for the establishment of the principles of democracy, equality and fellowship — there was an awareness that the ferocity of its determination to re-enslave those who had freed themselves and to wrest control of the land from the Indians would tarnish the image of the U.S. revolution by revealing more sordid motivations of greed for land and slaves.

Many of the early revolts of enslaved Africans celebrated by the Gullah in the Carolina coastal region seem to have been directly connected with the efforts of the masses of enslaved Africans to escape

captivity and reach Spanish-held Florida (now called Georgia and Florida) in order to join forces with the Gullah exiles and their allies. Many enslaved Africans learned that when they reached St. Augustine, they would be able to receive arms and training. They may also have hoped to be able to live in freedom in the liberated region where autonomous Africans lived in villages, cultivated crops, and managed their own affairs. Assuredly, this possibility in such relative proximity to the U.S. colonists' plantations would have had a much greater attraction for Africans still in chains than escape through the more highly celebrated "underground railway" to the distant Canadian North, with its less familiar climate and ecosystem.

Our research findings indicate that wars which have often been regarded as Indian wars—the Seminole Wars—should more accurately be portrayed as a component of what we have called the Gullah War than as yet another Indian war. As far as it concerned the "seminoles" (runaways), most of the key Seminole leaders were in fact Gullah.[6] Indeed, many of the most celebrated Indian leaders who were allied with the Gullah while leading the resistance to U.S. forces were intimately linked to the Gullah through family ties.[7] Records of many of the more prominent military encounters indicate a predominant proportion of Gullah.[8] The key battles were fought in Florida, a region whose population at the time was predominantly Gullah.[9] As General Andrew Jackson wrote in 1818, the American motivation for the invasion of Florida was:

> To chastise a savage foe [the Spanish], who, combined with a lawless band of Negro brigands, have for some time past been carrying on a cruel and unprovoked war against the citizens of the United States...[10]

But more significant than any of these factors were the motivational forces for this conflict which spanned over a century: the implacable pursuit of U.S. colonists to re-enslave formerly enslaved Africans for motives which ranged from psychological (fury at the knowledge of Africans not only living at peace with other groups, but in freedom, equality and economic success), and pecuniary (to replace or acquire "property") to politico-military (to eliminate the threat that free communities of Africans posed to the slave holding system further north); and its corollary, the unquenchable desire of the Africans to remain free, and indeed, to liberate those of their people whom they knew to still be in chains. This was a war over enslavement; as long as there were Africans who lived in freedom — whether in Florida or in the West — their existence posed a threat to the system.

Wars are generally known and their major battles remembered by descendants of those who fought them, and this of course was true in relation to the Gullah War. These battles started in South Carolina, in what were successful and unsuccessful anti-enslavement revolts — the unsuccessful revolts leading to the garden of death, and the successful to liberated Florida, the northern or western U.S., or Canada.[10] Due to the proximity, political climate and nature of the population of Spanish Florida at the time, it was there that the masses of Gullahs consolidated, allied and prepared to do battle.

A period of almost continuous low intensity conflict leading to exile pursuit by slave-hunting U.S. colonists and Creek mercenaries preceded battles in which colonist militias fought against Gullah and Indian forces. This fanatical determination of the Carolinian, and later the Georgian and Florida colonists to maintain their system of African enslavement coupled with unquenchable Gullah resistance gave rise to major battles with the U.S. army, and eventually may have influenced the decisions which led to the Civil War, the Northern victory (achieved with the support of African American troops), the occupation of South Carolina, the forcible dismantlement of the system of enslavement, and Reconstruction.

Historical records as well as the oral history traditions of the descendants of the Gullah exiles in various parts of the Americas recall many of the major battles of the Gullah War. An adequate elaboration of these battles and the convolution of events between and surrounding them would require more space than this article can admit. The following, however, is a general account of some of the most significant battles of the Gullah War.

The Stono Rebellion, 1739

While we have decided to date the commencement of the Gullah War at 1739, the date of the Stono Uprising, this is not to say that Gullah resistance had not been significant even before that time. Peter Woods notes:

> "[The Stono Uprising]... was preceded by a series of projected insurrections, any one of which could have assumed significant proportions. Taken together, all these incidents represent a brief but serious groundswell of resistance to slavery, which had diverse and lasting repercussions."[12]

A lengthy chapter in Woods' book, *Black Majority*, deals with the subject of "Runaways." Numerous details are provided from historical records[13] of the unsuccessful efforts of enslaved Africans to escape, and indeed numerous details of records are provided indicating their recapture.

The measures enacted to prevent the escape of enslaved Africans[14] were so extensive and severe, and the records of *recapture* of fugitives so extensive, that one might well have wondered not only how any had managed to escape, but also how any had dared to try. And yet, while one might view the measures of control put in place by the colonists as so extensive as to have made flight and resistance near impossible, it is also possible to read, by the very extent of the preventative measures, the extent of resistance and flight which must have either been happening, or at very least, been anticipated. As William S. Pollitzer notes (see his article herein, p. 63), 18th century Charleston newspapers ran ads for 2, 424 runaways. As noted by Murial Miller Branch, during this period there were *hundreds* of runaway African American encampments from the border of South Carolina to St. Augustine, Florida. "Approximately one hundred African Americans were killed or executed for their participation in the *Stono Rebellion*."[15] But for each African who was killed in an escape attempt, there was another rising up elsewhere to "escape."[16] Ms. Branch quotes a Sea Island *grio*, Janie Moore, as pointing out the location of the Stono rebellion and saying:

> This is where some Sea Island slaves began their rebellion back in 1739. They were trying to escape to Florida... The Stono Rebellion took place in St. Paul's Parish, near the western part of the Stono River. These rebels for freedom marched through South Carolina on their way to Spanish-held Florida, beating their drums, carrying a flag, and calling out "Liberty!" as they marched.[17]

While this uprising was crushed, it evidenced what must have been a widespread awareness of the promise of freedom in Florida.

Battles with the state militia, 1736-1812.

Assuredly, the enticement to flee to Spanish Florida existed.[18] According to Mulroy, "Runaways from South Carolina began arriving in St. Augustine as early as 1687." Likely this was because "(t)he Spaniards welcomed runaways from southern plantations, gave them their freedom, and asked for little in return save for their cooperation in repelling elements hostile to both parties... In 1739, Montiano set aside for these fugitive Africans an armed garrison near St. Augustine called Gracia Real de Santa Teresa de Mose, which became the first known free black community in North America."[19] A buffer zone protected by Gullah and First Nations warriors formed an integral part of Spanish defenses in Florida, and this policy operated with some

success. In 1812, faced with an invasion force from Georgia, "a force of Africans and Indians under black leadership cut the patriots' supply lines and finally raised the siege of St. Augustine."[20]

While mainstream historical writing typically portrays the Gullah in Florida as escaped runaways who fled helter skelter through the bush to the security and protection offered by the "Seminole"[21] Indians (who, prior to the defeat of the Creek Nation in 1814 were said to number some 2,000),[22] African communities were already in existence in Florida at that time and were flourishing due to African familiarity with a tropical climate, and knowledge of rice growing, for which the Gullah were especially noted. As Joe Opala noted: "From the beginning of Seminole colonization in Florida, the Indian may have depended upon African farmers for their survival."[23] Assuredly, for that substantial section of the Creek nation which had just been exiled, the Florida terrain was substantially different from that of their own homelands. Africans lived in well-built homes and raised fine crops of corn, sweet potatoes, vegetables and cotton. They owned herds of livestock, and hunted and fished. This is hardly the picture of disorganized, dependent and pitiable fugitives which arises from historical writings which define the Gullah consistently in terms of their enslavement — either as slaves, runaway slaves or maroons, i.e. runaway slaves.

The liberated territory in Florida was populated by "a loose organization of associated towns enjoying a great deal of local autonomy and displaying a large measure of cultural diversity... The constituent members came from different regions and spoke various languages."[24] While most historical writing refers to the Gullah in Florida as Seminoles,[25] the actual incorporation of Gullah into the Confederacy was not as individuals who had been assimilated to an Indian culture, but rather as collective groups, living independently in their own communities and maintaining their own languages and ethnicity. As Mulroy noted, "The black towns fitted easily into the confederation but, with few exceptions, the Indians did not consider Africans to be Seminoles"[26] — if "seminole" were construed to mean "Indian" as opposed to "runaway" or "exile." Presumably, neither did the Africans consider themselves to be Seminoles, i.e. assimilated to Indian culture.

> While certain aspects of the maroons' and Seminoles' daily lives were similar, others were not. The differences formed the bases of the maroons' ethnicity and defined them as a people...The maroons' first language was what linguist Ian F. Hancock has termed Afro-Seminole, a creole related to Gullah... The [Indian] Seminoles' native tongue remained either Hitchiti or Muskogee.[27]

Similar to the situation in Haiti,[28] the political and military circumstances created by the efforts of three European governments to claim the same area of the Americas (Florida) in confrontation with the emerging revolutionary U.S. nation-state lead to a situation where the Gullah and First Nations[29] were able to secure weapons to pursue their own best interests of seeking freedom from enslavement in the creation (in effect) of a multi-racial egalitarian democracy.[30] This strategy of the European states — so-called "freeing the slaves" so that they would fight against those who had enslaved them, knowing that once the common enemy was defeated, the African Americans would be totally at the disposal of their emancipator — was probably later used by the North in order to take control of the southern portion of the U.S. from the Confederate government.[31]

The major alliances at play in the Florida region over time were as follows:

a) The Spanish supplied arms and political recognition to the African American Gullahs in order to enable them to protect the political border between Spanish Florida and South Carolina.[32] These borders were constantly threatened by aggression from the American colonists in South Carolina.

b) The English also supplied African Americans with some arms, military fortifications and safe passage to Canada. They hoped to spur African and Indian resistance to enslavement and permanent settlement of land in order to discourage the U.S. colonists from using land- and slave-grabbing as credible reasons for seeking independence from England.[33] They also sought to curtail these practices through limiting colonial expansion in the west, and disallowing slaveholding in Georgia.

c) A significant number of formerly-indentured servants sought personal freedom and economic opportunity by joining the Gullah and their allies.[34]

d) Last and most important (next to Spanish and English supply of arms and political space) was the alliance with the First Nations.[35] This was by far the most natural and strategic alliance, providing both logistics and manpower. The First Nations were interested in preventing the European settlers from controlling land usage, which they considered their right; and it is likely that they saw the Africans as posing no threat to their way of life, not only because the Africans were not attempting to impose their culture or way of life, or take possession of the right to determine land usage, but equally because the Africans were in no position to do so. In the most true sense, both were exiles, the Gullah exiled from their home in Africa, and the First

Nations from their tribal lands in America.[36] It is also likely that the Africans represented themselves to the First Nations as persons ultimately wanting to be free to return to their home in Africa. The religious beliefs of many of these African Americans indicate that the worst thing that could happen to them after death was for their spirit not to find its way home to their families, and therefore be left to wander endlessly.[37]

The negative aspect of the alliance with the Indian First Nations was that it provided the U.S. colonists with a credible cover to disguise the fact that African Americans were resisting their enslavement "en masse," and posing a credible politico-military threat to the existence of the U.S. enslavement institutions, and thereby to the U.S. itself.[38] By labeling the Gullah insurgency an Indian war, the U.S. colonists sought to hide it among the many ongoing wars with the Indians for control of their territories, to which the colonist population and the world at large had become accustomed.

It was only natural that they would seek to prevent those Gullah who remained enslaved from knowing about what was occurring nearby, thereby reducing the possibility of their imitating, supporting or joining those Gullah who had successfully revolted and escaped to Florida.[39] And in turn, the Indians were portrayed to the enslaved African Americans as people who would either enslave them or help recapture them if they were to escape, a practice actually encouraged by colonist governments.

There was a need to hide this insurgency not only from the enslaved themselves, but also from colonists, the nation, and world public opinion at large. The maintenance of the illusion that the Africans were content with their situation served to encourage European immigration into Carolina and prevent panic and out-migration by those already there. It assured settlers and potential immigrants from Europe that all was going well and according to plan, and that the only wars involved the Indians, wars which were already well known to the world. By creating new Indian tribes on paper, accrediting as leaders only those Indians who would cooperate with them, and inciting individuals from existing Indian tribes to capture and re-enslave African Americans, the U.S. was able to turn the Indian nations against each other, and neutralize the natural affinity between the struggle of African Americans for freedom, and that of the Indian First Nations for the right to free use of their land. This U.S. legacy of divide and rule can be observed today in the tendency of the U.S. government to attempt to divide African Americans from any African, Asian or European nation that recognizes and expresses the natural affinity

between its struggle against the global political and socio-economic hegemony of the U.S. and the African American struggle for human rights.[40]

The methods used in earliest suppression of information[41] concerning the success of this mass revolt of African Americans against enslavement were gross. Yet these misconceptions continue to be passed on, even by those who may have no interest in minimizing African participation. A few observations from early historical writings to more contemporary scholarship may alert future researchers:

a) When reports from the battlefield involved the Gullah, the words "black," "Negro" or "African" were simply omitted, or replaced by asterisks. This served to prevent the African American community from knowing that the Gullah were in the process of conducting a successful revolt or war. It also served to prevent records of the African American nature of this war from being picked up by later more fair-minded scholars (black, white or Indian) when they researched these earlier texts and newspapers for historical data.[42] It succeeded most at bedazzling the later researchers and scholars with confusing data, thus distorting their conceptualization of what had occurred.

b) Reports from the battlefield were frequently not even released to the public until a later date. For instance, the U.S. public heard nothing about the destruction of Negro Fort, which occurred in 1816, until 1837, when Congressman William Jay broke the story.[43] When General Gaines moved his troops out to burn down the Gullah town of Fowltown, "believing it was best for citizens to learn little of the mounting U.S. war in Florida, the U.S. Secretary of War kept Congress in the dark."[44] This was typical of the practice of nonrecognition of Gullah resistance.[45] The *South Carolina Gazette* had refrained from even mentioning the early Stono Uprising, which had occurred within a scant twenty miles of Charleston,[46] and was subsequently regarded as a major uprising in the state.

c) When referred to specifically, the Gullah were frequently mentioned in such a way as to minimize and denigrate them. As an instance, in 1822, the U.S. secretary of State reported that in Florida there were "five or six hundred maroon negroes wild in the woods."[46] This is typical of the image of "maroons:" terrified fugitives crashing through the bush, disorganized and isolated from each other, rather than functioning effectively as guerrilla units or living in communities. Further, if Gullah who had successfully fled were mentioned, they were mentioned so that the nomenclature itself differentiated them from the bulk of the African population who still were enslaved. They were referred to as Seminoles (a term without apparent African content), or

as Seminole Negroes, Black Seminoles, Seminole maroons, etc.. Any mention of joint Seminole Indian and Gullah initiatives always put the Gullah in the "Tonto" position: "the Seminoles and their allies," "the Seminoles and the blacks," etc.. Gullah presence in peace negotiations was always accounted for by their appearing as "interpreters," etc., rather than as leaders or persons whose assent to agreements was required. Perhaps to English-speaking readers and writers this seemed only natural, since, as far as they were concerned, the Gullah were "owned" by the Seminole Indians in the way that the English understood ownership.

d) By referring to this insurgency which the militias were unable to quell as a "Seminole" insurgency, reports disguised the nature of the population against whom they were fighting.[48] As Mulroy acknowledges, "In what turned out to be a taste of things to come, moreover, it was the blacks who did most of the fighting in what is considered to be the main battle of the First Seminole War."[49] As far as the second Seminole War is concerned, General Jesup noted in December, 1836, "This, you may be assured, is a negro and not an Indian war."[50]

e) Ignoring the existence of Gullah leaders further disguised the Gullah insurgence. While the name of Osceola has been justly celebrated, it should be remembered that he perished at the age of 34 in Fort Moultrie, years before the end of the Seminole Wars, and that only months before, he had been surrounded by a personal bodyguard in which Gullah numbered 52 out of a total of 55. John Horse, Ibrahim (or Abraham)[52] and various Gullah surnamed Bowlegs numbered among the foremost leaders of what have historically been referred to as the second and third Seminole Wars. Is it too much to suppose that much of Osceola's fame derives from the fact that the colonists had succeeded in capturing him, and hence represented him as the major leader of the Seminoles, even though the Seminole wars continued long after his death? Or perhaps that those against whom he struggled were more willing to recognize him as their adversary, particularly given the degree of his European ancestry,[53] than the Gullah leaders, whom personal racism and the threat to the institution of slavery, rendered permanently unacknowledgeable as leaders. Indeed, while Ibrahim went to meet with U.S. president John Quincy Adams at the negotiating tables in Washington, and John Horse later went to meet with President Polk, the significance of their presence has been routinely disguised by referring to them as 'interpreters' for the Indians, rather than as leaders in their own right. However, is it not more likely that they were designated as interpreters by the U.S., for whom it might have been not only psychologically untenable to negotiate with those they had formerly enslaved, but also politically untenable for what

such a recognition of Gullah leadership would signify in relation to the institution of slavery in the colonies, and its political impact on the masses of Gullah still enslaved, yet yearning to be free. The likelihood was that Ibrahim and John Horse were leaders whose attendance was necessary, even if it couldn't be officially accredited.

While the U.S. tactic of divide and conquer was successful in splitting the Gullah from the five "civilized" Indian nations — who gave in to U.S. offers to accord them the right to enslave Africans — such tactics were never successful with those Indians who were then called the Seminoles. That this First Nation group *alone* withstood the combined threats and enticements of the Florida colonists and the U.S. government may indicate much about the composition of the Seminole Confederation itself and the relative influence of the Gullah within it. The Treaty of Multrie Creek, signed in 1824, conceded a reservation of 4 million acres plus a yearly annuity, farming implements, a school, a blacksmith and a gunsmith in exchange for their forbidding so-called runaway slaves from their reservation; however very few Indians moved onto the reservation, which ultimately proved uninhabitable, and the mutual assistance between Indians and Gullah didn't cease. Not only did these Indians continue to abet fugitive slaves; they even demanded that slave catchers return the free Gullah they had kidnapped from their villages.[54] Even in 1837, when the Seminoles were forced to sign a treaty accepting to no longer harbor "their negroes, their bona fide property," they ignored it.[55] The U.S. sought to inculcate a mutual antipathy between Gullah and Indians by keeping the African American and Indian peoples in general ignorance (insofar as was possible) concerning their alliance in resistance, by engendering situations and conceptualizations that encouraged anti-black propaganda to Indians, and anti-Indian propaganda to African Americans. It is little wonder that some among the Indians gave in to the U.S. government's temptations.[56] Even today, some Indians prefer to view Seminoles as Indians who enslaved the Gullah instead of as an Indian Gullah alliance, a preference which might be well understood in relation to a contemporary Indian desire to be associated upward with the victorious, rather than downward with the discriminated against. However humanly understandable, this desire continues to negatively affect relations between Indians and African Americans.

All of the encounters through 1812-13 were relatively small compared with the battles to come. During most of this period, the U.S. colonists, bred on notions of African inferiority, seemed unconvinced that the Gullahs and their allies could pose a real threat to their enslavement system. It was as if they felt they would be able to capture and re-enslave the Gullahs at will. However, after state militia

expeditions into Florida met with numerous defeats, they began to change their minds.

This can be described as a period of great uncertainty for the colonists, both North and South. The Gullah insurgency raised the more important and disturbing question of whether the enslavement system could be continued without the almost certain eventuality that the South would become African and hostile. The only way that this apprehension could be put to rest without establishing a multi-racial democracy, in the minds of the U.S. colonists, would be to utterly destroy or devastate the Gullah runaways, and to ignore and obliterate their existence from historical memory. Later Northern colonists seem to have decided that stopping the slave trade (further importation of Africans into the South) was also necessary.

In the years 1812 and 1813, Gullah defenders figured largely in thwarting the efforts of the Georgia "Patriots" to conquer Florida. Militarily speaking, the period was marked by hit and run skirmishes in which neither side achieved victories on the battlefield, and during which most of the losses were suffered by the militias. From the point of view of the militias' objectives of capturing and re-enslaving African Americans, these expeditions were a complete failure. Thus they served to convince the U.S. colonists that state militias would be unable to provide the force necessary to discourage the African American Gullahs from fleeing to Florida by recapturing them once they had reached it.

Heretofore, U.S. colonists' experiences with enforcement of their enslavement rules and codes, and the suppression of the liberation struggles (which they called rebellions) consisted of little more than ganging up on outnumbered individuals — unarmed or poorly armed African women, men and children. Now, having to face trained and armed Africans under relatively even military conditions, they experienced great shock at not being able to outmaneuver or outflank them and consequently great embarrassment at the incorrectness of their racist assumptions of moral and intellectual superiority. To restore the personal faith of their soldiers in their racist socio-political system and to prevent the settler population from wanting to abandon slavery (or more particularly, the struggle to preserve it), thereby foresaking its economic advantages which had numbered among the reasons for colonizing America in the first place, the U.S. colonists needed to overcome the insurgency or at least disguise the true nature of whom they were fighting with. The collapse of the enslavement system might have meant the collapse of U.S. colonists' efforts to conquer and settle this part of the Americas, as did the collapse of the enslavement system in Haiti lead to the collapse of French efforts to settle this island, perhaps

also dimming their interest in settlement of the Louisiana and Canadian territories as well. After all, without African enslavement, the Golden Triangle would turn to brass, and the resources of Europe would have to be invested in more profitable areas of their colonial empire. Clearly, the U.S. push into Florida involved more than simply another land grab.

Reacting to the challenge posed by uncrushed Gullah enclaves to the south, the colonists called for the help of the continental U.S. army.

The Battle at Horseshoe Bend, 1814

In 1814, General Andrew Jackson crushed the combined forces of the Creek Confederation at Horseshoe Bend on the Tallapoosa River. By imposing a treaty upon the defeated Creek Confederation which ceded several million acres to the Americans in such a way that it sundered and fragmented the Creek lands, Jackson made it impossible for them to exist any longer as a cohesive society. The Creek divided in two: those who submitted to the U.S. colonists' agenda, and those who resisted. Some five thousand warriors and their families (the exiles) followed the indomitable Creek leader, Sacafoca, over the border into Florida to ally with the Gullah forces and other allied First Nations groups.[57] The defeat of the Creek Confederation and the movement of Chief Sacafoca into alliance with the Gullah freedom fighters provided the extra manpower for what can be called the grand alliance of the "exiles" against the U.S. continental army.

The Battle of Negro Fort, 1816

The second Anglo-American war was marked by British efforts to ally with both enslaved and escaped Gullah. To that end, two British sloops of war and some smaller vessels landed troops in Appalachicola Bay under Lieutenant-Colonel Edward Nichols, and provided a large force of First Nations and African American insurgents with arms and ammunition. Nichols proceeded to build a fort on the east side of the Appalachicola river, some thirty miles from its mouth, which was then taken over by the African American insurgents to serve as a bulwark against aggressions by the colonists. It became known by the U.S. colonists as *"Negro Fort,"* and by many enslaved Africans as the place to flee to for safety from enslavement. With a force of some three hundred men, women and children (of which only 34 were Indians, and only 11 Seminoles)[58] directed by black officers under the leadership of Commander Garçon (or Garcia or Garson),[59] it served as one of the most strategic African American fortifications. Due to the cooperation

of their Creek allies, the U.S. army had been unable to reach it by land. However, after crushing the Creek confederation at the Battle of Horseshoe Bend and meeting with unyielding Gullah resistance on the land route to Negro Fort, the new U.S. government released the combined sea and land forces of the continental army on the Gullah component of the war. U.S. naval and land forces invaded Spanish territory without a formal declaration of war, and destroyed Negro Fort in July, 1816, two years after it was built. As described by Katz:

> Each side fired off cannonballs that landed harmlessly in the mud or shallow water. Eight times U.S. ships fired and eight times no one inside Fort Negro was hit. A ninth cannonball, heated red hot in a ship's furnace, landed with miraculous accuracy inside the fort's ammunition dump.[60]

Giddings describes what ensued:

> [A] blazing hell followed. The agonizing screams could be heard above the crescendo of explosions... That holocaust killed one-third[61] of those African Americans who had fled to Florida for safety. The Indians who died with them had been their friends and families... By Jackson's orders, any 'leaders' were to be handed over to the Creeks[62] for torture. The sixty-two injured [those who survived] were carted away... [and] re-enslaved by anyone who claimed them — and they need offer no proof.[63]

The destruction of Negro Fort marked a turning point in the strategy of the Gullah leadership. Henceforth, they would avoid fighting from fixed, fortified positions, and return to their traditional guerrilla-oriented tactics. They would strike and vanish, maintain many hidden arms caches, lure the enemy into the swamps, forests and pastures where they enjoyed the advantage of knowledge of the land, and live constantly in a state of preparedness of the whole community for flight.

The Battle of Suwanee, 1818

In 1972, Northwestern University Professor Emeritus Jan Carew interviewed an aged descendant of the African American insurgents, an African American migrant to Andros Island in the Bahamas, and was given an account of the Battle of Suwanee in 1818:

I heard 'bout the battle of Swanee' against Stonewall Jackson, my grandmother tell me 'bout it and her grandmother tell her 'bout it long before. Stories like that does come down to us with voices in the wind. She tell me how the Old Ones used to talk 'bout the look on them white soldiers' faces when they see Black fighters looking like they grow outta the swamp grass and the hammocks, coming at them with gun and cutlass. Jackson get hurt at Swanee, man, the ancestors brutalize him there. He run away, and never come back to face Blacks and Seminoles fighting shoulder-to-shoulder — black flesh touching red and brown — that kind of thing does give the white man nightmare and day-fever all at the same time. But after them Black and Seminole fighters punish Jackson good and proper, he turn on the women and children that the Seminoles did leave behind, and any of them that look like they had African blood, he carry off to sell into slavery. Oh, God! That man Jackson was cruel, eh! *He enslaved them who was free already for two and three generation. He sell the grandchildren of former enslaved to the grandchildren of former slave owners!* [Italics added.] My old face already beat against eighty-odd-years and my children and grandchildren all gone to far places looking for work and a better life. But when Jesus of Nazareth decide to send Mantop to carry me to the Great Beyond, wherever my blood-seed scatter, they will spread the word 'bout how Black and Seminole ancestors fights side by side at Swanee.[64]

As Jan Carew noted, the old woman had been talking about the Battle of Suwanee, claimed by General Andrew Jackson as a victory, despite his troops having failed to defeat a heavily outnumbered force of Gullah and First Nations insurgents who disappeared in the swamps and bayous after having inflicted heavy casualties on their attackers. The only victory he achieved was over a settlement of women and children who were noncombatants residing in their villages.[65] In Carew's own words:

Looking at that old woman with hair like combed and bleached Sea Island Cotton, an age-serrated, benign ebony face and a white clay pipe held between teeth grooved by an infinite number of pipe stems, I almost considered it a miracle that, after more than a decade of following promising leads that had often turned out to be useless, I should have, quite unexpectedly, stumbled upon her eloquent testimony. There she was, telling me quite calmly between puffs on her clay pipe about a battle that Joshua Giddings described as 'the bloody Seminole war of 1816-1818, (which) arose from the

efforts of... the U.S. Government to sustain the interests of slavery.'[66] This 1816-18 war to re-enslave those who had liberated themselves from slavery and to conquer Native American territory, is officially known as the 'First Seminole War.' This grandmother... was in fact telling me about an event that had taken place a century and a half earlier, and she was doing this on the island of Andros, one of the farthest outposts to which descendants of [liberated African Americans and their Indian allies] had escaped after the war had ended in the 1850s.[67]

However inadequately achieved Jackson's purported victory at Suwanee might have been, he went on to smash through the Gullah towns under the leadership of Billy Bowlegs. By May 24, he had captured Pensacola, and Florida fell into U.S. hands. At this point, in confrontation with the U.S. army and no longer enjoying the political protection and arms provided by Spain[68] or England,[69] the Gullah/ First Nations alliance lost the strategic assets which once might have allowed it the hope of withstanding an assault by the U.S. indefinitely. The U.S. army pursued the exiles into southern Florida, undertaking with them there a series of negotiations and enticements in hope of terminating the effective alliance between the two groups. In particular, the U.S. sought to promote the practice of slaveholding among the Gullah's Indian allies.

After 1819, the central focus of U.S. policy in Florida would be to re-enslave the Gullah who had liberated themselves and, by trickery and further treaty, to expel the Indian First Nations from lands given to them by treaty in Florida. Realizing that defeat meant re-enslavement, the Gullah played a decisive role in fostering and strengthening the exile alliance's opposition to removal, an opposition which unquestionably paved the way for the onset of what is known as the Second Seminole War.[70]

The Denmark Vesey Conspiracy, 1822

Despite the efforts of the U.S. to prevent knowledge of the Gullah insurgency in Florida, it appears highly unlikely that this would have been completely successful. In the course of the implacable pursuit of the Gullah by the U.S., many were captured (either through the efforts of colonists, their Indian allies, or the federal government forces) and returned to enslavement. Their subsequent dispersal throughout the slaveholding territories was likely to have proliferated word of Gullah battles with U.S. colonists and even with the U.S. military throughout the enslaved populations, either directly or by word of mouth.[71] This,

combined with the inspiration of and assistance resulting from the successful Haitian revolution,[72] helps to clarify how an insurrection plotted in Charleston, South Carolina in 1822 could have been deemed feasible by the plotters, and illicited the support of over 9,000 Gullah in the area. By 1822, almost all the enslaved Africans in the plantations surrounding Charleston had joined the revolt. Peter Poyas, among Vesey's lieutenants and said to be one of the great military and organizational geniuses of the early nineteeth century,[73] organized the revolt into separate cells under individual leaders.

That this revolt was not simply drawing on local forces in the Charleston area is possibly indicated by the involvement of Gullah Jack, who was selected to lead the contingent from a coastal island near Charleston. Having been liberated during what is usually referred to as a "Seminole" raid and attack on Kingsley Plantation, and likely captured and re-enslaved at some point during the Gullah War in Florida,[74] Gullah Jack would have brought to the conspiracy an awareness of the Gullah insurgency that had been taking place in Florida — as would all other Africans who had been captured and re-enslaved, who had doubtless been the most resistant elements within the community. This connection would have tied the Vesey revolt into the fabric of the ongoing Gullah struggle, word of which must have spread to some degree to the plantations by means of those who had been captured and returned to enslavement.

The date set for the uprising, July 24, 1822, was advanced to June 16th when Vesey learned that one of the enslaved tied to the black church found out about the revolt and informed the authorities, who immediately increased patrols and began hauling in suspects for questioning. While he sent a messenger to inform the insurgents in St. John's Parish, a military patrol prevented him from leaving the city. Though there were an estimated 1,000 armed men prepared to strike on the appointed date, Denmark Vesey called off the attack, fearing an extensive defeat and reprisal.

The trials of the conspirators went on for 5 1/2 weeks. The defendants were divided into two groups: planners, those who had attended meetings, contributed money or showed no remorse after the initial hearing and a second group formed of all the rest. It was determined at the outset that the first group would be executed and the second deported — perhaps since little other alternative remained as to what to do with them. The uprising itself may have confirmed that reintegrating resistant (albeit recaptured) Africans among the more docile elements of the enslaved had had the effect rather of rousing the dispirited, than quelling the resisters. Jail for such numbers was

impossible, as was mass execution. Although an estimated 9,000 were involved in the conspiracy, only 67 were convicted of any offense. Denmark Vesey and 34 others were hanged.

THE SECOND PERIOD OF THE GULLAH WAR

By 1834, some 10,000 men, a major part of the Regular Army of the United States, were concentrated in Florida.[75] What is traditionally called the Second Seminole War erupted again in 1935, caused by continuing U.S. efforts to force the Indians to abandon their alliance with the Gullah, leave lands in Florida agreed to by treaty in 1824 and resettle amid their Creek enemies in Oklahoma. While U.S. colonial expansion typically sought to expropriate the lands of the First Nations, the question must be raised as to whether the desire for lands already ceded to what were called Seminole Indians by treaty in 1824 could possibly be greater than the desire to resolve the dilemma posed by the existence of African communities not bound in a system of onerous enslavement. Indeed, it might be said that the only resolution to the dilemma of free Africans in the context of slavery was the elimination of either one or the other.

When Seminole Indian leaders were tricked into signing a treaty concerning their removal,[76] hostilities broke out.[77] It was a war which General Sidney Thomas Jesup, the commander of U.S. forces, viewed as "a negro and not an Indian war, "[78] although "the two races... are identified in interests and feelings."[79] It began with a series of Gullah/First Nation victories, among them the victory over the Fort King Relief (termed the Dade Massacre)[80] in 1835, and over the U.S. army led by General Clinch at the Battle of the Withlacoochee.

The Victory over the Fort King Relief (the Dade Massacre) 1835

The relief forces of Major Francis L. Dade were en route to supplement forces at Fort King when the allies attacked them by surprise. According to Luis Pacheco, their African guide who escaped and later joined the allies, "There was a whole 'passel' of hound dogs in the troop" — possibly indicating that slave hunting was anticipated.[81] In the initial volley of shots, the officers were specifically targeted.[82] The U.S. forces responded with musket and cannon fire, until the cannon ammunition ran out. The final assault upon them was undertaken by "about fifty mounted black warriors."[83]

Customarily termed a 'massacre' rather than a battle by historians (thereby discrediting historical recognition of the Gullah/First Nations

victory), this battle led to significant U.S. troop casualties: more than 100, compared with exile alliance losses of three.

The Battles of the Withlacoochee River, 1835

Porter provides a fascinating description of the Battles of Withlacoochee, [84] in which vastly outnumbered African and First Nations insurgents held the river against successive contingents of U.S. forces from December, 1835, up to November 13th, 1836, when an overwhelming force led by General Call and augmented by Creeks who had been promised the booty of any blacks they might capture, finally crossed the river without meeting any opposition.

In the first battle on December 31st, 1835, the exile forces were not only able to prevent six companies of the U.S. Fourth Infantry and a regiment of Louisiana volunteers from crossing the Withlacoochee River, but nearly succeeded (but for a change in the wind direction) in overcoming their erected defences on the other side of the river. Had it not been for the arrival of reinforcements under General Cinch, the demoralized and famished U.S. army contingent would surely have succumbed — either to the superior and innovative military tactics of the insurgents, or to starvation. As it was, having gained vital time for the evacuation of their communities, the insurgents were compelled to withdraw further south, for further resistance against insuperable numbers was futile. In this battle, the exile forces lost three men, with five wounded, while Gaines' losses were five dead and forty-six wounded.[85] A period of recuperation for his troops at Camp Izard ensued, after which "General Gaines soon left Florida, issuing a statement that the enemy had been 'met, beaten, and forced to sue for peace.' But his men had not crossed the Withlacoochee River, and the allied tribespeople and blacks still held the region."[86]

U.S. troops did not succeed in crossing the Withlacoochee until nearly a full year thereafter, but when they did, the vastly outnumbered insurgents had taken the only recourse that common sense demanded: they had melted away to the south. While the U.S. forces could be said to have succeeded in crossing the river, they cannot be said to have won these battles. The encounter at Wahoo Swamp which followed thereafter, though it occasioned heavy losses among the allied insurgents (some 620 men of which 200 were Gullah), still found the contending forces on opposite sides of the Withlacoochee. It concluded with a mutual withdrawal, officially proclaimed by the U.S. side as "a brilliant day, redounding to the honor of our arms..."[87]

Having regarded the Gullah element as crucial in the war ("this is

a negro war"), and the alliance between Gullah and Indians as "identified in interests and feelings," the U.S. General Jesup, commander of the Florida Territory, endeavored to break the Gullah/Indian alliance and remove the threat posed by independent black communities in Florida through promoting black slaveholding among the Indians. When this in turn proved largely unsuccessful, the next option was removal. Anxious to appease Florida settlers complaining of African and Indian depredations, and southern planters concerned over the loss of runaways, the Jackson administration sought an immediate removal treaty with the Seminoles.[88] Insofar as the Gullah were seen to have played a major role in marshalling Indian opposition to removal,[89] this period of the conflict was ultimately terminated by a treaty which sought to remove them to the West "as part of the Seminole nation." This in turn furthered the popular legitimization of the "black Seminole" conceptualizations prevalent today.

The dilemma which the U.S. faced was this: how to rid Florida of the free Gullah communities and the threat that they posed? Jesup did not propose to "allow the dissemination among southern plantations of maroons, trained in the use of arms and accustomed to freedom, who could take the lead in slave insurrections."[90] Clearly, on the other hand, as the above military encounters indicated, it was exceedingly costly and difficult to bring the insurgents to their knees, or to sufficiently decimate their numbers militarily. Somewhere along the line, their acquiescence to removal had to be obtained, as the best of the scanty options. Accordingly, Jesup commenced a series of negotiations. On March 6, 1837, a treaty was made with "the Seminole nation of Indians and their *allies*," undoubtedly referring to the Gullah. Article 5 stated that:

> Major General Jesup, in behalf of the United States, agreed that the Seminole and *their allies*, who come in and emigrate west, shall be secure in their lives and property; that *their negroes*, their bona fide property, shall also accompany them West.[91]

The wording, a masterstroke in diplomacy, sought to satisfy Gullah demands and thirst for emancipation, while at the same time catering to the Florida settlers' concerns that the Gullah should not be emancipated, negotiated with, or spoken of in any way other than as somebody's property.

But even Gullah removal — if it occurred in association with any hint of emancipation — did not remove the potential threat of Africans living in freedom on the same continent to those areas where Africans

were enslaved. The Florida settlers forced Jesup to return to hammering the Indian contingent for the surrender of the Gullah, something of course Jesup knew they did not have the power to do even if they were willing. Jesup returned to his efforts to break the alliance, and to turn the allies against each other. In the face of ongoing resistance, in February 1838, through African emissaries to the leading maroon exiles, August, July, and John Horse, Jesup ultimately promised "freedom and protection" if they would separate from the Indians and surrender, accepting to be sent to the west. As Mulroy noted: "Black emancipation and removal suddenly had become the policy of the United States army." But to disguise this, it had been necessary to view all Gullah insurgents, perhaps four-fifths of whom were runaways or their descendants, as property of the Seminole Indians. Whether this was now, in any manner in practice, the case — or had ever been in any sense similar to that understood by U.S. colonists — was immaterial to the politico-legal necessity to assert that this indeed was the situation, and thereby camouflage the noxious notion of African freedom, equality or independence existing either to the south or to the west.

The Battle of Lake Okeechobee

What Jesup couldn't accomplish in battle, he accomplished by trickery and deceit, capturing the Seminole Indian Chief, Osceola, who had approached him with a contingent of some seventy hostages, to further negotiate the terms of peace.

While Osceola languished in prison at Fort Moultrie, his life slipping away due to illness at the age of 34, some twenty or so of those captured with him escaped to freedom, led by John Horse and Wild Cat. They were pursued by Colonel Zachary Taylor with a force of 70 Delaware Indians, 180 Tenessee volunteer sharpshooters and 800 U.S. soldiers. According to William Loren Katz:

> The first shot had hardly been fired when the Delawares deserted. Tennessee riflemen plunged ahead intending to wipe out the Seminoles and a withering fire brought down their commissioned officers and then their noncomissioned officers. The Tenesseeans fled.
>
> When the U.S. regulars were ordered forward, pinpoint accurate fire brought down, according to Colonel Taylor, 'every officer, with one exception, as well as most of the non-commissioned officers' and left 'but four... untouched... The battle of Lake Okeechobee became the most decisive upset

the U.S. suffered in more than four decades of warfare in
Florida. But since the Seminoles had finally abandoned the
battle scene [knowing they were no match for hundreds of
soldiers], Colonel Taylor claimed a victory.[92]

Typical of the victories of U.S. forces against the Gullah/Indian
alliance, the commander on the U.S. side declared victory as his enemy
melted into the bush.

Eventually, without sources from whom to secure arms and
ammunition or the protection of political borders, the exile alliance
forces would be outgunned by the superior arms, logistics, and
demographic and political situation of the U.S. army. Nonetheless,
during this stage of the Gullah War, which was essentially a defensive
action, there emerged many outstanding leaders among the insurgents,
whose names might well join the historical roster of those who resisted
the oppression of African Americans and Indians over the centuries.
*These names appeared again and again in official dispatches, yet largely remain
unknown to the peoples who might most wish to recall them. The names of the
African Americans such as Garçon, Ibrahim, John Horse, Luis Pacheco, and
of First Nations Chiefs, such as Alligator, Wild Cat, Talmieco-Hadjo, Arpeika,
Tiger Tail, and many others will one day find their place in history alongside
other great freedom fighters.* These were among the leaders who formed
an alliance of resistance between African American Gullahs and Ameri-
can Indians, which endured for over a century, despite the onslaught
of U.S. troops in the field, and a barrage of ploys put forward by
governments, military officers and other U.S. Indian agents and allies.
These were the leaders who formed the soil from which later leaders
were nourished — Marcus Garvey, Elijah Muhammad, W.E.B. DuBois,
etc. — who in turn provided the soil for the contemporary martyred
leaders of our day: Martin Luther King and Malcolm X. These were
the forefathers of African American resistance.

Seeing only defeat in remaining in Florida, elements of the Gullah/
Indian alliance regrouped first in Oklahoma with the most steadfast of
their fighters, then went on to Coahuila, Mexico, where they once again
benefited from the protection of a political boundary and a well-wishing
state.[93] The exiles established themselves close to the small town of
Santa Rosa. Unable to rid themselves of their predilection for the
benefits of enslaving others, U.S. settlers from Texas organized two
expeditions against them for the purpose of seizing and re-enslaving
them. Their efforts met with armed resistance, and the settlers were
reported by Texas newspapers to have returned without "accom-
plishing the objective intended and... with their own numbers
diminished in conflict" with the Gullah exiles. Yet even at this point,

Leaders of the Gullah War

After being brought to America as slaves, thousands of Africans fled to the swamps and marshes of Florida. There they formed an alliance with another group of settlers, refugees from the Creek and other nations who called themselves Seminole, meaning runaway. As early as the 1700s, there were over 100,000 black runaways. *Source:* Tyndell's Home Page, http://web.fie.com/~tonya/blkind.htm. Following the writing of this article,the author had a discussion with Gullah descendants now called black Seminoles, whose self history does not contradict any of the points made in this article. While publication deadlines did not permit the inclusion of pictures of John Horse's descendant, Mr. Warrior, or more appropriate pictures of John Horse or Ibrahim (or Abraham), we feel that future researchers should make this one of their goals.

Above left: **Abraham (or Ibrahim)**
Above right: **John Horse or Cavallo**
Bottom right: **"Seminole Indians."**

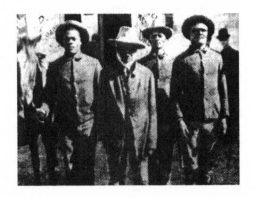

the Gullah insurgency had not collapsed to the point of mere self-defense. The Texas press reported some six months later that "Indians" (again, the disguising of African American insurgency) had crossed the frontier, and destroyed plantations, burned buildings, and set enslaved African Americans free. As Giddings noted, African American and Indian guerrillas appeared ready, even at what might have appeared the culmination of their epic efforts, to make war on all who fought for slavery.[94] The descendants of the Gullah exiles never signed or voluntarily surrendered anything to the U.S. government.[95]

CONCLUSION

To regard these wars as simply regional struggles is to vastly understate their impact; this insurgency challenged the very institution of enslavement. Its existence remained a constant negation of the notion propagated by plantation owners: that the enslaved Africans were benefiting from what was called the civilizing and Christianizing influence of their captors. Within the span of two short decades, with the passage of the Emancipation Proclamation after a Civil War in which African Americans once again arose en masse to fight for their freedom, the entire system crumbled.

These Gullah ancestors left Afro-Carolinians and all African Americans with a history of which they can be rightfully proud. In no prior civilization, whether in ancient Egypt, in Africa under Sundiata Kiata, the ancient Jews of Masada, or the contemporary Palestinians, did any people fight more gallantly for freedom and democracy under more difficult circumstances. Thousands of miles from Africa at a historical period when communication with their homeland was absolutely impossible, forcibly relocated to a continent where they were strangers and without historical allies, allying with unknown nations whose languages and customs were alien to theirs just as their own individual African languages and customs were alien to each other, designated as slaves by a powerful nation of people heretofore unknown to them who refused to speak to them, write about them or deal with them in any other capacity than as someone's slave, nonetheless individuals from these different African tribes mounted a resistance so fierce that they were able to forestall the will of a vastly superior power for over a century and instill in the minds of the most stout of the racist U.S. colonists, the fear or realization that the captured Africans could not be held in slavery indefinitely. Assuredly, if one were to ask where the true American revolution for freedom and democracy took place, the answer would have to include the Gullah War.

When we contrast the collective efforts of the Gullah African Americans with that of the collective U.S. colonist efforts of the time, we cannot help but ask which stood most in line with the spirit of the celebrated U.S. Declaration of Independence: "We take these truths to be self-evident: that all men are created equal..." The historians tell us: from 1739 onwards through the Gullah War, the U.S. Government sought to re-enslave the African insurgents who had liberated themselves. Northern legislators acquiesced to this shameful policy by silence, while in the south, the notion of enslaving Africans was almost part of the self-concept of the Confederacy. Even after the American Revolution of 1776, the U.S. government abandoned its promises to the African American allies to the Union cause, and acquiesced to the institutionalization of gross domination and oppression by accepting the dismantlement of Reconstruction and the racist premises of segregation. Thus, the actual history of the U.S. brings us to a very striking realization: the ranking of the American Revolution among the benchmarks of the western world's struggle towards freedom and democracy, in line with the Magna Carta and the French Revolution should be qualified, to say the least. While the latter were marked by efforts to extend freedom and equality, the influence on the American revolution of less honorable objectives tending in quite the opposite direction — the effort to continue to seize land from the Native peoples, and to continue to enjoy the benefits of the enslavement of Africans[96] — must be acknowledged.

Whatever the future may hold, this much, surely, should be reclaimed and recognized as a key axiom of African American history: that the Gullah War played a major role in convincing the U.S. colonist power structure that the institution of enslavement had no future, since those it enslaved could be counted on to mount unending resistance. Were the U.S. to achieve the social peace that its Euro-demographic profile, and economic development, etc., required, then the effort to maintain a system based upon the enslavement of Africans had to be abandoned. Indeed, it might be said that it was here in America, during the Gullah War, that the globalized institution of enslavement as a system facilitating capitalist development was halted — not for the "inutility of slave labor," but because those who were enslaved made it clear that the enslaved would never accept their enslavement, and in all the ways that were possible, they would rebel.

To the Gullah forefathers of African American resistance, all hail.

[1] The term "Gullah Wars" was coined by Muriel Miller Branch in *The Water Brought*

Us, (Cobblehill Books/Dutton, New York, 1995) to refer to the ongoing and consistent Gullah resistance to enslavement, as manifested not simply in insurgency, but also in incendiary activities, poisonings, sabotage and flight. However, Ms. Branch did not further concern herself with the extensive insurgency surrounding the general flight of the Gullah to Florida, their establishment of communities there and normalized living patterns, their resistance to the state militia and later U.S. army incursions into what was then Spanish-held Florida in order to destroy their communities and re-enslave them, and their subsequent removal and pursuit into Oklahoma and on into Mexico.

[2] We regard this prolonged conflict as a war composed of many battles, rather than as a series of wars, insofar as it evolved around a single major issue — the Gullah resistance to enslavement and re-enslavement and the threat it posed to the institution of slavery. In the course of the century and longer struggle, the issue was never fully resolved. The Gullah did not surrender, and ultimately the institution of slavery, the issue which gave rise to this prolonged confrontation, was abolished due to exigencies related to the Civil War.

[3] The threat of this prolonged insurgency to the existence and maintenance of slavery is fully recognized in William Loren Katz, *Black Indians: A Hidden Heritage*, Atheneum Books, New York, 1986; Jan Carew, "The Undefeated: Joint Struggles of Native Americans and Peoples of the African Diaspora," in *Exploring the African American Experience*, edited by Niara Sudarkasa, Levi A. Nwachuku, Robert E. Millette and Judith A.W. Thomas, Cornell University Press, Ithaca, 1998; Kevin Mulroy, *Freedom on the Border: The Seminole Maroons in Florida, the Indian Territory, Coahuila, and Texas*, Texas Tech University Press, Lubbock, TX., 1993, among others.

[4] This is not to say, however, that as the subsequent resistance to cultural assimilation of those who successfully fled to Florida continued, it did not lead to their acquiring additional ethnic characteristics which may have distinguished them from what is generally regarded as African American culture at large.

[5] While the Seminole Wars could equally, and with justice, be called the American Anti-Slavery War, the African American/Euro-American War, the U.S./African War, etc., it would seem blatantly inadequate to refer to it as the Slave War any more than as the Seminole Indian War. The Africans and African Americans who fought these wars likely did not define themselves in terms of either their capture or enslavement. Referring to Africans as "slaves" — irrespective of whether or not they were even living under conditions of enslavement — was a U.S. colonist conceptualization fostered and enforced for socio-political reasons. The mass efforts to escape enslavement which they considered unjust and unacceptable serves as indisputable evidence that Africans and African Americans never accepted enslavement; they were more likely to have considered themselves to be captives. There is nothing in pre or post Civil War history to support this colonist conception of African Americans as slaves rather than enslaved except the fact that U.S. law and society so defined them. According to Porter, p. 33, "whites named those who escaped to Florida as 'Seminole Negroes' and had recognized them as an independent group during the Second Seminole War. We do not know how the maroons referred to themselves at this point."

[6] Ibrahim (or Abraham, see footnote 52), John Horse, those of African descent attached to Billy Bowlegs and taking his surname.

[7] Wild Cat's brother, a son of King Philip, was of African descent. Osceola's wife, Morning Dew, was of African descent. It may be that the marriage between "Morning Dew" and Osceola, plus his skills as a warrior, made it possible for

Osceola to be projected as the leader of both the African American and Indian armies. It should be noted that Osceola was partially of European ancestry. As Celia Bland points out in *Osceola: Seminole Rebel*, "Osceola had not always been a Seminole, nor had he always lived in Florida." His great-grandfather was a Scottish hunter who settled with the Tallahassee Indians; the granddaughter of this marriage married an Englishman, and the son was named Billy Powell. In time, Billy Powell changed his name according to Creek custom, and became Asi Yaholo, or as the whites pronounced it, Osceola. (See Celia Bland, *Osceola: Seminole Rebel*, Chelsea House, New York, 1994, p. 21.) Indeed, dressed now in calico as had been prescribed by law in colonial settlements for Africans, now in a blue officer's jacket during the Battle of the Withlacoochee (Bland, *supra.*, p. 67), and surrounded by a Gullah bodyguard, one should be moved to speculate: just who was this man who had won such renown as an Indian warrior? As Bland further notes, "Osceola was often mistakenly identified as the chief of the Alachua Seminoles. This was Micanopy's position, one that the Tustenuggee Osceola could not have held, but at the time, whites often assumed that any Indian who spoke with authority in the councils or led warriors into battle was a chief. Osceola, as the nephew of Red Stick leader Peter McQueen, did hold an important position on Micanopy's council, and gained authority as a leader in battle. However, there is little doubt of the predilection of the colonial press for Osceola." (See Bland, *supra.*, p. 69). To what extent may this have been, even at this early time in history, yet another instance of the media deciding for itself who were the leaders of groups whose leadership processes or allegiances it did not and did not care to understand, or indeed, an instance of the predominating power deciding which among the contending leaders within an enemy group or nation, it preferred or refused to recognize?

[8] When General Jesup's troops stormed Osceola's headquarters in January 1837, fifty-two of the chief's fifty-five man personal bodyguard were Gullah (Katz, *supra.*, p. 60).

[9] By 1710, "the population of northern Florida had all but disappeared — except for a fringe of white settlers along the east coast and a few Indian villages scattered in the interior, the region, still claimed by Spain, lay uninhabited." Bland, *supra.*, p. 23.

[10] John K. Mahon, *History of the Second Seminole War, 1835-1842*, University of Florida Press, Gainesville, 1967, p. 26.

[11] Most historical accounts tend to separate and diminish the African American resistance, portraying it simply as flight either to the northern U.S., to Canada or to Florida. However, it seems more adequate to view all three of these actions as part of a generalized revolt *en masse* against enslavement which could be said to include the efforts of the abolitionists (including John Brown) as well as the flight leading to the Canadian settlements (particularly Afriville in Halifax, etc.), as part of the Gullah War. John Brown has typically been discredited as having acted in almost lunatic isolation; however, were his actions to be viewed as occurring in the wake of a prolonged insurgency in Florida which sent its tremors through the entire coastal region, they might seem less out of context, albeit belated, since by the time of his death, the "third Seminole War" had already drawn to a close.

[12] Peter H. Wood, *Black Majority: Negroes in Colonial South Carolina From 1670 through the Stono Rebellion*, Alfred A. Knopf, New York, 1974, p. 308-309. Wood goes on to say that "The slave system in the British mainland colonies... never again faced a period of such serious unrest." However, if in fact the Gullah may be regarded as the major contenders and opponents in what have been called the "Seminole Wars,"

then clearly this is far from the case.

[13] Primarily marshals reports, advertisements in newspapers, etc.

[14] See Woods, "Patterns of White Control," in Black Majority, *supra.*, p. 271ff.

[15] Ms. Branch, who seems to have confined her research efforts within the standard U.S. politico-historical framework, tells us much about the *failed* efforts of enslaved African Americans to escape to freedom in Spanish Florida, but little about the main event: the efforts and battles of those who succeeded in reaching Spanish Florida, and their successful launching of an anti-slavery war by encouraging other enslaved African Americans to escape, and by organizing militarily for self-defense, to protect themselves against recapture, barbaric torture and re-enslavement. She mentions the "hundreds" of African American encampments only in passing. One might well presume that hundreds of encampments *en route* indicated a population of substantial numbers; these numbers should be added to those of the established villages and communities in Florida. Tyndell's Home Page (http://web.fie.com/~tonya/bblkind.htm) asserts that as early as the 1700s, there were over 100,000 "black Indians,"*[sic]*. While these figures are usually contradicted by official U.S. statistics from this period, there is no particular reason to believe these statistics over information handed down from generation to generation.

[16] The fateful African (Ibo) mass suicide at Ibo Landing speaks for the African mood of that time, and is said to be the inspiration for the famous African American spiritual, "Oh, Freedom."

[17] The author quotes Janie Moore as going on to say that "None of the tours would ever have brought you out here just like they didn't take you by the Emmanuel A.M.E. Methodist Church where Denmark Vesey planned his uprising." Ms. Branch further states that "the site of the Stono Rebellion of 1739 is now the home of an African American farm cooperative, but the memory of the rebellion is as fresh in Janie's mind as if she had actually been there to witness it."

[18] The Spanish, who still enslaved Africans and Indians by the hundreds of thousands in their colonial territories were, with an urbane cynicism, willing to offer freedom rather than to fight those captured by their imperial rivals, since these formerly-enslaved were staunch fighters who could protect a sparsely populated but strategically located colony. While policing the northern border of Spanish Florda, the armed African American militias, along with armed English, Indian and African American farmers and cattle ranchers, were, in their own view, protecting ttheir own interest. See Jan Carew, *supra.*

[19] Mulroy, *supra.*, pp. 8-9.

[20] Mulroy, *supra.*, p. 12.

[21] The word "seminole" is a Creek word meaning "runaway" or "exile." Though later applied to both Indians and Africans, and even to Indians in Florida prior to 1814, the term came into existence afer the defeat of the Creek Confederation in 1814 at the Battle of Horseshoe Bend, to apply to a section of the Creek who fled to Florida. Those Creeks who refused to accept defeat, left their tribal lands, and moved to Florida, continued their struggle by joining with the Gullahs, who were also readily incorporated under the "exile" rubric expressed in the Creek word, "seminole." Those Creeks who remained were coerced into becoming subordinate to the U.S. colonist government. They were used to help fight the exiles (Seminoles) and to capture Africans and African Americans fleeing to Florida for the purposes of re-enslaving them. The U.S. colonists, for obvious socio-political reasons, preferred to use the Creek word for exile (seminole) to refer to all their anti-slavery adversaries in Florida, particularly the Gullah. Then, where it facilitated their

interests, they attempted to identify this word only with the Indian exiles. See Joshua Giddings, *The Exiles of Florida*, University of Florida Press, Gainesville, 1964. The colonists, in their fanatical racist determination not to admit that Africans were capable of defending themselves distorted the history of this war to such an extent that even African American and American Indian scholars today, who might otherwise find it difficult to conceptualize Africans as Indians, have not laid the distortion bare. We suggest that avenues for further study might include the democratic example of a fully developed multi-ethnic confederacy, as existed in Florida in the 18th and early 19th centuries (African, Indian, Spanish and English populations), and its possible example and influence upon subsequent efforts towards the establishment of multi-ethnic democracy. While today some 2,000 Seminole Indians live on 6 reservations in Florida, in the 1930s and '40s their attempts to organize for federal recognition purposes (pursuant to the Wheeler-Howard Act) were not successful, and did not succeed until 1957 when a majority of tribal members voted to establish the Seminole Tribe of Florida. Even then, a group among them seceded to become the Miccosukee Tribe in 1962. Further, the U.S. government has not seen fit to recognize those of African descent who termed themselves "Afro-Seminoles." (See Stacey Bomser and Janet Maizner, "History of the Seminole Tribe of Florida," Press Release, internet http://www.seminoletribe.com//news/access/history.html.)

[22] It swelled to 5,000 with the incursion of the Creek " runaways" in 1814.

[23] Cited in Katz, *supra.*, p. 50.

[24] Mulroy, *supra.*, p. 7. Mulroy refers to this as the "Seminole Confederation."

[25] Whether black Seminoles, Seminole Negroes, Seminole maroons. See Mulroy, *supra.*, p. 1. Mulroy notes "This term, Seminole Negroes, would become prominent in the writings of white observers during the mid-to-late 1830s and contribute to outside perceptions that the maroons constituted a separate group." p. 18. Mulroy goes on to note: "By that time, the group clearly had self perceptions as a corporate body, also." But as Seminoles? Might it not be reasonable to assume that such an identification would come later?

[26] Mulroy, *supra.*, p. 21.

[27] Mulroy, *supra.*, p. 22.

[28] As in the contest between the Spanish, English and French for control of Haiti, the contending European states, not having sufficient population on the land, chose the strategy of arming the Africans (assuring that they would fight for their freedom from whomever was enslaving them) and relying on them to withstand or overthrow the particular European power in place. There is little indication that any of these powers were less against African enslavement than the U.S. colonists — indeed, the Spanish and English participated in the slave trade at that time, themselves. However, they were willing to give support to the African American anti-enslavement effort, if it offered the only possibility of holding on to their American colonial possessions or securing new ones.

[29] The term "First Nations" is used here to describe the American Indians who allied with the Gullah. While typically employed in Canada rather than in the U.S. as yet, this term seeks to recognize the Indian peoples as nations, while indicating their aboriginal rights. It is particularly useful to describe those Indians who allied with the Gullah, since they likely consisted of a number of Indian nations such as the Yuchi, Hitchiti and Alabamas, insofar as, at that time, there was no such thing as a Seminole Indian tribe or nation in the ethnic sense, and the word seminole itself meant "runaway" or "exile."

[30]Indeed, viewing the relations between Seminole Indians and the African communities in Florida prior to its acquisiton by the U.S. in 1819, one might even say that this multi-racial democracy was practiced with the inclusion of a concept of minority rights; the Africans lived in autonomy in their own villages, and participated as equals in military campaigns, etc., contributing only a minor portion of their produce to the other group, whose own internal relations were collectivist. The difference between U.S. colonists' notions of "ownership" and those of the Indians was so extensive that one might properly question whether using this term in relation to Seminole Indian "ownership" of Africans was in any way appropriate, given its connotations for English-speaking peoples. On the other hand, its propaganda effect (maintaining the notion of Africans as people who could not be seen otherwise than as being owned by somebody) is indisputable.

[31] The late African American leader, Malcolm X, referred to this strategy as "the fox emancipating the chickens from the protection of the farmers."

[32]It was a force of Africans and Indians under black leadership which cut the patriots' supply lines and finally raised the U.S. seige of St. Augustine. See Mulroy, *supra.*, p. 12.

[33] In 1814, Lord Cochrane issued a proclamation which invited enslaved Africans to board his vessels along with their families, providing them with the option either to serve in His Majesty's navy or settle as free persons in the British West Indies. Such a proclamation was not based on humanitarian intervention, however, for slavery was still widespread elsewhere in the British empire.

[34]One finds in the early colonial slave codes repeated mention of "Negro and other enslaved." See Giddings, *supra.*, p. 2. The "other" were the Native Americans and some whites. Also see Buckmaster, *supra*, p. 29.

[35] The epic struggle waged by the Gullah and Indian exiles (seminoles) in Florida between 1736 and 1853 can be viewed as a continuation of one that had begun in the first four decades of the Colombian era when Africans and Native Americans had joined forces against the Spanish colonizers in Hispaniola and Puerto Rico. See Jan Carew, *supra*. Such united struggles of Africans and Native Americans were to continue in the Americas in the decades and centuries afterwards. "They were," as Patterson explains with respect to the cimarron communities, "the dialectical response, the desires and struggles, of the multitudes who did most of the real work in the Indies to improve the quality of their lives." Thus such black and Indian alliances are known to have existed in southern Mexico, Central America, the Caribbean, the Guianas, the Brazilian northeast, and North America throughout the colonial period and beyond.

[36] Similar to succeeding generations of scholars referencing his work, Giddings, in *The Exiles of Florda*, refers to African American escapees from the Carolinas to Spanish-owned Florida by various labels — fugitive slaves, fugitive Negroes, Negro Indians, Seminoles, and exiles — but it should be emphasized that Giddings referred to "exiles" as the most appropriate because the captured Africans were uprooted from their own homeland and permanently exiled in the Americas, while colonialism and conquest made the Native Americans exiles in their own land.

[37]Georgia Workshop Project, *Drums and Shadows*, University of Georgia Press, 1945.

[38] The constant escape of the enslaved — African, Creek, and a small number of whites — was the principal reason for Spain's "establishing a free colony between South Carolina and Florida... it was thought that this colony being free (sic) would afford the planters of Carolina no protection against the future escape of [those they considered to be] their slaves from their service." Giddings, *supra.*, p. 3

[39] Prior to the successful U.S. revolution of 1776, and the conquest of Spanish Florida, the colonists also had an interest in keeping their enslaved African populations from knowing of the (self-) interest of the English and Spanish powers in assisting the cause of the enslaved, thereby forestalling any notion of outside help or alliances.

[40] The main ploy of the newly independent U.S. was the ancient Roman one of divide and conquer.

[41] As before mentioned, the reason for suppressing knowledge about this war at the time as well as during the later period of segregation (which extended until the 1960's) should be relatively easy to understand from a purely socio-political perspective. However, what is more difficult to comprehend is how the suppression of information to African American and Indian scholars was managed, particularly during the period of segregation when African American public education was under the direct management of African American colleges and high schools. These factors, coupled with the call for U.S. patriotism and assimilation into the dominant American ethny as a means of achieving equality, wealth, respect, etc. left little room or inclination for scholars to dig below the surface to uncover the true story of what came to be popularly or expediently known as the "*Seminole* Wars."

[42] According to Giddings (*supra.*, p. 29-30), records of the real objective of the earliest battles of the war — to recapture exiled African Americans — were disguised. Giddings writes: "Under the command of the Adjutant-General, another army crossed the border into Florida with the avowed intent of exterminating the "seminoles;" the real object was the recapture and the re-enslavement of the African American refugees... But when (that army) re-emerged from the rank, brutal thickets of Northern Florida, all military glory had been left behind. Wild men, they said, had sprung at them from every bush, cut off their supplies, decimated their men and bloodied their uniforms... One interesting detail emerged for the first time: African American 'soldiers' were mentioned by the Georgians and the Carolinians. Mentioned in whispers, it is true, and their skill deprecated — and all mention deleted from the newspaper accounts. But however many asterisks the editors of the *Savanna and Charleston* (newspapers) inserted in the reports (informing their readers that the deletions were for reasons of local security), an incontestable fact had been established: that African Americans, organized in bands, well armed, had successfully fought a regiment of American soldiers... A second army was raised and went to seize eastern Florida and wipe out the African American settlements. It took the [so-called] slave-owners two years to grasp the fact that this army was also defeated. They sent in more men with guns. The African Americans and Indians, who were masters at fading into the dense swamps and forests, lost a few men and some cattle but claimed that not a single African American was captured... Some of the Georgians brought back tales of extraordinary courage, of African Americans and their Indian allies fighting together, the Indians under the leadership of Indians, the African Americans under the leadership of African Americans — and the great devotion between the two groups." (Giddings, *supra.*, p. 29)

[43] Katz, *supra.*, p. 55.

[44] *Ibid.*

[45] Indeed, this might be said to be typical of American reportage of the African American struggle in general — or of reportage of any contemporary entity, as it concerns the efforts and perspectives of those whom it seeks to suppress.

[46] Wood, *supra.*, p. 298.

[47] Katz, *supra.*, p. 57.

[48] As Henrietta Buckmaster stated in her book, *The Seminole Wars:* "From now on,

whenever 'Seminole' is referred to, it will mean Indian and Negro together. American policy linked them. The effort, then and later, to stress the "Indian" nature of the conflict and ignore the African American was a part of that curious myopia which had denied to the Negro American the forthright part he took in his own destiny." (See Henrietta Buckmaster, *supra.*, p. 42). However, what might be dismissed as "curious myopia" should rather be viewed as intentional and strategic misinformation which attempted to deny existing insurgency then and later, in order to forestall a widening of the insurgents' ranks. A similar strategy is seen today in the consistency of U.S. governmental policy and news media efforts to cast the total African American struggle for development within the context of the search for assimilation and civil rights, while ignoring (as much as possible) other equally important leadership directions.

[49] Mulroy, *supra.*, p. 16.

[50] Katz, *supra.*, p. 60. Jesup also noted: "Throughout my operations I found the negroes the most active and determined warriors, and during the conferences with the Indian chief I ascertained that they exercised an almost controlling influence over them." Seminole agent Thompson expressed his belief that "one of the major causes of Seminole hostility to removal was 'the influence which it is said the negroes, the very slaves in the nation, have over the Indians.'"[51] No matter what the facts indicated the situation to be, for Thompson, the negro could only be a slave.

[51] Mulroy, *supra.*, p. 28.

[52] While most accounts refer to this Gullah leader as Abraham, it is highly possibly that the name he called himself, i.e. his own name, was Ibrahim, a Muslim name, which then was mispronounced, intentionally or not, by the colonists, who were more likely to recognize the name as Abraham or to "correct" it to Abraham. Pictures of Ibrahim or Abraham show him wearing what appears to be an Islamic head dress.

[53] See footnote 7.

[54] Bland, *supra.*, p. 44.

[55] At first, the treaty had provided that the Indians would relocate to the Indian Territories in the west "secure in their lives and property... [and] their negroes, their bona fide property [sic], shall accompany them," but this so enraged the Florida slave hunters that this provision had had to be rescinded. As Bland noted, "Allowing so many runaways to migrate west threatened the very institution of slavery." (See Bland, *supra.*, p. 89.)

[56] As a result of the retreat of the main forces of the alliance under African American leadership into Mexico to avoid defeat, capture and re-enslavement or execution, some First Nations former allies of the Gullah found it expedient, with the assistance of the U.S. Bureau of Indian Affairs, to consolidate their interests and identity under the entity known as the Seminole Indian Tribe which exists today. However, this same hidden history has led to somewhat contradictory uncontested claims by blacks (formerly Gullah) who find it expedient to call themselves the Afro-Seminoles — "Afro" because the U.S. government, like its predecessors, continues to find it politically expedient to officially recognize only Indians as Seminoles. It was stated by one Gullah historian who investigated this Afro-Seminole group that they still speak "old" Gullah. Notes from conversation in Montreal with Marquetta L. Goodwine, Director of the Gullah/Geechee Sea Island Coalition, December, 1997. This Coalition was founded in 1996, and is concerned with soliciting support for Gullah survival. This "old Gullah" itself has been referred

to as "the language they call Seminole." (See Art Chapman, "Black Seminole Indians: Descendants honor heroes history almost forgot," *Star-Telegram*, September 22, 1997.

[57] Carew, *supra.*, includes among them the Tallahassees, the Muskhogeans, and the Mikasukis. Note Mulroy, *supra.*, indicated that the Creek exiles raised the Seminole population to 5,000, not increased it by this amount.

[58] Katz, *supra.*, p. 54.

[59] The uncertainty which surrounds much of the research concerning the Seminole is indicated by the fact that three of the major writers on the subject (Katz, Porter, Mulroy) are unable to agree on the name of the man who was commander of Fort Negro, site of one of the more celebrated battles of the first Seminole War.

[60] Katz, *supra.*, p. 55.

[61] This figure appears questionable, since it would place the number of Gullah in Florida as less than 1,000.

[62] Creeks who had submitted to the U.S. government upon the collapse of the Creek Confederation.

[63] Mulroy, *supra.*, p. 29

[64] Carew, *supra.*

[65] *Ibid.*

[66] Giddings, *supra.*, p. 15

[67] Carew, *supra.*

[68] As a result of the Peninsular Wars against Napoleon and the slaughter of Spanish subjects in Florida, Spain sold Florida (which was divided between Georgia and present day Florida) to the United States for five million dollars. While Spain attempted to prolong its protection through clauses in the treaty which stated that those in the territory who were free should remain so, this feeble attempt was soon disregarded. At this point, the victory of the insurgents became militarily impossible.

[69] Having by this time accepted its defeat in the American revolutionary war, Britain's natural strategic alliance with the insurgents paled into moral obligation, and was no longer implemented.

[70] Mulroy, *supra.*, p. 28.

[71] As but one instance: In 1812, in a "Seminole" raid and attack on the Kingsley plantation, approximately 40 Africans were liberated. Among these forty was Gullah Jack. Accounts of this man then appeared in Charleston, South Carolina in 1821, where he was purchased by Paul Pritchard. Gullah Jack was also a member of the African congregation along with Denmark Vesey. Just after Christmas of 1821, Vesey recruited Gullah Jack to be a lieutenant in the uprising that Vesey was planning for the city of Charleston and surrounding islands. Source: Marquetta L. Goodwine.

[72] See the Denmark Vesey section by Bernard Powers in ""De Ones Ya'll Kno' 'Bout".

[73] According to Richard Hooker, World Cultures Home Page, www.wsu.edu:8000/~dee/DIASPORA/REBEL.htm.

[74] Marquetta L. Goodwine, *supra.*

[75] Porter, *supra.*, p. 82.

[76] Katz, *supra.*, p. 59.

[77] An additional cause of hostilities may have been the effort to humiliate Osceola in the eyes of the Gullah by the capture and re-enslavement of Morning Dew by slave-catchers while Osceola was having dinner with Thompson. Luring her captors into a compromising situation, Morning Dew killed them, then committed suicide.

Osceola, overcome with grief and anger, had lain the blame at the feet of Thompson (described by Porter, p. 40, as "honest and conscientious") whom he felt not only had done nothing to save her, but might even have been complicit in her capture. *Thompson was shot and killed by Osceola's band after having been stalked for over a year in memory of his complicity in the plot to capture and re-enslave Osceola's wife.*

[78] Katz, *supra.*, p. 60.

[79] ibid., p. 61.

[80] It should be remembered that by this time, the U.S. army had over 10,000 troops in Florida, in support of U.S. policy determined to resettle the Indians and break the alliance between them and the Gullah. Dade's forces, albeit taken by surprise, had been at war with the exiles. This was not, however much the terminology might imply it, a "massacre of the innocents" but rather a military encounter in which one side made good use of the tactic of surprise.

[81] Porter, *supra.*, p. 40. Italics added.

[82] Porter, *supra.*, p. 42. The allied forces (though estimated by their opponents, of whom 3 survived, at some 800-1,000) were estimated by themselves at some 180 warriors. Porter describes 50 Africans who came forward to attack from behind the Seminole lines in such a way as to make them appear an encroaching contingent separate from those who had fought the U.S. forces until the U.S. guns were silenced This neatly discredits Africans from victory, and ombfuscates the nature of the combatants.

[83] Porter, *supra.*, p. 43.

[84] Porter, *supra.*, pp. 44-62. Compare this to the differing account in Bland, 66 ff.

[85] Extensive sources are cited by Porter, *supra.*, p. 52.

[86] Porter, *supra.*, p. 52.

[87] Porter, *supra.*, p. 64.

[88] Mulroy, *supra.*, p. 27.

[89] Seminole agent Thompson believed that a major cause of Seminole hostility to removal was "the influence which it is said the negroes, [said by Thompson to be] the very slaves in the nation, have over the Indians." Mulroy, *supra.*, p. 28.

[90] Mulroy, *supra.*, p. 31.

[91] Porter, *supra.*, p. 77.

[92] ibid., p. 67.

[93] Benito Juarez was then President of Mexico, the first indigenous president since the conquest.

[94] Giddings, *supra.*, p. 337.

[95] Giddings, a most reliable source on the Gullah War (War of the exiles/ Seminoles), states categorically: "It is a remarkable fact that in all the conflicts which occurred, no [exile] Indian nor African American warrior had surrendered even to superior numbers. They had fought gallantly, they had died freely; but they preferred death to that slavery which they knew would follow a surrender." Giddings, *supra.*, p. 139.

[96] Both these motivations, which permeated the Euro-American social fabric, appeared either threatened or forestalled by England. It should be remembered that Britain inserted a clause in the colonial charter given to Georgia in 1733 barring slaves from the colony; and had issued a proclamation of a western boundary designed to curb colonial land-grabbing. See Robin Blackburn, *The Overthrow of Colonial Slavery, 1776-1848*, Verso, London, 1988, p. 82-83.

The Relationship of the Gullah-Speaking People of Coastal South Carolina and Georgia to Their African Ancestors[*]

William S. Pollitzer

The presence of relatively unmixed blacks on the coast of South Carolina and Georgia and knowledge of the people of West Africa from whom they are descended provides a unique opportunity to compare a population in its biology, culture, and language with its ancestors over time and space. Data on the number imported from different regions of Africa also permit quantitative comparison of the incidence of many attributes of these African Americans with their representation in the slave trade. This article attempts to relate the various traits of the coastal black population to the source of those traits from different areas of Africa.

From the founding of Charleston in 1670, blacks were imported into the region, first in small numbers from the West Indies and then in ever-greater numbers directly from Africa. They were brought in to help with crafts, fishing, and farming, especially in the cultivation of indigo, then rice, and finally Sea Island cotton. Figure 1 shows a map of the coastal area of South Carolina and Georgia where African Americans labored for three centuries, often in considerable isolation on large plantations; there they greatly outnumbered whites, preserving their biological integrity and molding their distinctive patterns of language and culture.

Advertisements in the Charleston newspapers, usually the *Gazette*,[1] provide information on the origins of the more than 120,000 people brought from Africa between 1716 and the end of the legal trade in 1807 (see Table 1). Eight coastal regions of West Africa are recognized: Senegambia, Sierra Leone, the Windward Coast, the Gold Coast, the Bight of Benin, the Bight of Biafra, Angola (which includes Congo), and Mozambique-Madagascar.[2]

In Table 1, the category "others" refers to Africa when no region is identified. In addition to Africa, many came from the West Indies. The number of Africans in the cargo are known for some ships (col. 2);

[*]Abridged from *Historical Methods*, Spring 1993, Vol. 25, No. 2. and reprinted with permission of William S. Pollitzer

54

FIGURE 1
Coastal Area of South Carolina and Georgia

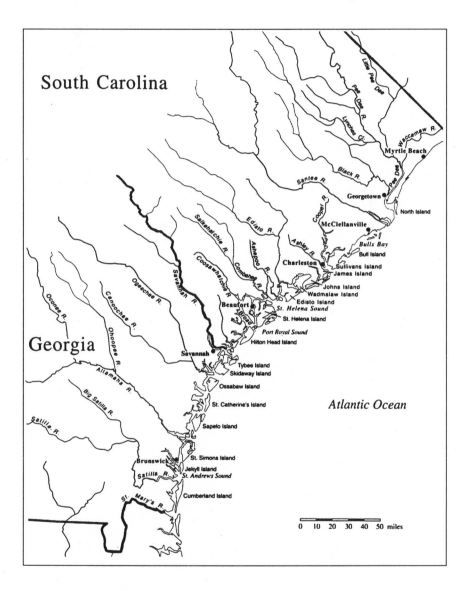

South Carolina

Georgia

Little Pee Dee

Pee Dee R.

Lynches Cr.

Waccamaw R.

Myrtle Beach

Black R.

Santee R.

Pee Dee

Georgetown

North Island

Cooper R.

McClellanville

Salkehatchie R.

Edisto R.

Bulls Bay

Ashley R.

Bull Island

Coosawhatchie R.

Ashepoo R.

Combahee R.

Charleston

Sullivans Island

James Island

Johns Island

Wadmalaw Island

Savannah R.

Edisto Island

Beaufort

St. Helena Sound

St. Helena Island

Oconee R.

Canoochee R.

Ogeechee R.

Port Royal Sound

Hilton Head Island

Ohoopee R.

Savannah

Altamaha R.

Tybee Island

Skidaway Island

Big Satilla R.

Ossabaw Island

Satilla R.

St. Catherine's Island

Atlantic Ocean

Sapelo Island

Brunswick

St. Simons Island

Satilla R.

Jekyll Island

St. Andrews Sound

St. Mary's R.

Cumberland Island

0 10 20 30 40 50 miles

TABLE 1
Enslaved Africans Imported from Africa and the West Indies into Charleston, South Carolina, 1816-1807

Coastal Region	Cargoes with count (1)	No. of slaves (2)	Cargoes without count (3)	Total cargoes (4)	Total slaves (est.) (5)	%of subtotal	
						With others (6)	Without others (7)
Senegambia	113	14,419	30	143	18,093	15.8	19.7
Sierra Leone	34	5,225	2	36	5,533	4.8	6.0
Windward Coast	85	12,925	22	107	15,879	13.8	17.3
Gold Coast	73.5	10,597	12	85.5	12,268	10.7	13.4
Bight of Benin	5	1,162	1	6	1,394	1.2	1.5
Bight of Biafra	10	2,171	1	11	2,303	2.0	2.5
Angola	133	33,103	11	144	35,812	31.2	39.0
Mozambique-Madagascar	2	473	0	2	473	0.4	0.5
Others[a]	107.5	17,232	36	143.5	23,033	20.1	
Subtotal	563	97,307	115	678	114,788	100.0	99.9
West Indies[b]	187	6,605	2	189	6,676		
Total	750	103,912	117	867	121,464		

[a] Refers to Africa; no specific region is identified.
[b] Does not include the many ships that brought fewer than 10 slaves and is thus an underestimate.

56

TABLE 2
Culture Areas and People of Africa of Significance to South Carolina

Group culture areas[b]	Murdock's areas[b]	People	Location
Western Sudan			
Sudanic Agricultural Civilization			
Nuclear Mande	11	Bambra, Malinke	Mali[c]
		Susu	Guinea
Voltai People	12	Senufo	Ivory Coast
		Mossi	Burkina-Faso
Plateau Nigerians	13	Tiv	Nigeria
North African Agricultural Civilization			
The Sudan Fringe	17	Hausa	Nigeria
		Songhai	Mali[c]
		Djerma	Niger
West African Pastoralism			
Fulani	55	Fulani	Guinea-Nigeria[c]
Guinea Coast			
Cultural Impact of Indonesia			
Southern Nigerians	31	Ibibio, Efik, Nupe	Nigeria
		Bini, Igbo, Yoruba	Nigeria
Twi	32	Ewe	Togo
		Fon, Popo[d]	Benin (Dahomey)
		Ga, Akan: Ashanti, Fanti[d]	Ghana
Kru and Peripheral Mande	33	Temne, Mende, Kissi	Sierra Leone
		Kru, Vai, Kpelle, Gola	Liberia
Senegambians	34	Wolof, Baga, Serer	Senegal
Congo			
Expansion of the Bantu			
Northwestern Bantu	35	(Few large groups)	
Equatorial Bantu	36	Fang	Gabon[c]
		Djema	Congo-Brazzaville
		Bobangi	Zaire[c]
Mongo and Luba	37	Luba, Songye	Zaire
Central Bantu	38	Kongo	Zaire, Angola
		Kimbundu	Angola
Spread of Pastoralism			
Southwestern Bantu	48	Umbundu	Angola

[a] Data are from Herskovits (1962), *The Human Factor in Changing Africa* (New York: Knopf).
[b] Data are from Murdock (1959), *Africa: Its People and Their Culture History* (New York: McGraw-Hill). Numbers refer to chapters in book.
[c] These people spread into adjoining nations; the Fulani spread widely over West Africa.
[d] The names of the people are usually the same as those of a language as shown in the table, with a few exceptions: The Ashanti and Fanti of Ghana speak an Akan language. The Fon and Popo of Benin (Dahomey) speak languages similar to Ewe.

for cargoes without a count, numbers were estimated on the basis of those known for that African coastal region (col. 4). Adding the two gives an estimate of the total for the region (col. 5). When percentages are calculated for the eight known regions of Africa — without "other" Africans and without West Indies importation — some 39 percent are identified as from the Congo-Angola area, or Central Africa; 20 percent from Senegambia; 23 percent from the Windward Coast plus adjacent Sierra Leone; 13 percent from the gold Coast; and only 4 percent from the neighboring Bights of Benin and Biafra combined (see col. 7). Thus, the whole East-West coast — the "Guinea Coast"— apparently contributed less than 20 percent, and very few came from Mozambique and Madagascar. However, the role of the West Indies must not be overlooked, for the majority of slaves were brought to those islands from the Guinea Coast.

The time of arrival is also significant. In the Early Period, 1716-44, three-fourths of the 22,117 Africans imported into Charleston came from Angola, a fact that explains their influence on later arrivals. In the great Middle Period, 1749-87, when 63,210 or half of all Africans arrived, Senegambia accounted for one-third, and the bulge of West Africa from Senegambia through the Bight of Biafra contributed more than three-fourths. In the Final Period, those four feverish years from 1804 through 1807 — when 29,461 were brought into Charleston — Angolans were again in the majority. The word Gullah probably comes from Angola. These Bantu-speaking Central Africans were employed especially as field hands; many from Sierra Leone and the Windward Coast were brought specifically for rice cultivation,[3] while Senegambians were often preferred as house servants.[4]

The continent of Africa is as varied as it is vast, and its geography has profoundly affected its climate and food sources, which in turn have influenced the culture of its people. Up in the savannah of the western Sudan, herding is combined with agriculture. Islam is influential; markets and trade flourish, art (the medium of terra cotta, in particular) is elaborate, and musical instruments are varied. Along the more tropical Guinea Coast to the south, the Indonesian impact is especially evident in the "yam belt"; art, often of brass and iron, is distinctive; secret societies and masks abound. Among the Bantu-speaking people of Congo and Angola (supported by agriculture), art features the human figure, and religion stresses death and the funeral.

Parasitic diseases such as malaria and worm infestations are especially prevalent in tropical Africa. The data in Table 2 identify some of the chief people within these culture areas. The location of the principal people and languages of West Africa that entered into the

FIGURE 2
People and Languages of West African

slave trade to South Carolina are pictured on Figure 2 against the background of modern nations.

Greenberg's (1970) classification brought some order out of the chaos caused by more than seven hundred languages of Africa. Although Songhai and Hausa of the Sudan Fringe are in separate linguistic families, the large majority of languages are within the Niger-Congo family. In the western bulge of Africa, in the West Atlantic subfamily are Wolof, Fulani, and Temne; in the Mande subfamily are Malinke, Bambara, and Vai. Along the Guinea Coast in the Kwa subfamily are Fanti, Fon, Ewe, Twi, Igbo (the language of the Ibo), and Yoruba. In the Benue-Congo subfamily are Efik of Nigeria; the large Bantu group that includes Kongo, Kimbundu, Umbundu, and Luba (or Tshiluba); and other languages of Zaire, Angola, and Central and Southern Africa.

Where early students of Gullah[5] encountered mainly a simplified English, the black linguist Turner, who lived among the Sea Island people for seven years, found indications of thirty-two languages of West Africa in vocabulary, syntax, and sounds[6]. He identified 3,595 personal, or "basket" names given to newborn babies, 251 other words

used in conversation, and 92 words heard only in songs and prayers. Among the ten languages that account for 75 percent of the total African vocabulary, Kongo and Yoruba are highest on the list, with 15 percent each (table 3). "Other" refers here to the twenty-two languages that make smaller but significant contributions to Gullah. Kongo, Yoruba, Mende and Ewe account for almost half the linguistic sources of personal names identified by Turner. Personal names are like fossils fixed among a people and are not as indicative of kinship between languages as words used in conversation.[7] Of such words Kongo far exceeds all others, with 25 percent of the total. Cooter for turtle, gumbo, goober, benne seed, and yam all attest to the contribution of African words to English. Turner finds words in stories to be almost exclusively in Mende and Vai (of the Windward Coast). But in addition to words, language comprises features of grammar and phonetics. Eye, Yoruba, Igbo, Twi, Efik, and Fanti — spoken by people of the Guinea Coast, from the Gold Coast through Nigeria — contribute some 60 percent of these linguistic attributes (see table 4).

Winifred Vass, daughter of a medical missionary who grew up in the Congo speaking Tshiluba, notes many place-names of Bantu origin in the southern United States, more in South Carolina than in any other state.[8]

To unravel the mystery of language influence, we must note that in the western bulge of Africa in the early seventeenth century, a pidgin English was spoken. Pidgin has no native speakers. It is a marginal language reduced in structure and vocabulary. As used by socio-linguists, Creole refers to a pidgin language that has become the mother tongue of a particular speech community in several ex-colonial parts of the world. The Krio spoken in Sierra Leone even today bears a striking resemblance to Gullah. Words and syntax from tribes of the Gold Coast and the Bight of Benin were kept alive in the West Indies, especially Barbados, and then in Carolina. Many words also came from Angola, but much of the deep structure of grammar and sounds probably entered Gullah from the Guinea Coast languages in the seventeenth century.

Wood documented the growing numbers and oppressive conditions of the Africans in bondage in Carolina from its founding to the Stono Rebellion in 1739;[9] many blacks thus sought to escape the hardship of slavery by rebellion or flight. When an enslaved African ran away, his owner reported all the details that might help to recover the fugitive, including his ethnic origin. From this information, Windley compiled a profile of runaways in Virginia and South Carolina and reproduced (183) advertisements for them in several Southern

TABLE 3
African Linguistic Sources of Gullah Vocabulary

Words	Personal Names		Conversational words		Words from stories		Total	
Language	No.	%	No.	%	No.	%	No.	%
Kongo	706	14.5	99	24.8			805	15.0
Yoruba	775	15.9	13	3.2			788	14.7
Mende	433	8.9	31	7.8	64	68.8	528	9.8
Ewe	403	8.3	15	3.8			420	7.8
Bambara	323	6.6	21	5.2	1	1.1	345	6.4
Twi	281	5.8	14	3.5			295	5.5
Vai	218	4.5	30	7.5	27	29.0	275	5.1
Hausa	251	5.2	21	5.2			272	5.1
Fon	229	4.7	10	2.5			239	4.4
Umbundu	211	4.3	18	4.5			229	4.3
Other	1,040	21.3	128	32.0	1	1.1	1,169	21.9
Total meanings	4,872	100.0	400	100.0	93	100.0	5,365	100.0

Source: Turner (1949), Africanisms in the Gullah Dialect (University of Chicago Press).
Note: Because one word is often assigned meaning in several languages, the total number of meanings considerably exceeds the number of words.

TABLE 4
African Linguistic Sources of Gullah Sounds and Grammar

Language	Phonetics	Sounds	Syntax	Morphology	Intonation	Word Formations	Total No.	Total %
Ewe	10	6	7	5	7	3	38	17.4
Yoruba	4	5	6	5	8	3	31	14.2
Igbo	3	5	5	4	6	1	24	11.0
Twi	4	6	4	1	1	2	18	8.3
Efik	–	2	2	1	6	–	11	5.0
Fanti	3	–	5	2	–	–	10	4.6
Kongo	–	3	1	3	–	2	9	4.1
Bambara	5	2	–	–	–	1	8	3.7
Kimbundu	1	1	4	1	–	1	8	3.7
Malinke	5	3	–	–	–	–	8	3.7
Other	9	14	10	6	1	13	53	24.3
Total	44	47	44	28	29	26	218	100.0

Source: Turner (1949), *Africanisms in the Gullah Dialect* (University of Chicago Press).

colonies.[10] In eighteenth-century Charleston newspaper ads for 2,424 runaways, an African birthplace is given for 508 — Senegambia, Sierra Leone, Guinea, Gold Coast, and the Ibo from the Bight of Biafra. The number of runaways from each area was similar to their representation in importation. However, there were more Ibo — who were famous for their resistance to slavery – and fewer people from Sierra Leone and Senegambia, perhaps because the latter were more often house servants.

Many aspects of culture connect the Sea Island people to specific areas of Africa. The magic practices and beliefs of the African Americans of the Georgia coast as collected by the Georgia Writers,[11] with tales of conjuring and root doctors and hexes, lend themselves to such analysis. Many Gullah believed that witches can ride them, that a baby born with a caul has special powers, that nail or hair clippings can be used to cast spells, and that special practices are required at a funeral to keep the spirit of the deceased from returning to punish them. The data in Table 5 reveals the frequency of such traits and their citation by major tribes. The people from the Guinea Coast again predominated in their influence on magic, possibly for the same reason they affected the deep structure of language; but with diffusion and artifacts and the method of scoring, such conclusions must be viewed with caution.

Many manifestations of the culture and history of a people, significant for their comparison with some other population, cannot be readily measured. Kinship patterns, polygynous marriage, the extended family, and the composition of the household found among the Sea Island people tend to reflect African patterns.[12] Religion among the Sea Islanders is a powerful culture trait that shows African influence. The call-and-response style of preaching, with audience participation in a rhythmic pattern, is reminiscent of West Africa.[13]

In the Praise House, the elders kept alive the beliefs and practices of their native religion along with the forms of the Baptists and the Methodists.[14] Beneath the cloak of Christianity, pagan retentions are evident. Baptism by immersion in the river, outwardly Christian, has African overtones. The staff with a cross that the deacon plants in the water is also symbolic of the Four Moments of the Sun, the cosmogram of the Kongo.[15] Its rising represents birth, noon stands for maturity, its setting is the close of life. Thus the horizontal line, like the surface of the water, separates the land of the living above from that of the dead below.

The distinction of the soul (which returns to heaven at death) and the spirit (which can roam the earth and cause problems for the living)

TABLE 5
African Origins of Practices of Blacks on Georgia Coast

Region	Major tribes	Traits		Citations	
		No.	%	No.	%
Senegambia	Mandingo	2	0.8	40	2.8
Sierra Leone	Vai	5	2.0	19	1.4
Windward Coast		6	2.5	37	2.6
Gold Coast	Ashanti	69	28.4	310	22.1
Bight of Benin	Dahomey	76	31.3	425	30.3
	Yoruba				
	Ewe				
Bight of Biafra	Ibo	58	23.9	336	24.0
	Ibibio				
	Fang				
Congo–Angola	Mpongwe	27	11.1	235	16.8
	Bantu				
Subtotal		243	100.0	1,402	100.0
West Africa		24		134	
Total		267		1,536	

Source: Georgia Writers (1940), *Drums and Shadows: Survival Studies among the Georgia Coastal Negroes* (University of Georgia Press).
Note: Traits and citations for Nigeria have been divided equally between the Bight of Benin and the Bight of Biafra. Percentage is based on subtotal and excludes West Africa.

is as deeply imbedded in the thinking of the Sea Island people as it is in Africa.[16] The custom of placing glass or broken crockery on the grave and marking off its boundaries with shells also derived from Bantu people.[17] Such items provide for the spirit and symbolize the continuity of life, but the initiation ceremonies with the "seeking" by the convert are reminiscent of the secret societies of tribes of Sierra Leone and the Windward Coast.[18] The ecstacy that comes from possession by the god is similar to that found in much of West Africa, especially among the Dahomey.[19]

Folklore and folk medicine also show affinities with African customs. Clever-talking animals like Brer Rabbit, usually associated with the Uncle Remus tales of Joel Chandler Harris, are also found on the Carolina coast and have antecedents in such stories told in West Africa.[20] Anansi, the wily spider, is known on the Gold Coast, Jamaica and the Sea Islands.

Spirituals are a much-loved heritage of African Americans. Discovered by the missionaries who came to Port Royal near Beaufort, South Carolina, in 1862 on the heels of Union troops, they have been widely sung and recorded ever since. Outwardly religious, many songs also contain veiled references to freedom. Certain features, notably rhythm, like the call-and-response in religious services and the famous ring-shout, have clear African antecedents.[21] Although drums are the most universal musical instrument in Africa, they were suppressed in Carolina because they could be used to signal revolt by the slaves. The fiddle first and then the banjo, both with African counterparts, were preferred instruments;[22] but the clapping of hands is the ever-present expression of rhythm on the Sea Islands, as it is in Africa.

Much material culture of coastal Carolina attests its African derivation,[23] notably the beautiful baskets woven of bullrush, sweet-grass, and long-leaf pine needles in the Charleston area today as of old.[24] The making of quilts from colorful scraps, combining the practical need for warmth with economy and esthetics, reflects textile designs and motifs from Ghana and Benin to the Congo and Angola.[25] The building of boats by blacks to travel and fish in the myriad water-ways of the Sea Islands also has an African heritage. Wood carving, ironwork, clay pottery and residential architecture—like graveyard decorations—all reflect techniques, themes, and improvisation characteristic of West African people.[26] The heritage of the textures of the Old World is expressed with skill and feeling in the New.

Indeed, archaeology provides a link between the Gullah of Carolina and their ancestors. Some Colonoware, ceramics once thought to have been made by American Indians, are now considered the

product of blacks as well and shaped by their recollections.[27] Excavations of slave quarters also reveal artifacts of African provenience, the influence of that continent on architecture, insights into diet and life style,[28] and even teeth for description and measurement. Dental casts made on the living people of James Island, South Carolina, also provide measurements of teeth useful for comparison with those of native Africans.[29]

Certain parasitic diseases illustrate the connection between coastal Carolina and West Africa. Malignant subtertian malaria caused by Plasmodium falciparum, hookworm form Necator americanus, filariasis caused by the microlarve of Wuchereria bancrofti, and dengue fever from a virus are examples of illnesses transported by enslaved Africans. Although African Americans proved resistant to benign tertian malaria and yellow fever, they were particularly susceptible to respiratory infections such as pneumonia and tuberculosis.

Several important crops first domesticated in Africa came with the slave trade to Carolina, notably okra (whose edible pods as well as a dish made from them are called gumbo), benne, or sesame seed, and cowpeas. Yams and sorghum, or Guinea corn, are also African importations. The peanut, originally from South America, founds its way to these shores by way of Africa.[30] Many medicinal plants are used by blacks on both sides of the Atlantic, often to treat similar ailments: among them are wormseed (Chenopodium), jimson weed (Datura), chinaberry (Melia), basil (Ocimum), and nightshade (Solanum)[31]

In summary, linguistic, cultural, and biological factors tie the Sea Island people of South Carolina and Georgia to their African ancestors. The early arrival of Bantu peoples from Central Africa, as well as their later infusion, left a permanent mark on vocabulary, religion, magic, and many arts and crafts. But the great influx of people from Senegambia and the Windward Coast through Guinea and the Bight of Biafra, especially in the later years of the eighteenth century, also left their stamp on the structure of language, beliefs, practices and other aspects of culture. The biological person, at least until recent times, is a blend of West African forebears with less apparent white admixture than that of African Americans elsewhere. Continued research holds promise of health benefits as well as elucidation of an important heritage.

[1] E. Donnan, *Documents Illustrative of the History of the Slave Trade to America*, vol. 4, Carnegie Institute Publication no. 409, Washington, 1935; Naval Office Shipping Lists for South Carolina, Colonial Office Papers 5/508-11, Public Records Office,

London, 1716-67; Records of the Public Treasurers of South Carolina, Department of Archives and History, Columbia, 1969.

[2] P. D. Curtin, *The Atlantic and Slave Trade: A Census*, University of Wisconsin Press, Madison, 1969.

[3] D. C. Littlefield, *Rice and Slaves: Ethnicity and the Slave Trade in Colonial South Carolina*, Louisiana State University Press, Baton Rouge, 1981.

[4] J. W. Holloway, "The Origins of African-American Culture," *Africanisms in American Culture*, Indiana University Press, Bloomington, 1990, 1-18.

[5] J. Bennett, "Gullah: A Negro Patois," *South Atlantic Quarterly*,1908-9, 7:332-47, 8:39-47; A. E. Gonzales, *The Black Border: Gullah Stories of the Carolina Coast*, The State Company, Columbia, 1922; G. B. Johnson, *Folk Culture on St. Helena Island, South Carolina*, University of North Carolina Press, Chapel Hill, 1930; S. G. Stoney, and G. M. Shelby, *Black Genesis: A Chronicle*, Macmillan, New York, 1930.

[6] L. D. Turner, *Africanisms in the Gullah Dialect*, University of Chicago Press, Chicago, 1949.

[7] F. G. Cassidy, "The Place of Gullah," *American Speech*, 1980, "Sources of the African Element in Gullah," *Studies of Caribean Languages*, University of Wisconsin Press, Madison, 1983.

[8] W. K. Vass, *The Bantu-Speaking Heritage of the United States*, Center for Afro-American Studies, UCLA, Los Angeles, 1979.

[9] P. H. Wood, *Black Majority: Negroes in Colonial South Caroina from 1670 through the Stono Rebellion*, Knopf, New York, 1974.

[10] L. A. Windley, *Runaway Slave Advertisements: A Documentary History from the 1730s to 1790. Vol. 3, South Carolina*, Greenwood Press, Westport 1983.

[11] Georgia Writers, *Drums and Shadows: Survival Studies Among the Georgia Coastal Negroes*, University of Georgia Press, Athens and London, 1940.

[12] M. A. Twining, and K. Baird, *Sea Island Roots: African Influences in Georgia and South Carolina*, African World Press, Trenton, 1991.

[13] P. Jones-Jackson, *When Roots Die: Endangered Traditions on the Sea Islands*, University of Georgia Press, Athens, 1987.

[14] M. W. Creel, *A Peculiar People: Slave Religion and Community-Culture Among the Gullahs*, New York University Press, New York, 1988.

[15] R. F. Thompson and J. Cornet, *The Four Moments of the Sun: Kongo Art in Two Worlds*, National Gallery of Art, Washington, 1981.

[16] Creel, *supra.*, 1988; Georgia Writers, *supra.*, 1940; Jones-Jackson, *supra*, 1987

[17] Thompson and Cornet, *supra*, 1981.

[18] Creel, *supra.*, 1988.

[19] M. Herskovits, *The Myth of the Negro Past*, Beacon Press, Boston, 1958.

[20] Jones-Jackson, *supra.*, 1987; E. C. Parsons, *Folklore of the Sea Islands, South Carolina*, American Folklore Society Memoir No. 16, Cambridge and New York, 1923.

[21] F. Bebey, *African Music: A People's Art*, Lawrence Hill, New York, 1975; D. Epstein, *Sinful Tunes and Spirituals*, University of Illinois Press, Urbana, 1977; B. Katz, *The Social Implications of Early Negro Music in the United States*, Arno Press and the New York Times, New York, 1969.

[22] P. Oliver, *Savannah Syncopators: African Retentions in the Blues*, Stein and Day, New York, 1970.

[23] J. W. Chase, *Afro-American Art and Craft*, Van Nostrand Reinhold, New York, 1971; Twining and Baird, *supra.*, 1991; J. M. Vlach, *The Afro-American Tradition in Decorative Arts*, Cleveland Museum of Art, Cleveland, 1978.

[24] D. Rosengarten, *Row Upon Row: Seagrass Baskets of the South Carolina Low Country*, McKissick Museum, University of South Carolina, Columbia, 1986.

[25] G-M. Fry, *Stitched from the Soul: Slave Quilts from the Antebellum South*, Dutton Studio Books, New York, 1990.

[26] Vlach, *supra.*, 1978.

[27] L. Ferguson, "Looking for the Afro in Colono-Indian Pottery," *Archeological Perspectives on Ethnicity in America*, Baywood, Farmingdale, 1980, 14-28; "Uncommon Ground: The Archeology of early African America 1650-1800," Smithsonian Insitution, Washington, 1992.

[28] T. A. Singleton, "The Archeology of Slave Life," *Before Freedom Came: African-American Life in the Antebellum South*, The Museum of the Confederacy and the University Press of Virginia, Richmond and Charlottesville, 1992, 155-75.

[29] R. M. Menegaz-Bock, *An Investigation of the Genetic Basis for Structural Relations in the Anterior Dentition*, University of Chicago, 1969.

[30] W. E. Grime, *Ethno-Botany of the Black Americans*, Reference Publications, Algonac, 1979; N. W. Simmonds, *Evolution of Crop Plants*, Longman, London, 1976.

[31] F. Mitchell, *Hoodoo medicine: Sea Island Herbal Remedies*, Reed, Cannon, and Johnson, Berkeley, 1978; J. F. Morton, *Folk Remedies of the Low Country*, E. A. Seeman, Miami, 1974.

De Ones Ya'll Kno' 'Bout
We Faymus Peepol an' We Ancestas*

Robert Sengstache Abbott

Raised in Savannah, Georgia, Robert Sengstache Abbott went to Chicago with only 50 cents in his pocket. In 1905, he founded the *Chicago Defender* newspaper as a weekly. It went on to be read by thousands in the South, where it was distributed by Pullman porters and sold by newsboys who risked being lynched for their actions.

The *Defender* was hated by southern whites for its editorials, which urged blacks to abandon the Jim Crow south and its cotton fields for the north's factories and less menacing segregation. Between 1910 and 1920, Chicago's black population increased from 44,000 to 109,000. A second major migration north of blacks, promoted by the *Defender,* occurred in the 1940's.

The *Defender's* editors also were threatened with jail during World War II for editorials pointing out that black soldiers were risking their lives for freedoms abroad that they could not enjoy at home. The newspaper was home to black writers ignored by the white press, including Langston Hughes and W.E.B. DuBois, a founder of the NAACP. In the 1950's, when it first became a daily, circulation topped 50,000.

Described by Dorothy Leavell, President of the National Newspaper Publishers Association representing owners of 215 black weekly newspapers, as "the only black daily newspaper left," the *Chicago Defender* is in danger of falling out of African American hands. As this anthology goes to press, it is being offered for sale according to the terms of the will of John Sengster, nephew of the founder. A Citizens Committee to Save the *Chicago Defender* has been organized by the Rev. Al Sampson.

Herman Blake

Herman Blake is a former president of Tougaloo College, Tougaloo, Mississippi.

* Due to restrictions of space, it was not possible to include all who might be represented here, particularly contemporaries in arts and entertainment. We apologize for any particularly significant omissions, and would be pleased to consider additional names for future editions. [The Editors]

Jim Brown

Jim Brown is considered by many to be the greatest football player ever. He established numerous records during his legendary career with the Cleveland Browns , then went on to become a screen actor (*The Dirty Dozen, Original Gangsta's, Mars Attacks!*). Jim Brown has been an activist in African American affairs for many years, beginning in 1966 with the Negro Industrial and Economic Union, whose motto was "produce, achieve, and prosper." In 1988, he founded and became President of Amer-I-can, an organization dedicated to empowering troubled young people, convicts, the disenfranchised and gang members with the self-esteem and life management skills needed to turn their lives around.

Dr. Buzzard

One of the ships from the continent brought over a man who eventually came to be known as Dr. Buzzard. Just as the animal with whom he shared his name, he had cunning and patience. This stately man, who was always dressed "sharp," often in white and wore purple shades to shield his eyes, brought with him the knowledge and power of what has become a feared religion — voodoo.

As Dr. Buzzard practiced on St. Helena, he was not interfered with by his "captor." It is difficult to say if this was out of respect for the fact that Dr. Buzzard did his task, because Dr. Buzzard "chewed the root" on him, or simply out of fear. Whatever the reason, this doctor became known from plantation to plantation to plantation. Many would steal away during the night to seek him out and receive treatment for ailments and powders, potions and mixtures to rid themselves of certain people and patterns. Some wanted to change and/or obtain "luck" and/or love. As Dr. Buzzard gave them things to work on their bodies and emotions, he also worked on their minds. He let other islanders know that "If you think free, you'll be free!"

*contributed by Marquetta L. Goodwine**

Emory S. Campbell

Emory S. Campbell is Director of Penn Centre on St. Helena Island. He is a native of Hilton Head Island, and has appeared in a number of documentarites about the Sea Islands and Gullah culture, and has represented the Gullah people in numerous interviews with the media.

* Excerpt, Marquetta L. Goodwine, *St. Helena's Serenity*, Kinship Publications, New York, 1997.

Leroy Campbell

Hailing from Charleston, artist Leroy Campbell's Neckbone art is sold in contemporary art galleries internationally. His work is displayed in corporations, universities and private collections, as well as on the television shows "Martin," "The Fresh Prince of Belair," "Livin' Single," "The Heat of the Night," "The Jamie Foxx Show," "The Cosby Show" and in the movie *The First Wives Club*. His works have been displayed in Japan, Senegal, England and Germany; he has been interviewed by Bryant Gumble, Chuck Currey, Gary Byrd, Mark Riley, Delores Edwards of Fox 5, Cheryl Washington of Fox News and others. Leroy's Neckbone series allows him to revisit the past in South Carolina with poignant snapshots of everyday family life in the city and in the rural south. His subjects, proud, God-fearing and self-reliant, are the backbones of the African American community. Leroy Campbell's Spiritual Rhythms Art Gallery is located at 150 DeKalb Avenue in Brooklyn. He has a bi-annual one man art show in Soho at Art 54 Gallery.

Ronald Daise

Ronald Daise was born on St. Helena Island and grew up there. He is author of several books, including *Reminiscences of Sea Island Heritage: The Legacy of Freedmen on St. Helena Island* and *Little Muddy Waters, A Gullah Folk Tale*. He contributed many of the stories which were dramatized in the Nickelodeon television series "Gullah Gullah Island," and starred in this hit pre-schoolers show along with his family.

Charlotte Forten

Charlotte Forten was the first Black Teacher of Penn Normal and Agricultural School, the first trade and agricultural school for "freedmen" (African people who were released from enslavement in the United States after the Civil War). Granddaughter of the abolitionist James Forten, she was sent by her father, Robert, also an abolitionist, to live with relatives in Philadelphia. Unable to attend the Euro-American schools there, she was educated by private tutors. Later, she moved to Salem, Massachusetts, where she lived with another abolitionist, Charles Lenox Redmond. Her application for a teaching job with the Boston Port Royal Educational Commission, established to provide assistance to freedmen, led to her departure, on October 27, 1862, to Port Royal, S.C..

Not having Gullah roots, Charlotte was not immediately embraced by the Gullah/Geechee Sea Islanders, who did not relate to her style and ways any more than she did to theirs. Though they all were African

American, there was nonetheless a culture clash. She wrote in her diary that the local people had a "barbaric" way of worship because she had never seen or experienced "shouting." The longer Charlotte stayed in the islands, teaching reading, writing (which had been banned by the Slave Code of 1790) and arithmetic, the more the Gullah folks taught her about spirituality from an African perspective and about their life-style based in praise of a Higher Being. Eventually Charlotte was no longer simply looked at as a "stuck up" (i.e. "sidity" in Gullah) Black woman. She became a part of the community and was sadly missed when she had to leave the island in May, 1864.

contributed by Marquetta L. Goodwine

Joe Frazier

Joe Frazier first achieved public acclaim as a boxer when he fought in the 1964 Olympic Games where, boxing in the heavyweight division, he defeated Germany's Hans Huber in a 3-2 decision. This victory, occurring after a defeat of three earlier opponents, was achieved despite the fact that Frazier fought the bout with a broken right hand, which he had concealed from team doctors. Later, Frazier became world heavyweight champion, winning the title in 1970 and holding it until 1973. Particularly remembered for his celebrated "rumble in the jungle" with heavyweight champion Muhammad Ali, Joe Frazier did defeat Ali in one of the three matches which the two former Olympic Hall of Fame members were to fight.

Georgia Sea Island Singers

The Georgia Sea Island Singers originated on St. Simons Island, Georgia, with the late Miss Bessie Jones, for the purpose of preserving the rich reservoirs of African American culture along with the customs and the songs of the Gullah language spoken on the isolated islands of the Georgia Coast. The Quimbys travel throughout the world most of the year, describing the world of their own enslaved African ancestors, leading children in games, performing dances and *a capella* songs, and explaining what those songs meant in the context of the last century. Their audiences include universities, schools, museums, conventions, and conferences. They have performed frequently for radio and television.

The Georgia Sea Island Singers have represented the U.S.A. at the Winter Olympics in Lillehammer and at the International Children's Festival in Vancouver; the Southern Coastal U.S.A. in West Africa at the invitation of the President of Sierra Leone; and the State of Georgia

at the Statue of Liberty Centennial in New York. They performed at the inauguration of President Jimmy Carter, at Ronald Reagan's White House Concert, the Smithsonian Institute, Wolf Trap International Farm and numerous other venues.

Marquetta L. Goodwine

Founder and Director of the Gullah/Geechee Sea Island Coalition, Marquetta L. Goodwine was raised in the Gullah and Geechee heritage during her many years on St. Helena Island, South Carolina, from which her family stems. Educated at Fordham and Columbia Universities, Ms. Goodwine's interest in African American history, heritage and culture led to her establishment of the Afrikan Kultural Arts Network (AKAN) in 1991, to provide cultural enrichment tours, a monthly newsletter, youth programs, lectures and consulting. AKAN has a national membership body with additional supporters in Canada, and has been featured in various books, newspapers, magazines, TV and radio shows. In 1993, she spearheaded the annual event, the *Ourstory & Heritage Conference*, held in Nova Scotia in 1994, St. Helena Island in 1996, London in 1997 and New York City in 1998. Awarded the *Harriet Tubman Women of Distinction Award* in September, 1997, she was also selected as Regional Director for the Sea Islands for the Smithsonian Institution's Anacostia Museum project: "African American Rural Experience: 1865 to the Present." Preservation of her native culture, Gullah, is her mission in life.

Jonathan Green

Jonathan Green is an artist whose work has been featured in major traveling exhibitions, solo presentations, and group shows. Trained at The School of The Art Institute of Chicago, Jonathan Green has been honored with numerous awards and commissions from art-sponsoring institutions, human service organizations, and national, state and local humanities councils, including an Honorary Doctorate Degree in Fine Art from the University of South Carolina, awarded for his recording of his Gullah heritage and cultural customs of the South. His paintings have appeared in such acclaimed publications as *American Visions Magazine*, the official magazine of the African American Museums Association, and in two children's books, *Father and Son* and *Noah*. Green's work has been noted in 130 publications, including major books, professional journals and magazines. Beloved for their sense of jubilation and rediscovery, his vibrant canvases evoke the meaning of community

in Gullah society, and display a reverence for the rich visual, oral and spiritual traditions of its culture. Born and raised in Gardens Corner, South Carolina, Green currently resides and paints from his studio in Naples, Florida, yet regularly returns to his home environment in South Carolina for a sense of community and belonging.

Gullah Jack

Gullah Jack was originally born in Africa in the region of the Congo River. Reputed to have been a priest, he continued to be highly regarded in the community of enslaved Africans for his putative ability to manipulate the spirit world. Jack played a crucial role in the Denmark Vesey conspiracy of 1822, recruiting widely in the city of Charleston and the surrounding rural regions. Some participants only agreed to join in the insurrection after he had "charmed" them by uttering incantations and providing magical amulets for their protection.

Charleston was a major center for the importation of African captives, and during the period 1804-1807, an estimated thirty-nine thousand entered through the port. Such a large number of Africans, many of whom remained in the vicinity of the city on nearby plantations, ensured the survival and unusual strength of traditional African culture. This demographic characteristic helps explain Gullah Jack's widespread appeal. Jack's most loyal following was based upon those who formed the "Gullah Society" which held religious ceremonies regularly at a farm outside Charleston. This organization may have contained substantial numbers of BaKongo (Angolan) people from Jack's homeland. It is clear that a profound African ethnic consciousness survived in the early nineteenth century Lowcountry. That is why when Denmark Vesey organized his supporters into groups, some were based upon African identity. For example, Gullah Jack led the Gullah contingent which was responsible for seizing weapons from a Charleston arsenal for distribution among the liberated Africans.

When information about the conspiracy reached municipal authorities, Jack was tried and hanged for his leadership role.

contributed by Bernard E. Powers, Jr.

Joe Pinckney

Joe Pinckney, a Hilton Head Island, South Carolina, historical artist for the past 25 years, is renowned among art lovers as "the Norman Rockwell of the Lowcountry". He is the only artist who has devoted his life to capturing on canvas the images of how ordinary people lived

in the Lowcountry prior to its development as a resort area. Many of his works depict the chores of daily life which changed very little from the early nineteenth century right up to mid twentieth century. Due to the physical isolation of the Sea Islands, including Daufuskie and Hilton Head Island, people survived off the land, creeks, and ocean, without benefit of electricity, telephones, supermarkets, or even running water. As a child in the 1940's, Joe Pinckney had an opportunity to experience this life style himself, and the characters and landscape scenes immortalized in his artwork are people and scenes which he knew or observed during that time. The facial expressions are classics which are well worth close scrutiny, especially that of regal old "Uncle Ben," a former resident of Daufuskie.

Joe Pinckney, a South Carolina Hall of Fame inductee, received his formal training in New York City, and has had his artwork displayed all over the United States, including the Smithsonian Institution. He now works in his studio on Hilton Head Island, using oils, acrylics, watercolors, pencil, pastels, and pen-and-ink media. While continuing his efforts to depict the Gullah culture, he also paints many portraits of private individuals, and is often commissioned by area businesses to create works for their public area decor.

Omar ibn Said

One of the most important remaining articles of Islamic material

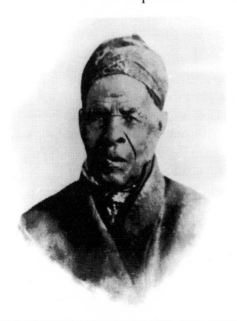

culture from early America is a manuscript written by Omar ibn Said. It is dated 1831, and is the only existing autobiographical manuscript that is known to exist in the Americas. Omar was born in FutaToro, Senegal around 1770. He was a Fula and a devout Muslim (Marabit or Marabout), and a member of a family of impressive wealth who were respected for their strict adherence to the laws of Islam. Omar ibn Said had made

Hajj and was a trader who probably spoke many languages, as was the case with most people of similar social standing. He was captured around 1807 and brought to Charles-ton, South Carolina. Upon arrival in North America, his name was contorted to such varied pronunciations and spellings as "Meroh," "Umeroh," "Moreau," "Omora," and "Morro." Despite his shift in status upon being removed from Senegal, Omar remained an individual noted for his "...whole person and gait bear(ing) marks of considerable refinement," (Reverence William S. Plumar, Presbyterian pastor and professor). The following is a brief written account from Omar's autobiographical manuscript:

> In the name of God, the Gracious, the Merciful.
> Thanks be to God, supreme in goodness and kindness and who is worthy of all honor, who created all things for his service, even man's power of action and speech... You asked me to write of my life. My name is Omar ibn Said. My birthplace was Fut Fur (Futa Torot) between the two rivers. I sought knowledge under the instruction of a Sheikh called Mohammed Said, my older brother, and Sheikh Soleiman Kembeh, and Sheikh Gabriel Abdal. I continued my studies twenty-five years and then returned to my home where I remained six years. Then there came to our place a large army, who killed many men, and took me and brought me to the great sea and sold me into the hands of the Christians, who bound me and sent me to the great sea and we sailed upon it for a month and a half, when we came to a place called Charleston in the Christian language... Before I came to the Christian country, my religion was the one of "Mohammed, the Apostle of God — may God have mercy upon him and give him peace." I walked to the mosque before day-break, washed my face and head and hands and feet. I prayed at noon, prayed in the afternoon, prayed at sunset, prayed in the evening...

Throughout the course of his life, Omar's deen (faith) was relentlessly challenged by the insistence that all slaves imported or born in the Americas accept Christianity or face dire consequences. As a result, Omar was forced to replace the writings of the Quran with

those of the Bible, and eventually began to go regularly to the Presbyterian church. Soon Omar did not publicly acknowledge that Islam was the faith he was born into. He began to hide it, thereby making Christian observers believe he had converted. In fact, Omar's Christian studies ended up being the bridge that reinforced what Omar had begun to feel he was losing — his Islamic faith. At the time of his death in 1864, he had fully rededicated himself to Allah as a Muslim.

contributed by Joshua Rabah

Phillip Simmons

Phillip Simmons of Daniel Island is famous for his ornamental ironwork. He carries on a long tradition begun with skills brought from Africa several hundred years ago, and carried forward by general craftsmen. Born in Wando in 1912, Simmons moved to Charleston while still a boy. He learned his craft from his grandfather, a skilled carpenter, and by watching the blacksmiths, one of whom trained him. Simmons began repairing and then making iron gates. Over the next forty years, he produced over 200 gates, as well as window grilles and fences. Much of his work can be seen outside of homes and buildings in historic Charleston. The Smithsonian Museum in Washington, D.C. honored Simmons as a National Heritage Fellow. He designed and crafted a "Star and Fish" wrought-iron gate for the Smithsonian to display. Simmons has been inducted into the South Carolina Hall of Fame, and the Folk Arts Program of the National Endowment of the Arts has recognized his work. The State Museum in Columbia displays a fine example of his work. While Simmons says that he thinks of himself as a blacksmith, he will be remembered as an artist.

Robert Smalls

Robert Smalls (1839-1915) was born into slavery in Beaufort, South Carolina on April 5, 1839, but was taken to Charleston in 1851 where he worked in various jobs along the waterfront. Eventually he learned the crafts of sailmaking and rigging and also how to read nautical charts. He was allowed the opportunity to hire his time out on board coastal vessels and learned the currents and shoals of Charleston harbor. During the Civil War, Smalls was part of a crew of enslaved Africans on board the Confederate ship, *Planter*, which supplied fortifications around the harbor. On May 13, 1862, Smalls and the other crew members boldly seized the vessel and then at considerable risk to life and limb, sailed it from the harbor and turned it over to the Union naval blockade. For this act of heroism, he was made a second

lieutenant in the Union navy, and used the *Planter* to perform quarter-master duties along coastal South Carolina.

Beginning during Reconstruction, Smalls became a leading Gullah politician with a base of support from the Beaufort area. He was elected to the 1868 constitutional convention and served as a state representative and senator from 1868-1875. In these capacities, he proved to be a champion of public education and civil rights. In 1870, he introduced the bill which eventually became South Carolina's first substantial public accommodations law. Between 1875 and 1887, he served five terms in the U.S. Congress representing South Carolina. There, he successfully promoted policies which enabled his constituents to purchase land, and his efforts led to upgraded naval facilities at Port Royal. Nevertheless, by the end of the century, with the rise of the rabidly racist Benjamin Tillman to the governorship, the political climate turned increasingly hostile towards African American Carolinians. Hoping to stem the tide, Smalls was elected as one of the few black delegates to the 1895 state constitutional convention. There he vigorously but unsuccessfully opposed the disfranchisement of African Americans in the state. Even after disfranchisement and the proliferation of Jim Crow measures, Smalls remained active in politics. As a reward for loyal service to the Republican party through the years, he was appointed collector of customs for the port of Beaufort. He held this position almost continuously between the years 1889 and 1913.

contributed by Bernard E. Powers, Jr.

Harriet Tubman

Although Harriet Tubman is not Gullah, she spent a great deal of time in Beaufort County, SC, on its various islands during the Civil Wars. She and Charlotte Forten are said to have been associates. She also formed a washing collective with Gullah women and opened a bakery with Gullah women while being a nurse and spy for the Union. Her work and that of other women such as Susie King Taylor, who also was a nurse for the Union, only contributed to the richness of the Sea Island region and its stories.

Denmark Vesey

Denmark Vesey was born in 1767 either in Africa or on St. Thomas in the Danish West Indies. Purchased from a slave market on that island in 1781 by Captain Joseph Vesey, a Caribbean slave trader, Denmark was then sold to a planter in St. Domingue. After only a few

months, though, Denmark was determined to be physically unsound, and was returned to Captain Vesey, who used him in his commercial enterprises. As a result, Denmark travelled widely and was taken to various Caribbean islands, to Bermuda and West Africa. Eventually he was brought to Charleston where Joseph Vesey settled during the early 1780's. In an unusual stroke of luck, Denmark won fifteen hundred dollars in a lottery, six hundred of which he used to purchase his freedom. Once freed, Denmark Vesey plied the trade of carpentry and enmeshed himself in Charleston's small community of free blacks. He is alleged to have had several wives in the course of his life, most of whom were enslaved; all the children resulting from these unions were enslaved.

During the early nineteenth century, free blacks found their lives increasingly circumscribed in South Carolina. In 1800, the state legislature added restrictions on the emancipation of enslaved Africans and in 1820, virtually eliminated the possibility of legal emancipation. In 1818, when black Methodists in Charleston established the African Church independent of white Methodists, municipal authorities began a campaign of harassment against the congregation. In that year, 140 of its members were arrested. Vesey was a very religious man, served as a class leader in this church, and often contended that Christianity condemned slavery.

Drawing support from a nucleus of urban and country bondsmen, Vesey organized a conspiracy to arm and liberate the enslaved Africans while burning sections of Charleston. The insurrectionists intended to slay their opponents and if necessary, to escape to Africa or the independent republic of Haiti. The example of the Haitian Revolution of 1791, Christian principles and traditional African spiritual ideas were all used to galvanize support for the rebellion.

The revolt was planned for July 1822 but before it could be consummated, enslaved African informants told the authorities. Trials and interrogations quickly followed, after which thirty-seven of the accused were banished, while thirty-five, including Vesey, were executed.

The Vesey conspiracy left its permanent mark on Charleston and immediately following its discovery, authorities passed more draconian legislation and also started to fortify the northern boundary of the city. In 1842 the South Carolina Military College was located here to help preserve domestic tranquility in this city where blacks comprised the majority population.

contributed by Bernard E. Powers, Jr.

Gawd Dun Smile 'Pun We[1]
Reflections on the Ancestors, Family
and the Gullah Heritage

"You don't know where you're going if you don't know where you've been." Thus, I had to journey back in order to go into the future. I had to return to St. Helena's soil to dig beneath it for the roots — my roots. While digging, I found the remnants of hearts and the soul they were wrapped in. I found the soil moist with tears and blood, and could almost hear the sand speak.

As I took the time to reflect on the steps that I had taken and what my soul had heard, I knew which path I needed to take next. After looking at St. Helena close up, you can take a step back and see it all — Beaufort County. So, just as an admirer of art and beauty does, I took a step back in order to look at the full picture. I found that in stepping back, I was actually going forward. The reflections of the past held vision and hope for the future. The serenity of St. Helena was and is able to radiate in the beauty of Beaufort. With all the turmoil that has occurred here, a treasure chest of culture was preserved and the sun brightly shines over the marshy shoreline and rippling palmetto lined waters. I could only think: "Gawd dun smiled 'pun we."

Marquetta L. Goodwine

I recall visiting Whitehall, S.C., during the summer and noticing beautiful Afrikan sisters carrying pails of water on their head. They would stop and greet each other. I felt very safe no matter where I was or whose house I visited, because everyone looked out for the children, and they would make sure that you were fed. I was taught by the elders that you must greet the adults wherever you saw them. After my father passed, my uncles helped my mother by calling or visiting her often to ensure that all was well, and when my sisters got married, they helped with the wedding, physically and financially. I recall, as a child, having a fight with a cousin; I was later punished by my grandmother and told in no uncertain terms that you never fight with relatives and that all disagreement should be settled peacefully, or to come to the older kids or adults. It was truly a village of peace and love. Most of the people were poor only in material ways but wealthy in moral and spiritual ways. Everyone shared their vegetable gardens

and readily invited each other to ride into town on Saturdays to shop mostly for food that was not grown by them.

Joseph Mustipher

People would put up jars for themselves. Then sometimes if you had a pleny and then the next person run out, well say, 'You got any jar? You can let me hab couple? — Yes.' People used to live in community then, but not now...One hand wash the other.

Samuel R. Brown, Sr. (91 years old) of St. Helena Island, S.C.
speaking about "cannin'" or "jarrin'"

Growing up Geechee in Pittsburgh, PA in the 1950s gave me a sense of being able to do anything I want to do! Even though the term "Geechee" had negtive connotation, the people who prevailed (not just surviving) were recent Geechee migrants from South Carolina and Georgia. I recall an uncle travelling back to SC from time to time and bringing food (and yes, even that red clay) that would be shared with all the relatives. I recall the great sense of knowing I and all my relatives had "a place in the family"... Oh, I could get so carried away with my many happy recollections growing up Geechee on the "Hill"...

As a youngster growing up on the Hill District in Pittsburgh, PA where everyone that I knew were Geechees, I never gave the Geechee culture much thought until I realized that the dysfunction in our African American culture is directly linked to our no longer being grounded in our families. African descendants understood family, the need for humans to be grounded. Somehow, we must return to our sense of being a part of the larger African American community. There is no better way to do this than to reconnect to our Geechee roots.

Jocie Burwell

My first vivid memory of Sheldon, South Carolina was the day I went to meet Big Jo, my future grandmother-in-law. I didn't know what to expect, but the name alone was cause for apprehension and wonderment. I had no photos, only stories and declarations of love from her grandson, who was now taking me before the matriarch of his family. I pictured a big hulking, strong and stern woman who with her hands on her hips would look me over and make a decision then and there if I was family material. That was almost twenty years ago and the memory is a real as the day itself. When I stepped across the threshold of her wooden house, pleasantly furnished with flowered

slip covers and warm colors, my anxiety gave way to resignation and I moved forward. Her grandson, Roy, went to the door of her bedroom and announced our arrival from Charleston by way of Philadelphia. To my surprise, there on a neatly made bed sat a small woman whose feet dangled some distance from the floor, combing her hair. Where, I wondered, where was Big Jo, the grandmother whom I had heard so much about?

She looked up with a quizzical smile and bade me enter and sit down beside her. She dismissed Roy with an adoring tilt of her head and patted the coverlet next to her. I sat down and met the clearest, strongest eyes I have ever seen. She didn't have a laundry list of questions for me, the city girl, as I thought she would. All she wanted to know was if I loved her grandson. Would I stand beside him and be a part of the family? Even though these questions seemed on the surface easy to answer, they held a deeper meaning for this small woman.

For her, family is who you are. She had borne and raised sons and daughters of her own, and their fierce allegiance to family was what she instilled in them.

I took my time before answering, gave her questions serious thought and took my place in the family. What I learned about family, I learned from her. In her family, once wife, always wife — divorce cannot break the connection. I watched her moving about quietly and ceaselessly as she communed with her children and grandchildren.

When I think of her now, I still smile and see her never-ending journeys into the kitchen for a bite of something or another. She had diabetes and had to eat frequent small meals. I see her now, in my mind's eye, with a bowl in her hand, coming out of the kitchen, making her way to her favorite chair. If you asked how she was doing, her response was always the same "very well, thanks the Lord." When she passed, I was not able to attend her funeral. It is just as well because she remains "very well" in my heart and mind.

Big Jo was Mrs. Joanna Robinson of the Polites of Beaufort and St. Helena Islands.

Dorothy Ferebee

... one night, as I walked onto the porch to go into the house, Uncle Manson looked at me and, noting my stocky build, told the others: "That boy there...that boy is gonna be another Joe Louis."

Well, those words made an impression. Eight-years-old at the time, I thought: why not? Boxing fit in with the rough-and-tumble character

I was. At school, classmates would give me a sandwich or a quarter to walk with them at final bell so that bullies wouldn't mess with them. Bullies would see me and say: "Oh, okay, Billy. I didn't know you was friends wit him." Around Laurel Bay, any scambooger who in my face soon regretted it: Billy Boy could kick anybody's ass.

Another Joe Louis. That sounded dead right to me. From the moment that Uncle Manson spoke those words, I took them to heart. The next day, I got an old burlap sack and filled it with rags, corncobs, a brick in the middle, and Spanish moss that grew on trees all over Beaufort County. I tied a rope to it and then hung this makeshift heavy bag from an oak tree in the backyard lot where the mules were kept. And for the next six, seven years damn near every day I'd hit that heavy bag for an hour at a time. I'd wrap my hands with a necktie of my daddy's, or a stocking of my mamma's, and get to it.

I told folks I was destined to be a world champion, the next Joe Louis. They looked at me as if I was from Mars.

Joe Frazier
Former Heavyweight Champion of the World[2]

Our ancestors, many of whom were farmers and fishermen before their forced exodus from Africa, managed their time much differently from the long grueling days required of them by slavemasters and overseers. Because Africa provided a climate that was conducive for fishing and growing rice and many other crops throughout the year, the Africans became skillful at proportioning their work so that it would be equally distributed over time. More importantly, the absence of growing seasons, which are typical of American crops, eliminated the need for precise planting and harvesting times. In Africa, all of this was accomplished efficiently and in a manner that interspersed work with relaxation. It is safe to say that how time was perceived and valued by the Gullah differed significantly from how it was perceived by slave- masters and overseers. From the latter's perspective, the enslaved Africans were seen as being lazy, shiftless and not dependable for exhibiting behaviors that showed little regard for punctuality. The major difference between the valuing of time by Gullah and by those who enslaved them was that the latter ordered their lives around events, while the Gullah were accustomed to ordering their participation in events around their lives.

This difference in how time is perceived by many African Americans gave rise to the concept of CPT (Colored People's Time).

While this concept has a pejorative connotation, it emanated from learned behavior that served Africans well. Contrary to popular belief, it does not mean being consistently late. It means simply that the lives of many African Americans are not ordered around events. This should suggest a conscious effort to base decisions about the importance of punctuality on a careful analysis of its benefits and consequences rather than on its complete disregard. The results of this kind of analysis are reflected in sometimes being early, sometimes being punctual and sometimes being late. It reflects Gullahs' attempts to control rather than be controlled by events.

Thomas J. Brown & Kitty Green[3]

Ooh child, let me tell you! That dune ["Nana" the sand dune that healed her of cancer and was also used to sooth her grandfather's ailments] is firm, it's been there so long. There's a drop off behind it, see, and as children we would go there and use it as a slide. We could hide away from the adults that way... Look at this view. Look at those trees. Look at my butterflies. All this is going to condos. It makes me want to cry... My cousin sold most of the land because he was in trouble financially and needed to liquidate... I had no idea what was going on at the time or I would have tried to stop him... my great-grandfather would have turned over in his grave if he ever knew.

We've got a crazy rich in this country. They pay hundreds of thousands of dollars to live in a little box where you can hear your next door neighbor every time he flushes his toilet. That's the samething the poor do.

MaVynee Betscha, "The Beach Lady"
(unofficial mayor of American Beach on Amelia Island, Florida)

My father's family is from Wadmalaw Island, one of the smaller bastions of Geechee culture located off the coast of Charleston. I remember my summers spent there with great fondness because though my father's family was poor and we were middle class, the beauty of the island touched me even as a child. I remember pumping water from the well, bathing from a bowl, using an outhouse, sleeping summer nights with the window open in my grandmother's shotgun house. I remember grits with shrimp and gravy, fried fish, crackling corn, and rice with every meal. I remember the talk and how my father remembered and relived his accent as we crossed the bridge to the island. I remember the smells and sounds of the water and the

birds, the weeping willows and the two lane roads. I remember the cousins and the uncles and aunts and the fact they assumed and acted as if we all were related –– even when we knew we weren't. And oh, I remember the stories, the history and herstory straight from the mouths of some of God's oldest people, the tall tales, the folklore, and all its wonder to the ears and imagination of a child.

Bentina Chisolm

It's a dying form of life we have here. In some ways I relish the new way while at the same time I feel such a heavy loss for the vanishing of the old ways.

Life on Sapelo goes on much as it does anywhere else, but if you get to really see and feel what's here, you will see the difference. The proud faces as well as the angry walk, the easy smile as well as the hard frown, the easy life as well as the hardship, it's all there reflected in the faces and stature of each individual. The old who don't want to change and the young who does. But get to know the young ones and you will see tradition and hear pride.

We are all proud of our heritage. I can still see the ladies at such places as Raccoon Bluff fishing with a drop line and cane pole from a batteau boat, while trusting in the Lord because they couldn't swim; the men fishing at night with flambeau, looking for alligators with a long pole and giant hook.

I remember the call of my Grandmother as she called my sister from King Savannah; the smell and sweat of the men as they walked behind oxen, horses and mules plowing task after task of fields; the Friday night hot suppers with music and food and dances like the Buzzard Lope. I can drive a horse and wagon as well as a car, I can use a garden hoe as well as a tiller and I can cook better on a wood stove than an electric one. Modern is good but old fashioned ways and ideas have built many a strong foundation for our young people of Sapelo; their lives are rich.

We don't want to lose the meaning of what a lot of gnats mean, how fresh-dug sweet potatoes taste cooked in hot ashes. I am Sapelo and all the hundreds of others who are descendants; we who remain here is Sapelo. We are one, bound by the spirit of an island and Bulallah the slave. Bound by high tide, fields, gossips, smoke mullet, and our faith. And I mustn't forget we are all surrounded by big water and have to be close to each other, real close!

The things we used to do! I remember as a kid sitting in the corner

and watching Papa and his friends dance the Buzzard Lope. They all got together on Friday and Saturday night with their moonshine. They were blowing on the comb, some playing the guitar, some doing the soft shoe, the tap dance, and one trying to outdo the other in dancing.

We didn't join in but it was fun watching them. Even if Papa used to come home late at night, some of these fellows would follow him back home and we'd get up out of bed just to watch them. Get up and sit in a corner someplace and watch them do their thing until they'd fall asleep or leave and go back home. And so we'd learn from all that. The next day we'd be trying to blow the comb, we'd get outside and try our best to imitate that comb!

Mama would talk about Grandpa Bryan. He was a mysterious fellow, being one half Creek and one half African and they say he came from the Okefenokee Swamp. He'd sell Blair Products and he would measure men for suits and shoes and actually cut their hair with a bowl! I remember as if it were yesterday. He used to cut Mr. Allan Walker's hair. He would go in the kitchen and get him a bowl. Well, he'd sit it up there on Mr. Allan Walker's head and he would clip all around it and then he'd take the bowl off, he'd trim it down a little bit more, and his neck would have a perfectly straight line!

Mr. Walker would get up in church on Sunday and these kids would be so tickled. He'd just had his hair cut with the bowl. He'd get up (he was a very proper old man) and he'd say, "My fellow constituents..." — what the heck is constituents? When you're little – – six and seven years old — matter of fact the majority of the church didn't know what constituents mean. You're talking to people who never went to school or went as far as the third grade and I don't think they used the word constituents in the third grade! Even back then when lessons were harder.

The songs we used to sing in church we've been singing for years and years. Nobody really goes to the hymnbook, they sing from memory. When Grandma would sing, she had a captivated audience. She'd sing "When I Get to Heaven" and "The Things I Used to Do." That was when I was little. I haven't heard Mama sing in years but she used to sing with Grandma. Though Grandma would be tipsy, Mama never drank but she'd sing with her anyhow.

Papa would sing once in a while around the house but he wasn't much on singing. He'd just sit down and tell us stories and build his homemade nets and fox traps and cook hominy grits for us. Papa provided for us the best he could. We had alligator dishes along with

pork greens. We had game birds and shore birds — wild turkey and gannet. We had fish of all kinds, we had turtle of all kinds. We had deer, squirrel, rabbit, raccoon, and possum. Some only in season, some by means of poaching. Sometimes nothing at all.

Papa showed us how to take the bladder from a fresh-killed hog and make a balloon out of it by rolling it in warm ashes until it was thin, and then blowing it up — our first balloon! Or how to make a whistle from a spent shell. Or whittling a toy for us to play with. Or bringing home a pocketful of kumquats from around the Reynolds' mansion.

First, Sapelo was described as a haven for slaves, then a paradise for the Black families that live here. Where is the paradise on Sapelo? Where? Maybe for those who don't have to live here they can see paradise, we can't. Our school are all closed down, our former communities are gone. Our churches have only a handful of worshippers left. Our organizations such as the Farmers Alliance, Masonic, Eastern Stars are gone. Why? Because the people are all gone.

Sunday nights, Tuesday nights and Thursday nights were prayer meeting nights at the local prayer houses. There are no more prayer houses. No more hot supper nights where the boys and girls meet, there are no more boys and girls to giggle in the dark under the stars, with a chorus of frogs and crickets for company.

Even our ghosts don't walk anymore. There is no one for them to scare now, no one walks the road at night, no jack o'lantern to lead the weak-minded or drunk-minded away to some dark woods for a night of fright.

Nothing is left, but then again we who remain is here still. We still drink, love, hate, and remember we are still living for our ancestors. My eyes water, my mind races and I get sad and angry. There are no more sawmills, no more cowboys, no one to tap the graceful pine trees — no more cotton, no more old-fashion anything. No more midnight fishing or alligator hunting with a long pole.

But once reminded, we can remember the rest. For in many ways we are still living in the days of the Buckra house and the Buckra fields. I am still in Massa fields. I can see and hear traces of the old days but there in those fields I can also retain my dignity and be myself without undo influences. It's not easy, but I watch the birds and my mind is free, even if the rest of me have committances.

*Cornelia Bailey is of the last generation
to be born, raised and schooled on Sapelo Island.*[2]

We are in the Gullah area and we grew up around Gullah. Now in all honesty, my mother didn't speak Gullah, but as a child growing up, and with friends going to school, you tend to get in with the group and imitate or get right into the group and do little things they do. But my mother would always chastize me when I got too much into the Gullah. She would grab a book and shove it under my face and tell me, 'Read so and so out of the book.' And reading the book — the book was written in almost perfect English — and she'd say to me, 'Why did you say so-and-so and so-and-so, if it's not the proper English that you read out of the book?'... I would try to make excuses that one of my other buddies talked like that or somebody else talked like that. Got a lot of slaps in the face because of it.

Samuel R. Brown, Jr., St. Helena Island

The location of our property has specific cultural meaning to us. This is the lands of our forefathers, passed down to us, generation after generation. This soil on which many of us were born, rared, lived, and died. It is our own property. We did not take it away from anyone. It is there that we have our closest family and cultural ties; and it is there that we wish to remain. It is this land that we wish to pass on to our children. It is the hope kept alive at each 'family reunion,' when our children are taken back to the 'old homestead' and told the history of their ancestors and the importance of owning the land. From these reunions, our children have acquired an insatiable thirst for keeping their ancestral homeland in the family. It is of uttermost importance that this land remain that of the 'Goodwine family heirs.'

Mary Goodwine Johnson of Polowana Island, S.C.,
responding to developers that want to build on and take over
Polowana, the home island of the Goodwine family.

This is the preface of the first Goodwine Family Reunion journal.

To know John Goodwine, forefather of the St. Helena Island, South Carolina Goodwine's, we must know also our African past, how slavery came to America, the impact it had on our new homeland America, about the Sea Islands of South Carolina and the culture of its people. We cannot ignore one for the other, for it is with the whole picture that we see John and through him the unwinding of the generations of Goodwines that followed and that we let our healthy minds drift back into time and form a more positive story before John, our tribal ancestors from Africa's Golden Strand, and the rich legacy we inherited

from them. For as we go forward, we must never forget from whence we came. We must never feel small, but stand tall through all adversity. We must never allow our ways to become down trodden, but soar like a mighty eagle to reach the lofty heights!

Mary Goodwine Johnson of Polowana Island, S.C.

[1] The title of this section comes from *Gawd Dun Smile Pun We: Beaufort Isles,* by Marquetta L. Goodwine, a Kinship Publication, P.O. Box 40-0199, Brooklyn, NY 11240-0199.

[2] Excerpt from *Smokin' Joe* by Joe Frazier: http://w3.mgr.com/mgr/macmillan/joe_announce/joe_excerpt.html

[3] Excerpted with permission of the authors from the book, *Lessons Learned from the Gullah Experience: Powerful Forced for Educating African American Youth,* 1998 -- in press.

[4] Cornelia Bailey's reflection is reprinted with her permission, from her website at http://www.gacoast.com/navigator/iamsapelo.html

De Good Nyews Bout Jedus Christ wa Luke Write: The Beatitudes

Gullah translation by the Sea Island Translation & Literacy Team [1]

[17]An Jedus come down he hill wid e postle dem. E gone an stan weh de groun been lebel, an plenty oda e ciple been wid um. An a whole heap ob people geda dey. Dey come from all oba Judea an from Jerusalem, an some come from dem down close ta de wata een Tyre an Sidon. Dey come fa yeh Jedus an fa habe un cuyre um.

[18]Fodamo, dem wa habe ebil sperit come an git heal.

[19]Ebrybody beena try fa tetch Jedus, cause powa beena come out from um. An dat powa heal all ob um.

Jedus Teach Bout Dem was Gwine Be Bless fa True

[20]Jedus look at e ciple dem an tell um say,

"Oona bless fa true, oona po people. Cause God esef da rule oba oona!

[21]Oona bless fa true, oona wa hongry now. Cause God gwine gee oona all oona want fa eat! Oona bless fa true, oona wa da cry now. Cause oona gwine laff lata on!

[22]Oona bless fa true, oona wa da folla me, wen people hate oona, wen dey ain't want habe nottin fa do wid oona an hole oona cheap, wen de say oona ebil. Oona bless fa true, wen dey da do all dat cause oona da folla de Man wa Come from God.

[23] Be glad wen de time come wen de people do oona dat way. Jomp op wid jaiy den, cause oona gwine git a whole heap ob good ting dat God da keep fa oona een heaben. Mus memba dat dem people was gwine make oona suffa dem ting yah, dey ole people done de same ting ta dem was God sen ta gee e Wod.

[24] Bot e gwine be a haad time fa oona wa got plenty now. Cause oona done habe ebryting easy een dis life yah!

[25]E gwine be a haad time fa oona wa da eat all wa oona want now. Cause de time gwine come went oona gwine be hongry fa sho! E gwine be a haad time fa oona wa da laff now. Cause oona gwine be too saary an cry!

[26]E gwine be a haad time fa oona wen ebrybody da praise oona. Memba dat de same ting dey ole people done ta dem wa say God sen um ta gee e Wod, bot dey ain't been no trut no way bout um.

from The Gospel According to St. Luke

King James Version

¹⁷And he came down with them, and stood in the plain, and the company of his disciples, and a great multitude of people out of all Judea and Jerusalem, and from the sea coast of Tyre and Sidon, which came to hear him, and to be healed of their diseases;

¹⁸And they that were vexed with unclean spirits: and they were healed.

¹⁹And the whole multitude sought to touch him: for there went virtue out of him and healed them all.

²⁰And he lifted up his eyes on his disciples, and said, Blessed be ye poor; for yours is the kingdom of God.

²¹Blessed are ye that hunger now: for ye shall be filled. Blessed are ye that weep now: for ye shall laugh.

²²Blessed are ye when men shall hate you, and when they shall separate you from their company, and shall reproach you, and cast out your name as evil, for the Son of man's sake.

²³Rejoice ye in that day, and leap for joy: for, behold, your reward is great in heaven: for in the like manner did their fathers unto the prophets.

²⁴But woe unto you that are rich! for ye have received your consolation.

²⁵Woe unto you that are full! for ye shall hunger. Woe unto you that laugh now! for ye shall mourn and weep.

²⁶Woe unto you, when all men shall speak well of you! for so did their fathers to the false prophets.

from Gud Yus Fo Olman: Di Nyu Testament

The Krio language of Sierra Leone version[2]

Jizɔs Tich ɛn Mɛn

¹⁷Wɛn Jizɔs kɔmɔt ɔp di il kam dong wit In apɔsul dɛn, I go tinap na di lɛbul grɔn wit plɛnti In ɔda lanin boy dɛn. Plɛnti pipul bin kam gɛda de, sɔm pan dɛn pipul ya bin kɔmɔt Judia, sɔm bin kɔmɔt Jerusɛlɛm, ɛn sɔm bin kɔmɔt na dɛn tong we de klos di wata na Taya ɛn saydɔn.

¹⁸Dɛn bin kam fɔ yɛri Gɔd In wɔd ɛn fɔ mek Jizɔs mɛn dɛn. Jizɔs mɛn dɛn wan we dɛbul bin de insay. ¹⁹Ɔl di pipul dɛn bin de tray fɔ tɔch Jizɔs bikɔs pawa bin de kɔmɔt pan Am we mɛn dɛn ɔl.

Blɛsin ɔ Wahala

²⁰Jizɔs luk In lanin bɔy dɛn, dɛn I bigin tɔk to dɛn. I se:
Una gɛt blɛsin, una dɛn popipul, bikɔs Gɔd de rul una!
²¹Una gɛt blɛsin, una we angri nae, bikɔs una go gɛt ɔl wetin una fɔ gɛt!
Una gɛt blɛsin, una we de dray naw, bikɔs wan de una go laf!
²²Una gɛt blɛsin wɛn mɔtalman nɔ lɛk una ɛn dɛn nɔ want gɛt ɛnitin fɔ du wit una, ɛn wɛn dɛn de kɔs una ɛn tɔk bad bɔt una, bikɔs una biliv Mɔtalman Pikin ɛn una de fala Am!
²³Una fɔ gladi wɛn dat bi, una fɔ dans ɛn jomp bikɔs una go gɛt big pe we Gɔd dɔn kip fɔ una na ɛvin! Dɛn pipul we de du una dɛn tin ya, na so dɛn granpapa-papa dɛn bin du di prɔfɛt dɛn.
²⁴Bɔt wahala go kam pan una we jɛntri naw, una dɔn gɛt ɔl di tin dɛn we dɔn mek una gladi!
²⁵Wahala go kam pan una we gɛt ɔl wetin una want naw, bikɔs tɛm de kam we una go angri! Wahala go kam pan una we de laf naw, bikɔs tɛm de kam we una go dray bita wan!
²⁶Wahala go kam pan una wɛn ɔlman de tɔk gud bɔt una; na so dɛn granpapa-papa dɛn bin du di lay prɔfɛt dɛn.

Mus Lobe Oona Enemy

[27]Bot A tell oona wa yeh wa A say, mus lobe oona enemy dem. Mus do good ta dem wa hate oona.

[28]Mus aks God ta bless dem was cuss oona, an mus pray fa dem wa do oona bad.

[29]Ef anybody knock one side ob oona face, mus ton de oda side an leh um knock de oda side too. Ef somebody take oona coat, mus gem oona shat too.

[30]Ef somebody aks oona fa sommin, mus gem. An ef somebody tief sommin was blongst to oona, mus don't aks um fa gem baak.

[31]Oona mus do ta ebrybody jes like oona want dem fa do ta oona.

[32]"Ef oona jes lobe dem wa lobe oona, oona ain't done nottin fa git praise fa, ainty? Cause eben dem people wa ain't try fa do wa God say, dey lobe people wa lobe dem!

[33]An ef oona do good jes ta dem wa do good ta oona, oona ain't done nottin fa git praise fa ainty? Cause same fashion, eben dem wa aint' try fa do wa God say, dey do good too!

[34]Ef oona lend ting jes ta dem wa onna spect gwine pay oona baak, oona ain't done nothin fa git praise fa ainty? Cause same fashion, eben dem wa aint' try fa do wa God say, de leng ting an spect fa git um baak!

[35]Bot oona must lobe oona enemy dem. Mus do um good. Wen oona da lend oona enemy sommin, mus don't spect ta git pay baak. Wen oona ain't look fa pay baak, oona gwine git pay baak wid big blessin. An oona gwine be chillun ob de Mo High God. Cause God good ta eben dem wa ain't preciate nottin an dem was libe wicked.

[36]Mus be mussyful ta all people jes like God, oona Papa, e mussyful ta ebrybody.

Mus Don't Jedge Oda People

[37]Oona mus don't jedge oda people. Den God esef ain't gwine jedge oona. Must don't condemn. Den God esef ain't gwine m op til e condemn oona. Mus fagibe oda people. Den God esef gwine fagibe oona.

[38]Mus gee ta oda people. Den God esef gwine gee ta oona. E gwine gee oona plenty, jes like wen people full op a baskut wid sommin an dey mash um down. Dey shake um bout an pile um op til e ron oba de top ob de baskut. So ef oona gee plenty, God gwine gee oona plenty. Ef oona ain't gee plenty, God ain't gwine gee oona plenty.

[39]Jedus tell um a paryable say, "A bline poson ain't able fa sho oda bline poson de road, ainty? Cause den, dey bof gwine fall down eenta de ditch.

[27]But I say unto you which hear, Love your enemies, do good to them which hate you.

[28]Bless them that curse you, and pray for them which despitefully use you.

[29]And unto him that smiteth thee on the one cheek offer also the other; and him that taketh away thy cloke forbid not to take thy coat also.

[30]Give to every man that asketh of thee; and of him that taketh away thy goods ask them not again.

[31]And as ye would that men should do to you, do ye also to them likewise.

[32]For if ye love them which love you, what thank have ye? for sinners also love those that love them.

[33]And if ye do good to them which do good to you, what thank have ye? for sinners also do even the same.

[34]And if ye lend to them of whom ye hope to receive, what thank have ye? for sinners also lend to sinners, to receive as much again.

[35]But love ye your enemies, and do good, and lend, hoping for nothing again; and your reward shall be great, and ye shall be the children of the Highest: for he is kind unto the unthankful and to the evil.

[36]Be ye therefore merciful, as your Father also is merciful.

[37]Judge not, and ye shall not be judged: condemn not, and ye shall not be condemned: forgive, and ye shall be forgiven:

[38]Give, and it shall be given unto you; good measure, pressed down, and shaken together, and running over, shall men give into your bosom. For with the same measure that ye mete withal it shall be measured to you again.

[39]And he spake a parable unto them, Can the blind lead the blind? shall they not both fall into the ditch?

Una fɔ Lɛk dɛn Wan we Nɔ Lɛk Una

[27]Bɔt A de tɛl una we de lisin Mi se, una fɔ lɛk dɛn wan we de fɛt una ɛn una fɔ du gud to dɛn wan we nɔ lɛk una.
[28]Una fɔ blɛs dɛn wan we de kɔs una ɛn pre fɔ dɛn wan we de trit una bad.
[29]If ɛnibɔdi slap una na wan ja, una fɔ tɔn di ɔda wan gi am fɔ mek i slap insɛf. If ɛnibɔdi tek una klos we ana wɛr pantap, una fɔ gi am di wan we de bɔtɔm, mek I tek insɛf.
[30]If ɛnibɔdi aks una fɔ ɛnitin, una fɔ gi am, ɛn if ɛnibɔdi tek tin we na una yon, una nɔ fɔ aks am fɔ gi una bak.
[31]Dɛn tin we una want mek ɔda pipul du to una, na I una fɔ du to dɛn.
[32]If na dɛn wan we lɛk una nɔmɔ una lɛk, una fɔ gɛt prez fɔ day? Dɛn pipul we bad sɛf, lɛk dɛn wan we lɛk dɛn?
[33]If una du gud to dɛn pipul nɔmɔ we de du una gud, wetin du una fɔ gɛ prez fɔ dat? Dɛn bad pipul sɛf de du dat.
[34]If una de lɛn dɛn wan we una no se go pe una, wetin du una fɔ gɛt prez fɔ dat? Dɛn bad pipul sɛf de lɛn dɛn kɔmpin bikɔs dɛn abop se dɛn go gɛt wetin dɛn lɛn, bak?
[35]Una fɔ lɛk dɛn wan we nɔ lɛk una ɛn du dɛn gud. Wɛn una de lɛn pɔsin sɔntin, una nɔ fɔ abop se I go gi una bak; da tɛm de una go gɛt big blɛsin fɔ dat ɛn una go bi Gɔd we pas ɔl, In pikin dɛn. Gɔd gud to pɔsin we nɔ de tɛl tɛnki ɛn to pɔsin we wiked.
[36]Una fɔ sɔri fɔ pipul lɛkɛ aw una Papa Gɔd de sɔri fɔ ɔlman.

Una nɔ Jɔj

[37]Una nɔ jɔj ɔda pipul ɛn Gɔd Insɛf nɔ go jɔ juna. Una nɔ kɔndɛm ɔda pipul ɛn Gɔd Insɛf nɔ go kɔndɛm una. Una padin ɔda pipul ɛn Gɔd Insɛf go padin una.

[38]Una gi ɛn Gɔd Insɛf go gi una, ɛn dɛn tin we I gi una, go so plɛnti, i go jɛs tan lɛkɛ wɛn dɛn ful kitul wit sɔntin, dɛn prɛs am, dɛn shek am ɛn I rɔnoba. If una gi plɛnti, Gɔd go ti una plɛnti; if una nɔ gi plɛnti, Gɔd nɔ go gi una plɛnti.

[39]Jizɔs pul wan parebul, I se: "Blɛnyay pɔsin nɔ go ebul sho in kɔmpin rod, dɛn ɔl tu go fɔdɔm insay gɔta.

[40]Anybody wa da laan ain't mo betta den de one wa da laan um. Bot anybody wa laan good ebryting wa a fa laan, e gwine kno all, jes like de one wa laan um.

[41]Wa make oona see de leetle splinta ob wood een oona broda eye, bot oona ain't pay no mind ta de big log een oona own eye.

[42]How oona gwine tell oona broda say, 'Broda, leh me take dat leetle splinta out you eye,' wen oona ain't eben pay no mind da de big log een oona own eye? Oona hypicrit! Fus mus take de big log out ob oona own eye. Den oona kin see plain fa take dat leetle splinta out oona broda eye.

De Tree en E Fruit

[43]A tree wa da good ain't beah no bad fruit. An a tree wa ain't a gro good ain't beah no good fruit.

[44]Oona gwine kno ef de tree good o ef e ain't good by de fruit wa he beah. Oona ain't gwine geda fig from de briah patch. An oona ain't gwine pick grape from a bramble bush.

[45]De same way a good poson da do good cause he habe plenty good ting een e haat. An a bad poson da do bad cause he habe plenty bad ting eeen e haat. Da wod wa come out oona mout come from all dem ting wa pile op een oona haat, wa oona da study bout all de time.

De Wise Man an de Food Man

[46]"Oona ain't do wa A tell oona fa do, so hoccome oona da call me, 'Lawd, Lawd'?

[47]Anybody wa come ta me an yeh me wod an do wa A tell um, A gwine sho oona haw e stan.

[48]E stan jes like a man wa da build a house. E dig way down een de groun til e find de rock an lay de foundation on top ob dat rock. Wen de flood come, a whole heap ob wata hit dat house, bot de house ain't moobe. Nottin happen ta um, cause de man done build um on de rock.

[49]Bot anybody wa yeh me wod an ain't do wa A tell um fa do, stan jes like a man wa build e house on top ob de groun. E ain't dig down fa lay de foundation. Soon as de flood hit dat house, e fall down. Bam! E smash op!"

[1]The Sea Island Translation and Literary Team note: "The writing of Gullah in this translation has been deliberately adjusted toward the English alphabet and spelling system. At the same time, it retains the grammatical features of present-day Sea Island language structure, as well as the writing of the most prominent phonemic features."

⁴⁰The disciple is not above his master: but everyone that is perfect shall be as his master.

⁴¹And why beholdest thou the mote that is in thy brother's eye, but perceivest not the beam that is in thine own eye?

⁴²Either how canst thou say to thy brother, Brother, let me pull out the mote that is in thine eye, when thou thyself beholdest not the beam that is in thine own eye? Thou hypocrite, cast out first the beam out of thine own eye, and then shalt thou see clearly to pull out the mote that is in thy brother's eye.

⁴³For a good tree bringeth not forth corrupt fruit; neither doth a corrupt tree bring forth good fruit.

⁴⁴For every tree is known by his own fruit. For of thorns men do not gather figs, nor of a bramble bush gather they grapes.

⁴⁵A good man out of the good treasure of his heart bringeth forth that which is good; and an evil man out of the evil treasure of his heart bringeth forth that which is evil: for the abundance of the heart his mouth speaketh.

⁴⁶And why call ye me, Lord, Lord, and do not the things which I say.

⁴⁷Whosoever cometh to me, and heareth my sayings, and doeth them, I will shew you to whom he is like:

⁴⁸He is like a man which built a house, and digged deep, and laid the foundation on a rock: and when the flood arose, the stream beat vehemently upon that house, and could not shake it: for it was founded upon a rock.

⁴⁹But he that heareth, and doeth not, is like a man that without a foundation built a house upon the earth; against which the stream did beat vehemently, and immediately it fell; and the ruin of that house was great.

⁴⁰Pɔsin we de lan nɔ pas di wan we de lan am, bɔt ɛnibɔdi we lan ɔl wetin I fɔ lan, gud, go sabi lɛkɛ di pɔsin we lan am.

⁴¹Wetin mek yu de si smɔl tik we fiba lɛkɛ di wan we de go insay pɔsin finga na yu kɔmpin in yay, bɔt uy nɔ de si da big tik we fiba bod we dɛn de tek bil os na yu yon yay?

⁴²Aw yu go tɛl yu kɔmpin se, 'Padi, kam mek a pul da smɔl tik de na yu yay' we yusɛf nɔ de si di big tik na yu yon yay? Yu ipokrit? Go pul di big tik we de na yu yon yay fɔs, so dat yu go ebul si klia wan fɔ pul di smɔl tik we de na yu kɔmpin in yay.

Wan Tik ɛn di Tin we I Bia

⁴³Gud tik nɔ de bia bad tin fɔ it ɛn tik we nɔ gud nɔ de bia gud tin fɔ it.
⁴⁴Yu go no if tik gud ɔ I nɔ gud bay di tin we I de bia. Pɔsin nɔ go pik fig pan tik we gɛt chukchuk, ɛn pɔsin n, go pik grep pan bush we gɛt chukchuk.
⁴⁵Gud pɔsin de du gud bikɔs gud de na in at ɛn bad pɔsin de du bad bikɔs na bad ful na in at. Wetin de na pɔsin in at, we I de mɛmba ɔltɛm, na in de kɔmɔt na in mɔt.

Sɛnsman ɛn Fulman

⁴⁶Wetin mek una de kɔl Mi 'Masta, Masta', bɔt una n, de du wetin A tɛl una?

⁴⁷ɛnibɔdi we kam to Mi ɛn yɛri Mi wɔd ɛn du wetin A tɛl am, tan lɛkɛ di pɔsin we A de kam tɛl una bɔt naw.

⁴⁸I tan lɛkɛ pɔsin we de bil os. I dig di grɔn go dɔng dɔng ɛn le di fawndeshɔn pan akpata bifo I begin bil. Plɛnti, plɛnti wata kam ɔp te I rich di os, agbara bɔs pan di os, bɔt natin nɔ du di os bikɔs dɛn bin bil di os gud.

⁴⁹Bɔt di pɔsin we yɛri Mi w,d ɛn I nɔ du wetin A tɛl am fɔ du, tan lɛkɛ wan man we bil in os, I nɔ le fawn deshɔn; I nɔ b,da fɔ dig bifo I begin bil. Wɛn plɛnti, plɛnti wata kam ɔp te I rich di os ɛn agbara bɔs pan di os, di os fɔdɔm ɛn brok patapata!

²A phonemic orthography version of the Beatitudes in the Krio Language of Sierra Leone. Translation prepared under the supervision of Lutheran Bible Translators, Inc.

The Inspiration of Gullah Culture

*Jonathan Green**

My community in the late 1950's and early 1960's constituted a small closely knit rural African American settlement of people referred to in South Carolina as Gullahs. My community, which was near the sea islands, was nestled among the inland marshes. It was in many ways more isolated than the sea islands and the community was quite self-sufficient as well as interdependent.

Farming, hunting, fishing and raising farm animals was common in all families. The community shared with one another, often through barter. My grandmother would feed anyone who came, often farm laborers and people from the community who were experiencing hardship. Her home served as the community hub as she was a lay minister in the local church. She practiced many of the oral traditions passed down through the generations and shared folk tales with eager listeners.

Religious life was a strong part of the community. Historical traditions brought from Africa (Angola) such as dream interpretation and sharing spiritual folk tales were very important. Many of the children, including myself, were expected to meditate for several days and share their dreams with the elders before being baptized in the church. It was only through the interpretation of the dreams that one was determined ready for baptism.

The community had a set of customs and mores that guided social behavior. The church was central to the social activities of community life, such as baptism, marriages, funerals and worship. It was the sense of community that I experienced through the church, my grandmother and subsequently my mother that instilled in me a deep belief in the value of self, life and others — a value that I hope continues to be revealed and communicated through my art, a value that reflects that all people have purpose and meaning, and should always be treated with dignity and respect.

* For biographical information on Jonathan Green, see "De Ones Ya'll Kno' 'Bout: We Faymus Peepol an We Ancestas."

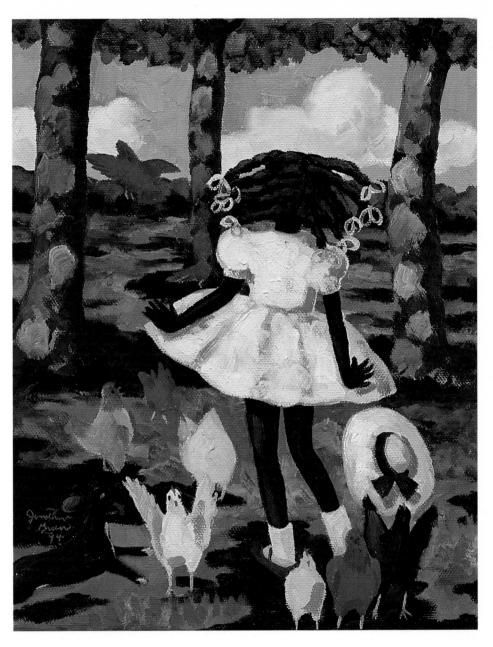

Before Sunday School, 1994
Oil on Canvas, 10" x 8"
Jonathan Green - Naples, Florida
Courtesy of Paul Langston, Photograph by Tim Stamm

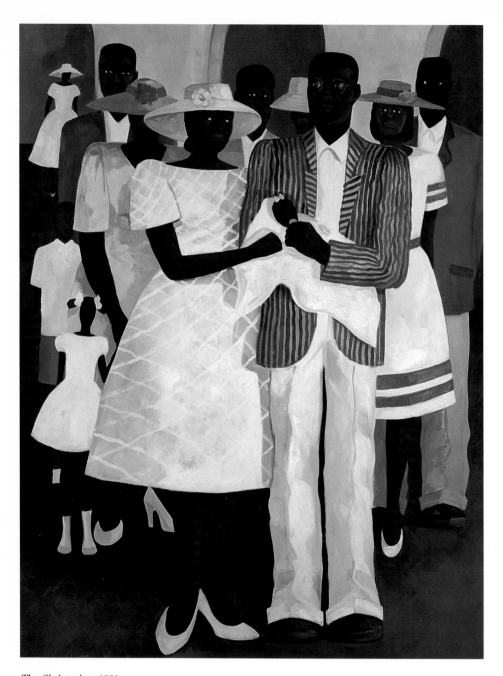

The Christening, 1991
Oil on Canvas, 52" x 34"
Jonathan Green - Naples, Florida
Courtesy of the Greenville County Museum of Art, Photograph by Tim Stamm

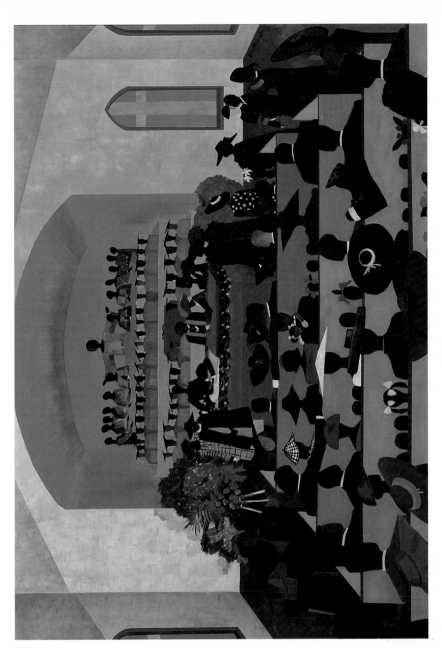

The Passing of Eloise, 1988 Jonathan Green, Naples, Florida
Oil on Masonite, 36" x 48"
Courtesy of Julia J. Norrell, Photograph by Tim Stamm

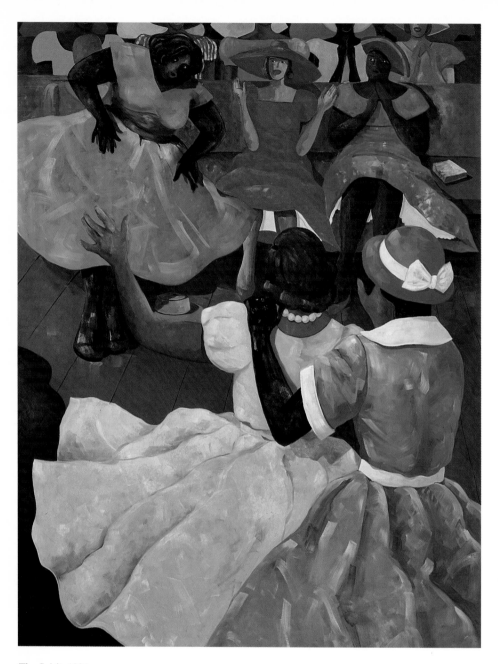

The Spirit, 1994
Oil on Canvas, 72" x 55"
Jonathan Green - Naples, Florida
Courtesy of Jill Farwell, Photograph by Tim Stamm

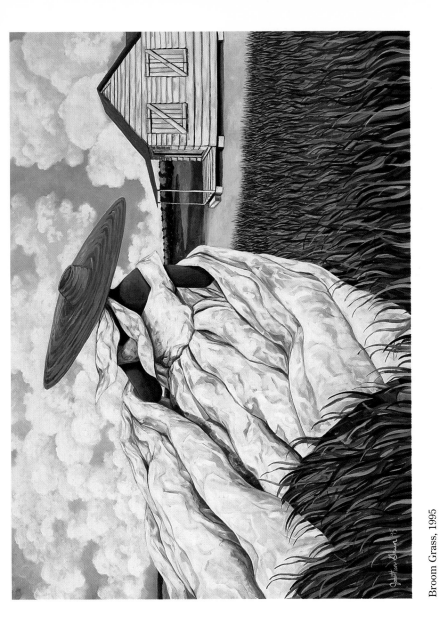

Broom Grass, 1995
Oil on Canvas, 48" x 60"
Jonathan Green, Naples, Florida
Courtesy of Allison Powe, Photograph by Tim Stamm

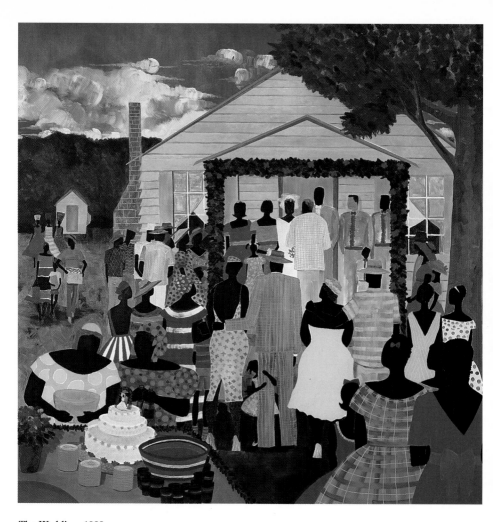

The Wedding, 1988
Oil on Masonite, 48" x 48"
Jonathan Green - Naples, Florida
Private Collection, Photograph by Tim Stamm

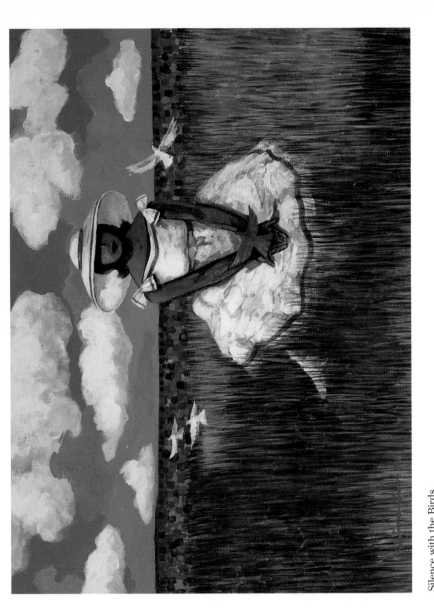

Silence with the Birds
Acrylic on Canvas, 16" x 20"
Jonathan Green - Naples, Florida
Courtesy of Richard Weedman, Photograph by Tim Stamm

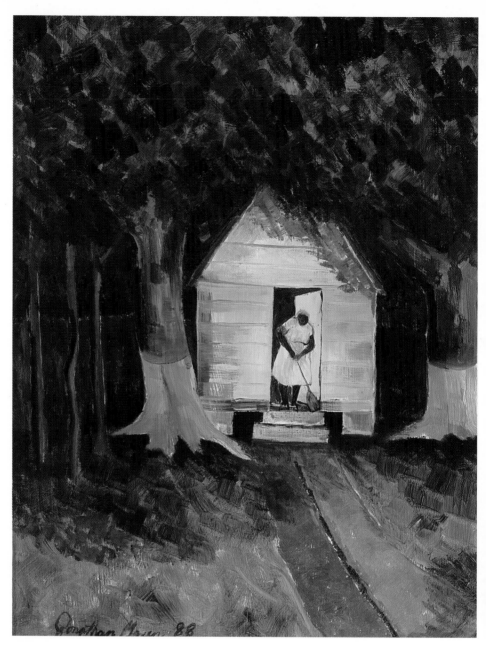

Praise House, 1988
Oil on Masonite, 14" x 11"
Jonathan Green - Naples, Florida
Courtesy of Sam Reed, Photograph by Tim Stamm

to prepare a way[*]

Ihsan Bracy

for alex

> *-herman!*
> *-hey you herman!*
> *-where is that boy?*
> *-herman! i say herman! you hear me?*
> *-herman! you hear me calling you boy?*
> *-herman!*

> *-ma'am? coming ma'am. yes ma 'am?*

called the sandy red haired boy as he ran up to the porch dressed in faded patched overalls, pieces of dried grass sticking to the back of his plaid work shirt. the color of his hair matched the color of the dust flying up behind him as well as the color of the setting sun. he had been playing with one of his younger brothers, hiding under a pile of wood in the shed out back of the house when he heard his mama's call.

> *-boy, walk your grandma home.*

> *-yes ma'am.*

> *-and don't stop to pick no blackberries!*

> *-no ma'am.*

> *-snakes get you up in there after dark.*

it was nearing dusk. the moon hadn't yet risen over the country road. the boy, who was nearly ten, took his grandmother's arm as they started down the steps of the porch. the boy always looked forward to this walk. he enjoyed any time spent away from the constant chores of the

[*] Reprinted from *ibo landing* by Ihsan Bracy, Cool Grove Press, 1998. More about *ibo landing* on website http://www.coolgrove.com

farm. he loved to explore, his favorite activity. he knew most of the county like the back of his hand.

his grandmother shook herself free of him as they started down the path that ran near the mill brook. although she was nearly ten times his age, he still was hard pressed to keep up with her determined step as she allowed her stride to open up. he fell in behind her. as they approached the little foot-bridge that crossed over the brook his grandmother remarked how low and still the water was for this time of year. the path then took them through the clump of woods where the blackberries grew buckwild. they were so ripe the boy could smell them. he had gotten sick more than a few times, unable to tear himself away from the sweetness of nature's charms. he looked out for snakes. the path took them past the old church grounds and the old graveyard where his grandfather and his grandmother's other husband were both buried.

the moon was beginning to rise. as it began to grow darker the boy had no fear of the return trip for he had practically grown up in these woods. there was little he didn't know about them. by the time they reached the fork in the road, the moon had barely risen above the edge of the trees.

this was a familiar walk to his grandmother's cabin. she had lived way back, out in the bosom of the woods for as long as he had known her. the family had tried to get her to move in with one of her children or grandchildren after her last husband had died. lord knows she had enough family, but she had been adamant in her determination to remain in her little cabin in the woods. she refused to be a burden to anyone, she had argued. besides, she didn't have a need to see them everyday. so when his grandmother came to visit two or three times a week, he always walked her back home. his brothers would complain if asked, but he enjoyed these walks and their talks. his grandmother would sometimes walk for miles without saying a word, then she might make one small comment which would have him thinking for the rest of the week. there were times when she could be so quiet, then there were times when she would be so full of stories that they would already be at her cabin and he nearly back home before he stopped laughing. he looked forward to these times. it gave him a sense of closeness, being alone with his grandmother and he loved not sharing her with all of his brothers and sisters. he had no way of knowing how meaningful these walks were to her.

-tell herman to come on and walk his poor granny home.

-that boy will be the death of me yet, his mother would complain.

-don't be so hard on my baby, now. he ain't nothing but a child.

-hard. i need to crack his behind more often.

-you leave my baby alone now.

-leave him alone? humff! that's what's wrong with him now.

-he's my baby.

-and you can have him.

-that boy gonna be the flowering of your old age.

-if he ain't the death of me. gonna put me in my grave.

-that boy got the sight.

-he got the devil in him, that's for sure.

-i'clare, he mind me of my virgil, that's for sure, when he was 'round about that age. he was that way, strong-willed, followed his own mind,

she would laugh, remembering.

-got his behind whipped more than a few times too. herman strong like him too. and the boy got the gift. i known it from time i first held him in my arms.

she was referring to the mark, the white tuff of hair at the top of his head that had been there at birth. the mark moved down through one eyebrow and would eventually pass through the mustache and beard that he would one day grow. she could see in him evidence of signs she had first recognized in herself. signs she had looked for, in vain, in every child and grandchild that had been presented to her until she had nearly given up. she had finally found satisfaction in the strong brown eyes of the sandy red haired bundle she had been handed on that cold november night. it was after she heard the first cry of this her

seventh grandchild that she had looked out the window to see the disappearing moon. the fact that he had been born during a total eclipse of the full moon only confirmed the signs dreamt of and the ones she had already witnessed in his eyes.

this night, as they approached the bend in the road that signalled the beginning of his grandmother's land, he heard a strange sound coming towards them. a creaking kind of sound, at first, something that sounded like a wagon wheel needing oiling. then the clump clump clumping of a mule drawn wagon ahead. he looked around but could see nothing. he strained his eyes and ears in the direction of the oncoming wagon, but still he could see only the darkness surrounding them. he wondered how it was even possible for a mule drawn wagon to come down this road anyway. at one time this had been a major thoroughfare, but now it was no more than just an overgrown pathway. it didn't connect anywhere, not with a road or anything. the sounds grew louder. he looked at his grandmother's back, but she continued to walk at her brisk pace, seeming to notice nothing. she had been relatively quiet this night. he didn't like to disturb her when she was in one of her moods. finally, as they reached the last turn in the path, the sound, which had grown louder by this time, came to a sudden halt.

-move over herman. let the wagon pass.

-ma'am?

herman looked again, but all he could see was the enveloping darkness in front of him and the shadows that his grandmother and he cast upon the road from the moon rising behind them.

-ma'am?

he repeated again, afraid that he had heard correctly.

-didn't you hear me, boy? move out the way so the wagon can pass.

herman looked, but could see nothing.

-what wagon? grandma? i don't see anything.

-that's cause you don't know how to look. besides you don't have to see anything, just move.

the boy peered into the approaching night, beginning to think for the first time that the things he had heard about his grandmother's strangeness and her spirit were true.

-chile, just come on over here and stand next to me.

he was still standing in the middle of the road. gently she grabbed his arm and pulled him off to the shoulder. as she did he could hear the creaking of the wheels slowly begin again. the clump, clump, clumping of a mule passed so close he could feel the breath of the mule hot on his face. as the sounds passed he noticed his grandmother slightly nod her head. eyes down into the nothingness of the night she gave a small smile and a quiet

-how do.

just as he was beginning to think that she was losing her mind he noticed the set of tracks in the dust of the road. a perfectly matched set of wagon wheel tracks, like those he had seen many many times before, along with the hoof prints of a mule. except this time he had seen no wagon. he stared at the receding tracks, following them with his eyes, unbelievingly. as he watched they grew in the direction of the fading sound, keeping pace with the creaking which moved ever so slowly away and eventually out of earshot.

he looked at his grandmother. wonder, curiosity and uncertainty was written all across his face, but she took no notice. she had just about closed the remaining distance to the fence which sectioned off her yard from the surrounding woods. he turned and moved hesitantly into a broken run in his effort to catch up to her. he turned back occasionally to look over his shoulder as the sounds of the wagon receded. when he reached his grandmother, he said gently

-i don't understand.

she turned to look at the bewildered boy in front of her.

-ain't nothing to understand.

standing there in his patched overalls in the darkening night in the

red dust of the georgia road with that look on his face she remembered her virgil.

the moon had finally risen, breaking through the two little clouds which had held back his brilliance. upon making his appearance the wooded night was lit up by the splendor of his presence.

-what did you see?

the boy looked at the wrinkled face of his grandmother, realizing for the first time what a beauty she was and must have been. it was as if the moonlight had brought out a beauty recessed for ages. it was as if he were really seeing her for the first time.

-i don't know. what happened?

-what did you *see? is more to point.*

it was hard for him to form the words because he wasn't exactly sure of what it was he had just witnessed.

-well, speak up boy. what did you see?

he shook his head. what had he seen?

-just some tracks that had not been there, and then they were.

- you must always look. not just with your eyes here,

she said, pointing to his head,

-but with the eyes of your soul.

-but there were tracks, i saw them. wagon tracks, and the sound of a mule, it was so close i could feel the heat of its breath...

his grandmother looked at him, pleased, in spite of herself.

-they just some of them that have gone on ahead, to prepare a way,

she said so softly under her breath that the boy could barely hear it.

she said nothing else as she walked into the front door of her cabin. she returned with a piece of rock candy for him.

-be careful with your gift.

he thought at the time that she had meant his candy. she held out her leathery chin. he kissed her before turning to start the journey home. he wasn't scared, exactly, but he had a lot to think about.

sucking on the rock candy as he passed the tracks, he stopped to examine them more closely. he stooped to touch them, they were real. it was then he ran all the way home.

december 1992

old man's sport[*]

Ihsan Bracy

for mustapha & jihad

daddy franklin could begin to see the stretch towards ninety-eight. when people would talk about his reaching the century mark he would smile but would say nothing. he knew he would never see a hundred. whenever asked the secret of his longevity his only answer was always,

-god don't want me, devil won't have me.

then he would laugh, his toothless gums sparkling in the daylight. he had heard the argument all his life. when he was younger it had been just a murmur. as he had gotten older it had slowly become louder and louder. finally he had been able to discern the separate voices and then finally the gist of the argument. he would smile,

-you only walk up this hill so far, and no more.

those who knew him well suspected it was the turtle soup.

-it's old man's sport,

he would say.

-turtles and me go along about at the same speed. a good match.

his great-grandsons would watch his figure fading slowly away up over the hill, growing smaller in the early morning light, leaning on his walking stick, empty canvas bag thrown over his shoulder. they would play all day, with one eye on the hill, waiting for him to return home, sometimes until dusk.

daddy enjoyed the battle. the battle with the turtles was a metaphysical event. they grew to know each other, he and the turtles, to understand the ways of one another. as he grew older they were evenly matched. each could prove a danger to the other.

[*] Reprinted from *ibo landing* by Ihsan Bracy, Cool Grove Press, 1998. More about *ibo landing* on website http://www.coolgrove.com

the turtles could hear him coming, and he could smell them. daddy would follow their traces through the valley between the blue mountains. an ancient valley, a swamp-like wilderness with overgrown woods reminiscent of prehistoric underbrush. he and the turtles moved at about the same speed. the turtles moved along as one slow herd. if daddy was too slow and allowed a leg to be caught between the ancient reptilian jaws it could prove fatal. he had seen what could be done to tree limbs he had used as walking sticks. it was here in the habitation of the turtles that the battles would be raged. after years of continued conflict, the adversaries had grown to respect and even love one another. there had developed a particular friendship with this one large male whom daddy named buster. buster was the undisputed leader of the turtle tribe, and had guided his clan to a successful flourishing in this swamp for more than fifty years. daddy had been beaten, out smarted, out flanked and out maneuvered on more than a few occasions. they had first battled some nearly forty years ago when daddy had first set foot into the primordial forest. in the course of the next forty years they found in each other not only worthy opponents but a lasting friendship. this friendship with buster had outlived all of his others. this had been solidified when finally they understood that they were able to communicate, able to read each other's thoughts. there had been that time last year when, after not seeing buster for nearly five years, he had come upon him, waiting. he hadn't even retreated into his shell. he seemed as happy to see him as daddy was. they had sat there, facing one another, like old friends visiting until near dark. buster had been the first to turn and head for home.

by then daddy had more than a hunter's interest in turtles or really turtle soup.

-*mable. hey you mable!*

-*what is it daddy?*

-*mable. hey you mable!*

-*comm' daddy, what is it?*

-*mable, hey you mable!*

-*yeah daddy? what you want?*

-mable, hey you mable, girl cook me up this chere turtle i done caught chere. i gots my mouth worked up for some turtle soup, do lord. got my mouth a fixed up to tasting some of your turtle soup.

-you want turtle soup now, papa? you know what time it is? you know how long it gonna take to cook.

-mable, hey you mable, gets that water boiling now, cause you know i wants turtle soup tonight. i gots plans for evening.

-plans? what sort of plans?

-none of your never mind what sort of plans, just cook up this chere turtle. whew, so heavy, i couldn't even bring back the shell. there was a time...

-you better leave them big old heavy shells just where they is, old as you are.

-woman, don't you be all the time worrying about me, look to your own self. i ain't no chile to be coddled to.

-everybody can see that daddy, you old coon.

the great-grandsons would watch in disgust as he set the sack of turtle innards on the table in the dining room.

-i'll cook it, but i don't want to clean it. don't put it on the table, daddy!

the great grandsons would clear the kitchen and retreat to the doorways before he could open up the canvas sack oozing the brownish green turtle blood. one of the great-grandsons would be dispatched to get some newspaper, one to get some water from the well, one for daddy's hunting knife and another for the big black cooking pan from under the oven. the great-grandsons would escape into the evening of fireflies and leave the postmortem to daddy and big mama.

-can't understand why you gotta have turtle soup tonight. ain't gonna be ready no time soon.

-mable, hey you mable, stop all that fussin, you hear? just fix me my soup.

-i am papa.

mable, his daughter, mother of thirteen, eleven living, big mama to all the nearly forty some odd grandchildren, would grumble and fuss some. she would complain of the lateness of the hour, or the trouble and the mess, but she was a good daughter. she loved and always obeyed her father and he in turn loved and cherished her.

-i have places to go.

-i can't hurry it up anymore than i can, daddy. it's gotta cook. lessin' you want it raw? you know that turtle wild as it wanna be, so you just should let it cook slow.

daddy franklin knew he would be busy until the early hours of the morning, and he was anxious for the night to begin. he would need all his strength. it was not easy to totally satisfy a woman with needs like rita, and he had every intention of doing so. he had been a widower at a young age. it didn't take long for him to realize how many widow women there were around in need. didn't seem to make too much sense in marrying again, considering he had curtailed his goings on as age had determined and demanded. he was down to only one night a week, saturday night. oh how he did live for blessed saturday night and the lips of sweet sweet rita. why not?

-he had a young dark honey,

he would confide to his great-grandsons,

-and she has a powerful need.

then he would wink, as he sat down to finish two full bowls of piping hot turtle soup.

-keep you going through the night,

he would say between mouthfuls, winking down at the soup.

rita wouldn't be eighty-seven until the beginning of the next year. shit...she still had her looks. rita had a great smile. in fact it had been her smile that had first attracted him. they had been in line at the supermarket when he had noticed her polygrip. instant love. his reply to questions concerning his continued virility and love making into his nineties was always the same,

-one doesn't live until your woman loses her teeth.

he would smile his toothless grin.

-give me a woman who puts her teeth in a jar every night. i got something for her!

he would laugh lewdly,

-she'll wake up in paradise each and every morning. when i see those teeth sitting up in that cup, boy i can feel something else sitting up, my passion rising.

-daddy, leave them children alone. they don't need to hear all that business here, no how.

-mable, hey you mable, go on now, this chere ain't none of your business no how. this chere is men's talk.

his great-grandsons would feel proud and important, they would sit up listening more intently, more like men.

the great-grandsons would stand around the table and watch daddy eat the turtle soup. they were mesmerized with horror. they would stand in the doorways to assure the turtle soup didn't come anywhere near them. they were repulsed by the reptile meat floating in its greenish brown broth. daddy would offer some of it to each of his great-grandsons ceremonially. he would howl with laughter as they each refused it and would turn up their noses and run.

after supper he would bathe in the big round tub in the kitchen. one of his great-grandsons would soap his back while another would pour the water to rinse. he would dress in his best summer suit, best dress shoes, with straw hat or in colder months his gray-blue pinstripe with dark hat, cocked to the side, bow tie, handkerchief, suspenders and mahogany walking stick.

-looking right sharp there, mr. franklin,

big mama would admire as he strolled toward the steps of the front porch. the cab driver would open the door for him.

-mable, hey you mable, don't wait up for me you hear?

he would say from the window before the cab rolled off down the hill.

-yes, daddy. i won't latch the screen door. i'll leave the porch light on.

they would watch the dust rise behind the cab as it disappeared down the hill. big mama would awaken many a morning to turn the porch light off herself, the sun having risen with no sign of benjamin franklin in sight. usually it was after dawn when she would hear his staggering steps trying to negotiate the front door. the cab driver would be holding him up, trying to shove the money daddy had taken out back into daddy's wallet, relieved that big mama had come out so that he could leave it all in her hands. then of course there was his singing, loudly, that could awaken the dead. the great-grandsons would slowly appear sleepily from upstairs to witness the return of the conquering hero. daddy would be in great spirits, his clothes every which way, suspenders on backwards, sometimes his pants.

-honestly, daddy!

-what woman?

he would ask,

-what? respect your elders,

he would admonish before he would break into song.

-really, and at your age. you ought to know better.

-i was better,

he would laugh heartily,

-and what's age got to do with it? everything still works. rita can attest to that. i gotta witness,

he would laugh,

-i got a witness!

he would confide to his great-grandsons that he would fill them in on all the sticky details as soon as this woman would let him alone.

-y'all go on and get on back in the bed.

-just not as often as i would like,

he would continue,

-but it worked tonight, do jesus! didn't miss a stroke. lover man. called me her special lover man. mable, hey you mable, you hear that?

-i don't wanna be hearing all that now papa. just go on to bed. you ought to be getting up and going to church with me, lover man,

big mama would admonish, halfheartedly. she tried to suppress the laughter growing inside in spite of herself as she pulled off his shoes and put daddy to bed.

-woman, i don't need to go to no church. i just got back from praying. lord, i done found me religion, and her name is rita! and don't be waking me up this morning none. this morning i'm sleeping in late.

he would sing again as he drifted off to sleep.

-if he ain't saved my soul by now, he don't want it,

he would mumble as he fell off to sleep, the sound of the eternal argument for his soul running through his head.

-never too late...

she would begin. he would be snoring before she reached the steps.

daddy was always at breakfast though, with a huge appetite. daddy truly loved to eat. he enjoyed sunday morning breakfast the most. breakfast was always a huge affair. cold or hot cereal, biscuits, fresh home made hot apple sauce, pancakes, bacon, sausage, scrambled eggs, country ham, last night's chicken or roast, fresh fried fish, grits, home fried potatoes, the ever present cucumber and tomato in vinegar, and what ever else big mama had a taste for. there would be daddy, the first one at the table, negotiating the fried corn with no teeth. daddy

was able to eat anything. he hadn't had a tooth in his head in over fifty years. those weathered gums would prove a match to any set of dentures.

there were only two times a day when the entire family sat down together, at breakfast and at supper. for lunch, dinner as it was called, you were on your own. it was always at or right after breakfast that daddy terrorized the little children with offers of vanilla milk from his withered right nipple or chocolate from the withered left that peaked out from behind little wisps of silver white hairs which stood standing straight out from his ancient chest. great-grandsons would scream and scatter in an attempt to escape the forced feeding. daddy would stand and laugh and laugh and laugh. big mama would just shake her head.

daddy would spend the remainder of his week in anticipation of his saturday night pursuits. his daily activity consisted of sitting on the porch watching the tracks the sun had made, watching the fruit trees ripen, or the rains. he admitted watching the endless trains traveling endless distances at full throttle across and out of his field of vision, wishing upon them, sending his magic all across the land as he had done for nearly a century.

without a doubt his driving weekday passion was the pity-pat games he would lure his great-grandsons into, as well as any unsuspecting victim who happened his way. he was a vicious pity-pat player. sitting, looking over his cards, studying the pairs of cards as they hit the table, studying the opposing players, chewing tobacco, spitting. he was crafty. if you were to have a chance at beating him you had to match his skill and wit. he would cheat and tell lewd jokes. cheat without hesitation, if you didn't watch. hell, he would cheat even if you did, and he enjoyed it. cheating was as much fun as playing. he enjoyed cheating and not getting caught. he enjoyed cheating when he did get caught. he enjoyed cheating and winning as he did everything else in life, fully, completely.

playing cards with his great-grandsons, who were his true joy, his crowning glory, gave him pleasure. the idea of great-grandsons pleased him. he taught them the important lessons of life, lessons that would stay with them the rest of their lives, lessons they would be richer for knowing. this was his legacy to them. this was their inheritance. it was here that he imparted the magic he had accumulated over a lifetime. he taught them the importance and the unimportance of the game, the sanctity of laughter, the enjoyment of one another and the value of the

moment, this, any, every moment. his love, his joy was infectious, and his progeny grew strong, nurtured by the twinkling in his eyes. they were the flowering of the tree, he was its root.

there was not a soul who had met daddy franklin who hadn't loved him. his was a great responsibility, to love and to be loved. it had been this way for ninety-seven years.

the image of daddy and his great-grandsons around him would remain. it had been this way since he had gone to live with his daughter after her husband died. they had been, daughter and father, good company for each other. in all the time they had lived together, had argued, fought and loved one another, they had come to understand each other and know each other's ways. each of them had been the comfort the other needed. together they had fought off father time, but even still the argument was drawing to a close. daddy knew he would never see a hundred.

finally, heaven and hell came to a compromise. suddenly, one day, the haggling came to an end, there was only silence. daddy sat up and took notice. it was a perfectly still tuesday morning in february. it was clear but cold. his daughter heard him call her from the front room. she ran from the kitchen. it was in the tone of his voice. she recognized death, and she knew immediately.

she ran as she hadn't since she had been a little girl, the wet dishtowel still in her hands.

-daddy?

he was stricken, pale, on the couch. he was holding his stomach, not quite able to catch his breath. he held out his hand to his only child and squeezed her arm tightly. he asked her for a glass of water so she would not witness his leaving. when she returned with the glass he was gone. the glass slipped quietly from her hand as she bent over the quiet prostrate figure of her father. she checked for breathing, but she knew. he was gone. he had left quietly, quickly, without fanfare or bother.

she sat in the chair across from him and rocked. this would be the last time they would get to spend together. she looked up at the pictures of her children and grandchildren, his grandchildren and great-grandchildren, which hung over the couch where her daddy lay. the debate between god and the devil finally settled. sitting there she

reconstructed for herself the chronology of his life. she had time to remember everything about him. time to give thanks for the blessing his life had been and the blessings his life had given. time to be comforted by the fact that she had been there when he left. time to be thankful that she had had this time to say goodbye. time to adjust to the weight of the family that had slipped so silently onto her shoulders, they were her's now. there had been no one to hold big mama when she had to say goodbye to daddy. she never did cry. there was no reason.

by the time her granddaughter found them, her goodbyes were complete. she wouldn't let any of them cry, not even at the funeral.

-hush,

she would say when any of them would begin.

-he lived a good and long life, to a ripe old age. he had a full and rewarding life. he lived fully the life he was given. he loved and was loved. he enjoyed life and that is all any of us can hope to do. don't dishonor him with your tears.

only one of his great-grandsons wondered about the turtles. it was he who had seen the huge turtle on the day of the funeral. right before they left the house. the turtle had come down the hill from the direction that daddy took on those saturday mornings. the turtle had come about halfway down the hill. he had come to pay his respects. he had stood there for a part of the day, as if to convince himself of the truth.

when the boy looked he was gone. only daddy could see the simple silent turtle tear that fell from the ancient eye.

december 1992

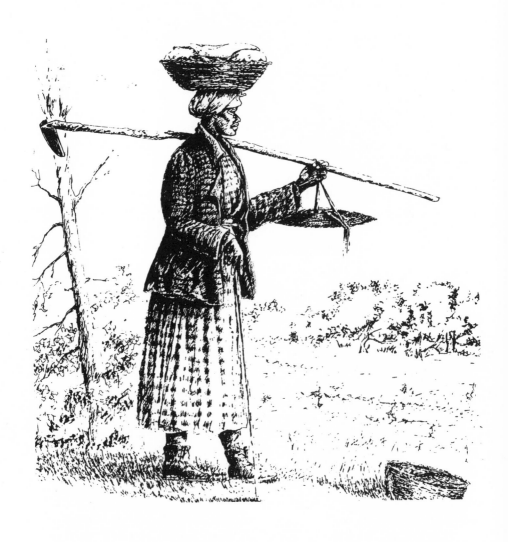

Gwine to the field by Joseph Pinckney. "She was going to work in the field, farming, so she was going to take the long-handled hoe which was created by the Gullah themselves, so that they did not have to bend over too far." *Joseph Pinckney*

A Gullah Folk Tale

translated by Virginia Geraty

Mistuh Adam en' Mis' Ebe

Fus' gwinin' off, de Lawd mek Mistuh Adam en' 'E sen'um fuh lib een de Gyaa'd'n ub Ed'n. 'E tell 'um 'e kin peruse da gaa'd'n en' 'e kin nyam de bu'd aig en' de breshberry en' t'ing. 'E kin pledjuh 'ese'f 'cep'n fuh one t'ing. 'E mus' ent fool wid de apple tree. 'E stan' so! Bimebye de Lawd wisit Mistuh Adam fuh quizzit'um en' fuh ax'um how 'e duh mek out. Mistah Adam suh 'e he'lt' sawtuh po'ly. 'E lonesome tuh dat.

Berrywellden, de Lawd mek Mis' Ebe fuh cump'ny wid'um. 'E tell Mis' Ebe mus' pledjuh 'ese'f, en' nyam de berry en' sparruhgrass en't'ing. Den 'E tell all two 'sponsubble, "Mus' ent fool wid dat apply tree!"

Mistuh Saa'punt yeddy dis en' 'e sweet'n'um tummuch. 'E staa't tuhreckly fuh study 'e head. Him bin berry big fr'en' wid Mistuh Debble. Ef him kin 'suade Mis' Ebe eeduhso Mistuh Adam fuh nyam de apple, Mistah Debble gwi' t'ink him bin uh berry soonman fuh true. Den him gwi' git eenbite tuh Mistuh Debble paa'ty wid de fancy 'ooman en' de fancy bittle, alltwo.

Adam and Eve

In the beginning, the Lord made Adam and sent him to live in the Garden of Eden. He told him that he was free to go anywhere and do anything he wanted to do in the garden, eat the bird's eggs, the berries from the bushes and other things. He could enjoy himself except for one thing—he must not touch the apple tree. This was the way that it had to be.

Some time later, the Lord visited Adam to find out how he was getting along. Adam said that he wasn't feeling very well because he was very lonesome.

So the Lord made Eve for his companion. He told Eve that she could enjoy herself, eat the berries, asparagus and things. Then He told both of them, emphatically, that they must not touch the apple tree.

The serpent heard this, and it made him very happy. He started immediately to make plans. He and the devil were very friendly. If he could persuade Eve or Adam to eat an apple, the devil would think that he was a very smart man. Then he would get invited to the devil's parties with the fancy women and the fancy food.

Mis' Ebe cabawt t'ru de gyaa'd'n staa't nakit. 'E run en' 'e jump. 'E nyam de bu'd aig en' de berry en' t'ing. Sametime, 'e min' run on dat apple, en' 'e yent sattify. 'E boun' fuh tas'e'um.

Mistuh Saa'punt bin uh berry schemy man. 'E folluh Mis' Ebe en' study 'pun plan fuh mek Mis' Ebe nyam de apple.

One mawnin', fo' dayclean, Mistuh Saa'punt gone en' t'row 'he yeye een de apple tree. 'E chuse de apple wut heng low tuh de groun'. 'E spit 'puntop um, den wrop 'esese'f 'roun' um fuh shin' um. Den 'e wrop 'ese'f roun' de lim' en' leh 'e tail heng down fuh mek Mis Ebe' fast'n 'e yeye 'puntop'um.

Bimebye Mis' Ebe peruse 'long de paat', den 'e 'membuh de apple tree, en' 'e tek 'e foot een 'e han' en' lean fuh de apple tree. Mistuh Saa'punt shum en' 'e staa't fuh hiss en' twis' 'e tail. Mis Ebe yeddy dis en' 'e figguh Mistuh Saa'punt een trubble, en' 'e gwine fuh he'p 'um. 'E quizzit Mistuh Saa'punt. Dis sweet'n Mistuh Saa'punt sence 'e bin plan fuh hol' compuhshashun 'long'um. Mis' Ebe IZ 'ooman, enty? 'E tell Mis' Ebe t'enghky, en' 'e feel fine dis mawnin'. De smell ub de apple mek 'um hiss an' twis'. Mis' Ebe done fuh hankuh attuh dat apple tummuch. 'E tell Mistuh Saa'punt mus' fling'um down. Mistuh Saa'punt suh 'e yent hab han' fuh fling, 'e mus' climb up en'

Eve played through the garden stark naked. She ran and she jumped, she ate bird's eggs and berries and things. At the same time, she was thinking about the apple tree, and she wasn't satisfied. She wanted to eat an apple.

The serpent was a very devious man. He followed Eve and made plans to entice Eve to eat an apple.

One morning before daybreak, the serpent went to the apple tree. He chose an apple that was on a low branch near the ground, spit on it and wrapped himself around it to shine it. Then, he wrapped himself around the limb and let his tail hang down to attract Eve's attention.

After a while, Eve came walking leisurely along the path. Then she remembered the apples, and she ran toward the apple tree.

The serpent saw her coming and he started to hiss and twist his tail. Eve heard this and, thinking the serpent was in trouble, went to help him. She questioned the serpent. This made the serpent very happy because this fit into his plan to get Eve into a conversation. Eve IS a woman isn't she? He thanked Eve and told her that he felt fine this morning. The smell of the apple made him hiss and twist. Eve wanted very much to have an apple. She told the serpent to throw one down. The serpent told her that since he didn't have hands to throw the apple down,

tas'e 'e mout'. Mis' Ebe climb up en' bite de apple. 'E stan' so good, 'e mek 'e jaw fuh leak! Mis' Ebe so tek wid'um, 'e mek'ace tuh Mistuh Adam fuh shayre'um.

Sca'cely Mistuh Adam set 'e teet' een dat apple w'en de light'n flash, en' de t'unduh roll. Den de Lawd come ridin' up 'puntop uh daa'k cloud. Mis' Ebe en' Mistuh Adam mos' skay-to-de't'. Dey mek demse'f skace en' mek'ace en' graff leabe en' t'ing fuh kibbuh dem nakit se'f. De Lawd bin berry bex. 'E scol' Mistuh Adam en' Mis' Ebe en' 'E tell 'um dey ent wut' 'E haa'd-head tuh dat!

De Lawd su sence 'e cyan' specifiy, 'e haffuh lef' de gyaa'd'n. Mo 'nuh dat, 'e haffuh wu'k fuh 'e bittle, en' de sunhot gwi' 'cawth 'e hid. Wussuh, de maa'sh skeetuh, de san'fly, en' de wawss gwi'jook dem jabl'n een'um, en' de bu'd, waa'ment en' wurrum gwi' nyam 'e crop. 'E stan' so!

De de Lawd scol' Mistuh Saa'punt fuh projic' up wid Him own wu'll'. 'E tell Mistuh Saa'punt 'e mus' gone spang tuh Hell! Dis sweet'n Mistuh Saa'punt, en' 'e min' run on Mistuh Debble paa'ty wid de fancy 'ooman en' de fancy bittle, alltwo. Berrywellden!!

Mistuh Adam en' Mis' Ebe heng dem head en' tek de road. Mistuh Saa'punt pick up 'e belly en' lean fuh Hell. De sun lean fuh down, en Gawd t'row Him shadduh obuh de eart'.

she would have to climb up and get one. Eve climbed the tree and bit into an apple. It was so good that she hurried to Adam to share it with him.

Hardly had Adam put his teeth into the apple, when the lightning flashed and the thunder rolled. The Lord came riding up on a dark cloud. Eve and Adam were very afraid. They ran and hid, and got leaves and things to cover their nakedness. The Lord was very angry. He scolded Adam and Eve, telling them that they were worthless and hard-headed.

The Lord said that, since they didn't obey him, they had to leave the garden. Also, they would have to work for their food and the heat of the sun would burn their skin. The mosquitos, the sand flies and the wasps would torment them, and the birds, the animals and the worms would destroy their crops. This is the way it would have to be.

Then the Lord scolded the serpent for interfering with His plans. He told the serpent that he had to go to Hell. This made the serpent very happy as he began to think of the devil's parties with the fancy women and the fancy food. This suited him very well.

Adam and Eve, sadly, left the garden. The serpent joyfully headed for Hell. The sun went down and darkness fell over the earth.

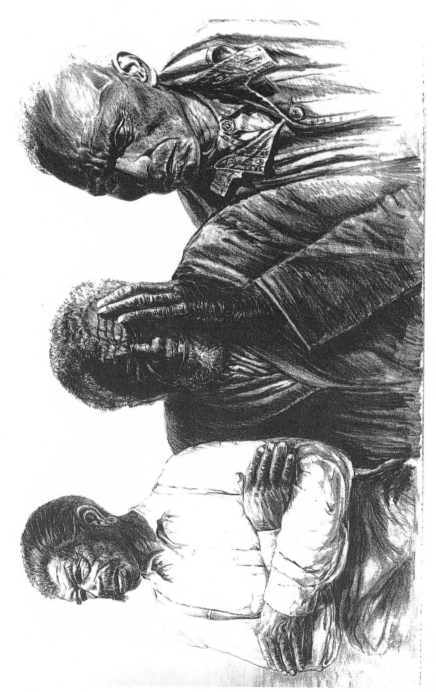

Perseverance.
Joseph Pinckney

About Hard Work & *Perseverance*

Joseph Pinckney

The picture *Perseverance* (left) was drawn was to show different men who had been responsible for providing for their families. Think of the first man with his arms folded as a teacher, the second man as a farmer, and the third, what we call a "creek man," who lived off what he could harvest from the creek. He also would have been responsible for fur trapping for muskrat, racoons, wild mink and sea otter. He would catch alligators as well. They would clean those hides, stretch them, and send them to Savannah to be sold. At that time, the man responsible for that freight was Charlie Simmons, who is still living today, in his nineties. He had a boat by the name of *Edgar Hearst*. He would bring the money back to share it with those who shipped the materials.

They were called "isolated" because they were extremely independent. It was said that they were living by barter, but this wasn't the case. To prove that they did nòt live by barter: they had an oyster factory on Daufuskie, and there was also a company that brought their trucks over on barges to the mainland to haul off lumber to Savannah. The Coast Guard bivouacked from 1941 on a place called Bloody Beach, Daufuskie.

These three men represent the stalwart determination of the Gullah to provide for themselves and their families. I know many mornings that I got up and went out into the creeks early, about 4 o'clock in the morning, to work from about four until about two in the afternoon. In winter, this meant harvesting oysters, tending traps, and some fishing. In summer, about May, it was commercial crabbing. We had a long trauling line, about a block and a half long; every 18" there was a piece of bait tied in it. It would be dropped in the water with a weight on one end and a buoy on the other to mark where the line was dropped. You would row, letting that line out, and it would go for about a city block and a half. At the end of that drop, my father would push the boat, and row back. I'd take a dip net, and every time I'd pull up the cord wherever the bait was, there'd be one or two crabs hanging on it. I would dip those crabs up and put them into a barrel in the boat. At the end of "a drop," I would have half of a moving van barrel filled with crabs. That was the commercial way we used to fish for crabs, not like the crab traps they use today. Then a boat, the *Gator*, would come by about two o'clock, and take the catch to Savannah. Each man in *Perseverance* represents a man who worked and provided for his family.

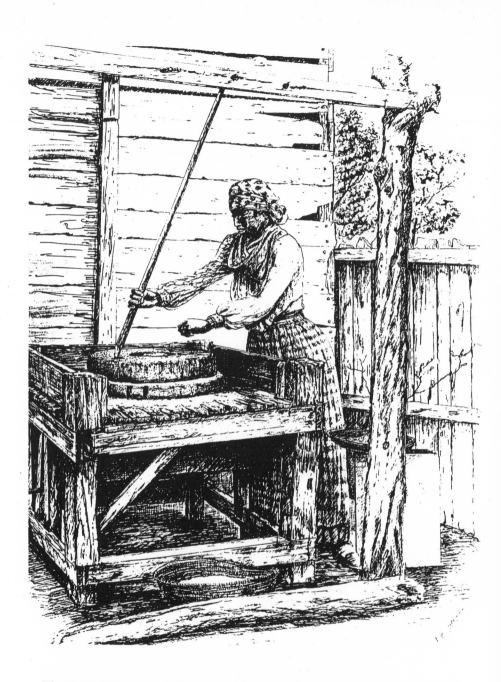

The Grit Mill by Joseph Pinckney. "Those big stoves were used to grind corn; in the center of that stone, there's a hole. As she drops the corn in the hole and pulls that stone around, the powder of the corn acts as a lubricant for the stone. The end product of that is grits for food, powder for cornbread, another coarse kind of grit for horse feed."

Joseph Pinckney.

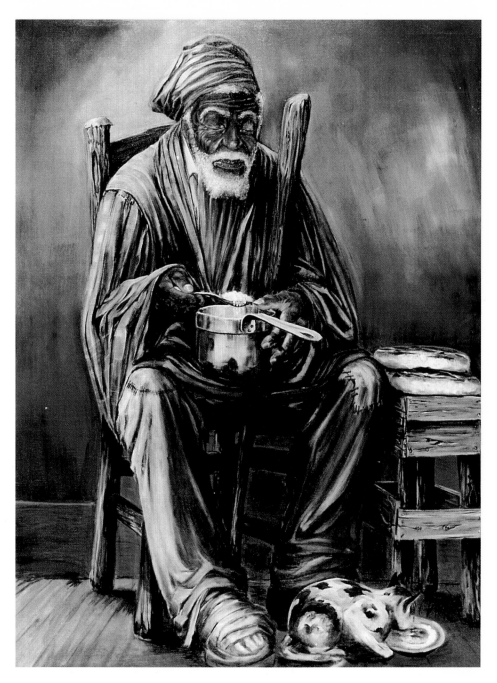

Uncle Ben Eating Hoe Cake and Clabber.
Joseph Pinckney

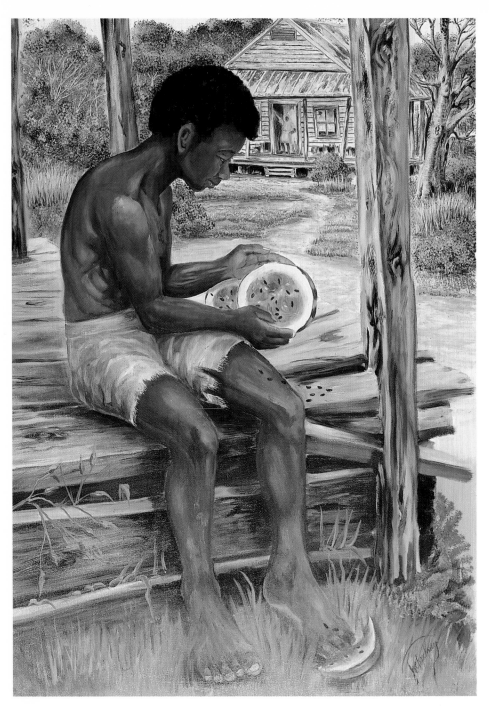

Watermelon Boy.
Joseph Pinckney

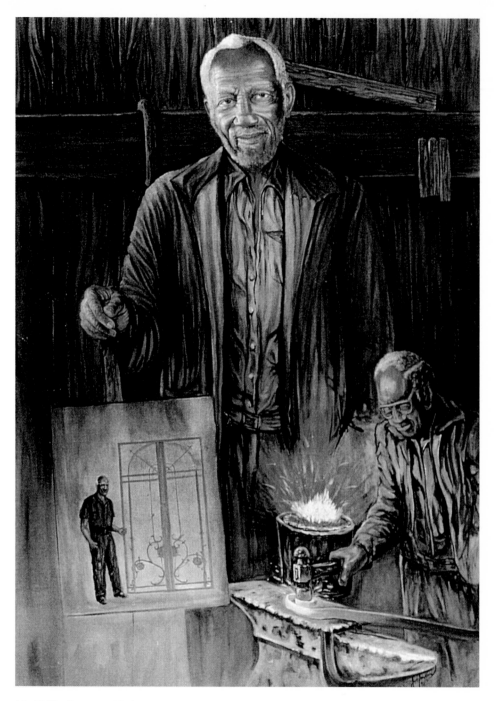

Mr. Phillip Simmons, Blacksmith.
Joseph Pinckney

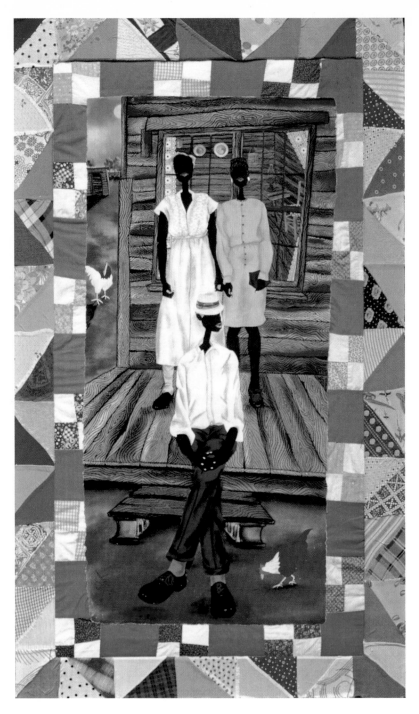

Corn Bread.
Leroy Campbell

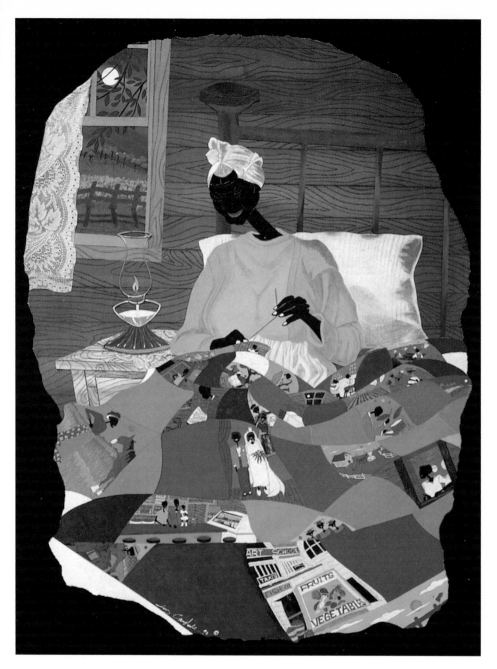

You Reap What You Sew,
Leroy Campbell.
Original acrylic on paper.

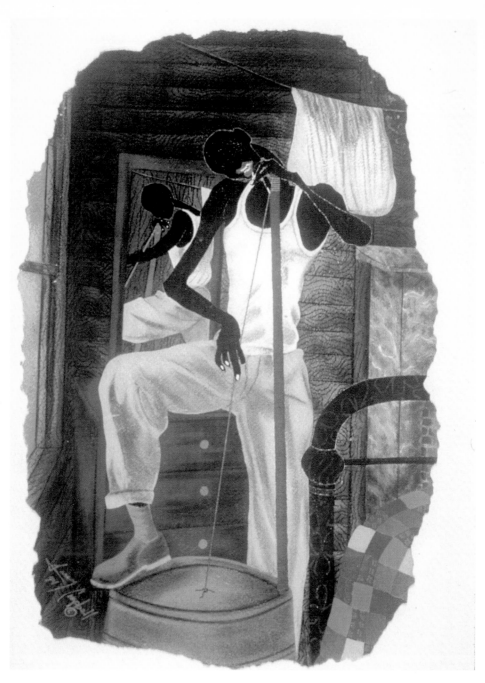

Bath Tub Base.
Leroy Campbell

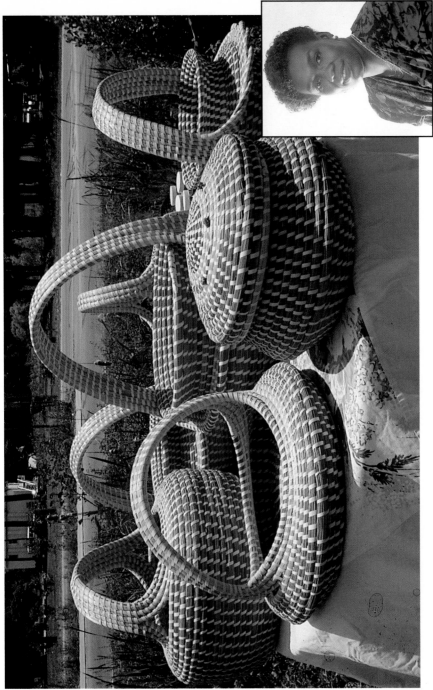

Jery B. Taylor, Basketmaker, and her baskets. Jery is among the numerous female and male basketweavers of the Lowcountry that are keeping this tradition alive and passing it on. (*Slide courtesy of Kitty Green*)

Sea Island cuisine draws on local produce from land and sea.
(Photo courtesy of Kitty Green)

We Got Our Way of Cooking Things
Women, Food and Preservation of
Cultural Identity among the Gullah*

Josephine A. Beoku-Betts

Gullah communities in the Sea Islands and neighboring mainland regions in Georgia and South Carolina provide a unique opportunity to study some of the distinctive elements of African cultural influences on African American culture in the United States. Despite variations in the demographic structures and economic practices of communities on or near these islands, strong similarities exist in proximity of location and in historical and cultural background. One significant characteristic of these communities, for example, is that most residents are descendants of enslaved Africans who worked on these islands as early as the seventeenth century. Beginning in that period, Africans were captured and transported as slaves from various regions in Africa, extending from Angola to the Upper Guinea Coast region of West Africa. Between 1670 and 1800, however, Africans from rice-cultivating regions in West Africa, such as Liberia, Sierra Leone, Senegal, Gambia, and Guinea, were sought because of their knowledge of cultivation of rich, which was then a lucrative crop in Georgia and South Carolina.[1] Rice planters were particularly interested in enslaving Africans from the "Rice Coast" of West Africa because the planters themselves lacked knowledge about rice cultivation in tropical conditions. The system of rice cultivation adopted in these coastal regions of Georgia and South Carolina drew on the labor patterns and technical knowledge of the enslaved West Africans.[2]

Because of the geographical isolation of these islands, cohesive communities evolved and preserved African cultural traditions more fully than in any other group of African Americans in the United States. These traditions are represented in the Gullah language spoken among Sea Islanders, in birth and naming practices, in folktales, in handicrafts such as grass-basket weaving, carved walking sticks, and fishing nets, in religious beliefs and practices, and in a food culture based on rice.[3]

Today the sources of livelihood in these Sea Island communities vary according to available economic opportunities. In communities such as John's, Wadmalaw, Edisto, St. Helena, Ladies, and Hilton Head Islands, many inhabitants are engaged in the vegetable truck industry; others are involved in fishing, crabbing, and marketing of crafts. Most

*Abridged with permission from *Gender & Society*, Vol. 9 No. 5, October 1995.

of the young and the old in these communities garden, fish, hunt, and sell crafts and other services to supplement their incomes.[4] As a result of development of the tourist industry, such as on Hilton Head and St. Simon's Islands, many inhabitants (particularly women) work in minimum wage service positions. Limited employment opportunities on islands still inaccessible by bridge, such as Sapelo Island in Georgia and Daufuskie Island in South Carolina, have led many of the younger or more highly educated community members to seek work elsewhere, causing an imbalance in the age structure of their populations. Sapelo Island, for example, has a population of just 67 people; a disproportionate number are in the economically dependent years, over 60 and under 18.

CONNECTIONS BETWEEN THE NATURAL ENVIRONMENT AND GULLAH FOOD PRACTICES

The value of self-sufficiency in food supply is an integral aspect of the Gullah food system. Men and women of all ages are conversant with hunting, fishing and gardening as ways to provide food. From an early age, both men and women are socialized into the concept and the practice of self-sufficiency as a primary goal of the food system and are encouraged to participate in the outdoor food-procuring activities of parents and other kin or community members. Velma Moore, a woman in her mid-40s, became sensitive to environmental causes when, as a child, she accompanied both her parents on daily walks in the woods. This experience taught her a variety of survival skills involving the use of the island's natural resources for subsistence and medicine. She learned how and where to collect medicinal herbs, and when and for what purpose they should be used. She also learned various folk remedies that had been passed down in her family for generations, such as life everlasting tea for colds or leaves of the mullien plant for fever. Velma recollected that when she was a child, her mother kept these herbs on hand in the kitchen and stood over a reluctant patient to make sure every sip of the tea was consumed. Now married and the mother of five children, Velma pointed out that she encourages the practice of these traditions among her sons and daughters. She even performs regionally as a storyteller and writes local newspaper articles about the significance of these traditions in her culture.

Grandparents also play an important role in developing children's skills in food self-sufficiency. A typical example was Maisie Gables, a lively and active woman about 70 years of age. When I interviewed Miss Maisie, as she was called, I did not know that our scheduled

appointments conflicted with her plans to go fishing with her five-year-old granddaughter, whom she was teaching to fish. Miss Maisie explained later that her granddaughter liked fishing from an early age, so she had decided to cultivate this interest by teaching her the necessary skills, as she had once been taught by her mother. By transmitting these skills, which are part of collective memory, the senior generation of Gullah women fosters and sustains cultural identity intergenerationally, thus broadening the base of cultural knowledge in the community.

While the Gullah depend on their natural surroundings as a reliable source of food, they also have a deep understanding of their coexistence with other living things and believe that the use of these resources should be moderate and nonexploitative. This sense of shared membership in the natural environment stems from Gullah belief systems, which emphasize harmony and social exchange between the human and the natural world. Such a view is influenced by African spiritual beliefs, which are community centered and involve a set of relationships involving God, the ancestors, other human beings (including those yet unborn), and other living and nonliving things. In this complex system of relationships, the well-being of the whole is paramount; individual existence is woven into the whole.[5]

Some aspects of this world view are reflected in my interview with Velma Moore. She describes herself as a self-taught woman, although "self-taught" does not adequately describe her intelligence, strong will, and vast knowledge of Gullah history and culture. During one interview, she revealed that she, like many Gullah women, had been taught to hunt and would do so if necessary. Even so, she considered herself a keen environmentalist, with concern for the protection of nature, and would not engage in such activities for recreation because "it is not sporting to go up and kill animals that can't shoot you back." In other words, although she would rely on these resources for survival, anything beyond that purpose would threaten the harmony with nature.

Velma also expressed concern about the threat of environmental destruction in the region, a result of increasing tourism and economic development. She conceptualized this problem in connection with the struggle to preserve her own endangered cultural heritage:

> I always felt that if you don't deal with one and the other, if you just strictly deal with one, then you're losing the rest of it. Because you cannot have stabilization in a minority community in this area here unless you recognize the culture

and the environment. And if you mess up the environment, and you move the people away because the environment is not right, then you are taking away their culture at the same time. So if you take away their land, you are also taking away the culture when you move the people, and so forth. (Velma Moore 1991).

In making this connection between the threat of environmental destruction and the survival of her own cultural heritage, Velma reveals an awareness of her relationship, represented by culture, with other living beings, both human and nonhuman. She does not distinguish between the two because she perceives them as natural allies in a struggle to protect tradition from the intrusion of dominant cultural practices. Because both are woven into her existence, the survival of one depends on that of the other and must be defined and challenged from this standpoint.

Interviews with Gullah women suggest that engagement in fishing, gardening, hunting, and other outdoor activities is not based strictly on gender role divisions. Although many of the outdoor activities related to food procurement are men's domain, women are more likely to be associated with these activities than men are with activities regarded as women's domain. In other words, it seems that at each successive stage of food preparation (which can overlap somewhat), work activities become more gender-specific. This is true, for example, of role expectations in some fishing activities, such as men's use of the cast-net method and women's use of the reel and rod method.

THE CENTRALITY OF RICE IN GULLAH CULTURE

Dependence on rice as a staple food is the most significant way the Gullah express cultural identity through food practices. Rice is the main food that links Gullah dietary traditions with the food traditions of West African rice cultures; women play a primary role in fostering the continuance of these practices. In such cultures a person is not considered to have eaten a full meal unless rice is included.

Although most Gullah families no longer cultivate rice regularly, people are still conscious of its significance. Rice was described as the central part of the main family meal by at least 90 percent of the women I interviewed. Typical were responses like:

It's the one that makes us fat because we go to sleep on it... My father used to say, "Eat something that sticks to your rib." (Velma Moore, 1991)

> Many people feel if rice isn't cooked, they haven't eaten. Take my grandson, for instance. No matter what you cook, whether it's potatoes or macaroni, you have to prepare a separate portion of rice for him. Otherwise he'll feel like he hasn't eaten. (Carla Bates, 1989)

> Rice is security. If you have some rice, you'll never starve. It is a bellyful. You should never find a cupboard without it. (Precious Edwards, 1992)

> Well, they have to have that rice 'cause, see, they be working hard at the farm and they have to have something to give them strength. They don't hardly bother with too much grits. They eat that grits in the morning now. But when dinnertime come they have to have that rice. They always say that Black people like too much rice. They don't eat like the white people. I don't know why they always say so. (Wilma Davies, 1991)

Because of Gullah women's daily involvement in food preparation in the home, they are very conversant with the stories and traditions passed down in their families about the significance of rice to their culture. On the occasions when I stayed as a guest in study participants' homes and helped prepare evening meals, women often shared stories and folktales with me, as well as songs and dances connected with their rice culture. On Sapelo Island, I learned about formerly enslaved women who prepared special rice cakes made with honey for their families on particular days and months of the year, in observance of Muslim religious festivals.[6] Women also told me about folk traditions such as a song called "Blow Tony Blow." This accompanied a traditional dance still performed by Gullah women at cultural festivals to demonstrate how rice grain was removed from its husk with a flat, round, woven grass-basket called a fanner.

Several elderly women also recalled a time when rice held such a special place in their communities that children were not permitted to eat it except on Sundays or special occasions:

> They have folklore on rice down here. One of the things we grew up with, for instance, after the birth of a child you wasn't given rice—no rice. Because rice is supposed to been too starchy for the newborn baby to digest through the mother's milk, and so you wasn't given rice to eat at all. (Velma Moore, 1991)

> Some of the old folks believe that rice was also a cure for sick chickens, believe it or not. If your chicken were looking like

they were kind of sick, you was to feed them raw rice, and it supposed to make them feel better. So they will take raw rice and toss them in the chicken yard. (Velma Moore, 1991)

I've known people to parch rice and make their coffee. Put it in the frying pan or something, and you toss it lightly and keep shaking it lightly until it brown—you mix it and you can drink it, and you put water and you make (it) like coffee. (Velma Moore, 1991)

These accounts are distinctive because of choice of words and expressions used to communicate custodianship of these traditions. For example, the use of terms such as "security, strength, bellyful, make us fat" helps us to understand the role of this food not only as a means of survival when families are on the brink of economic disaster but also in times of plenty. Recollections of folklore traditions similarly enable us to explore the versatility of the culture, as expressed in the ability to transform rice into a form of coffee or a cure for animal ailments.

It is also significant that these recollections are narrated by women, because through such stories we learn how marginalized cultural groups construct a familiar and identifiable world for themselves in a dominant cultural setting. Although pressure from a dominant culture may weaken their ability to reproduce their knowledge and perceptions of themselves and of their world, the ability to remember and to create a communion of memory in the group provides the foundation for establishing membership and continuity of that group.[7] A parallel can be drawn in the role of Gullah women in maintaining a sense of shared tradition through food practices. Through their recollections of stories and songs and in their performance of dances and enactments of past traditions, they create a frame of reference alternative to those promoted in the dominant culture, while at the same time transmitting collective memory to the next generation.

One way of promoting an alternative frame of value reference through food practices is in the daily observance of strict rituals of rice preparation. In Gullah and West African rice cultures, for example, it is typical to commence the preparation of rice by picking out any dirt or dark looking grains from the rice before washing it. Then the rice is washed vigorously between the hands a number of times before it is considered clean enough for cooking. As a girl growing up in Sierra Leone, I was taught to cook rice in this way. I still follow this practice faithfully, even though most of the rice available for sale today in the United States is labeled as prewashed.

Whenever Gullah women speak of cooking rice, they distinguish between the various types of grains before explaining which cooking method will be most appropriate for a particular grain. They also take pride in describing the proper texture and consistency of a well-cooked pot of rice, although the suggestion that food must have a particular appearance to be satisfying is as culturally specific to the Gullah as to other ethnic groups.[8] Indeed, the belief that well-cooked rice must be heavy to be filling to the stomach is a cultural trait that the Gullah share with many African societies that eat heavy staple foods.[9]

RITUALS AND NORMS OF MEAL PREPARATION

Gullah culture is influenced strongly by rules and norms of West African food preparation. Many women who cook perpetuate these practices daily. One of these practices involves the selection, the amounts, and the combination of seasonings for food. These elements differentiate Gullah cooking practices from those of other cultures, according to many women I interviewed. Although the Gullah identify certain foods as their own, such as Hoppin' John (rice cooked with peas and smoked meat), red rice, rice served with a plate of shrimp and okra stew, and collard greens and cornbread, the interaction between European American, Native American, and African American food systems in the South has carried these popular southern dishes across ethnic lines. One way in which Gullah women try to control cultural boundaries in their way of cooking these foods, as distinct from other southern practices, is to assert that although similar foods are eaten by others in the South, their style of preparation and the type of seasonings they use are different. Just as West African cooking is characteristically well seasoned with salt, pepper, onions, garlic, and smoked meat and fish, Gullah food is flavored with a combination of seasonings such as onions, salt, and pepper, as well as fresh and smoked meats such as bacon, pigs' feet, salt pork, and (increasingly) smoked turkey wings (to reduce fat content). The Gullah women's views are expressed clearly in the following statements:

> Interviewer: As an African American living in this area, what do you think makes the food you eat different?
>
> Culture and what's available to you. I call it a "make do" society on Sapelo because you can't run to the supermarket to get things. We are plain cooking. We use salt, pepper, and onion as basic additives. Our flavoring comes from the type of meat we put in it. Bacon is white folks' food, pig tails, neck bones, and ham hock is what we use. Soul food is

what other Americans call it, but we consider these to be foods we always ate. We never label ourselves or our food. (Velma Moore, 1991)

On Sapelo you got things like red peas and rice. You know, they cook the same things on that side over there too, but we assume that we have the monopoly on it, that nobody cooks it the way we cook it... although they call it the same thing, the ingredients may be a little different than they use, or the taste is definitely different. So it's considered Sapelo food. I mean very few places you go [where] they cook oysters and rice or they cook clam and gravy the way we do, and stuff like that. So we got our way of cooking things. So we pretty proud of calling it Sapelo food. Yes. (Vanessa Buck, 1989)

By claiming these features of the food system as their own through daily cooking practices, and by situating this knowledge in the community through the use of such words as "we" and "strictly ours," the Gullah women maintain the credibility and validity of a familiar and recognizable tradition in resistance to pressure to conform to dominant cultural practices.

A strong preference for food produced and prepared from natural ingredients is another norm of Gullah food practice. In many of my interviews, women stated that much of the food they prepare for their families is grown locally and naturally. When asked to comment on what makes Gullah food distinctive, Betty Smith, who is married, in her mid-40s, and an active community and church member, explains:

A lot of what we eat is locally grown. Not the rice, but everything else. We dabble in other things that are imported, but.. I guess the type of food we eat is indigenous to this area. It's what we have kind of grown up on. Most of my food is still prepared traditionally. My rice is usually boiled. I don't buy parboiled rice. I don't buy too many processed foods.

Annie Willis, in her 70s and also active in church and community activities, lamented the demise of locally grown goods and expressed concern about the quality, taste, and health implications of store-bought foods.

When I was a child coming up, we never used to put fertilizer in our crop to rush up the food. Food used to taste much better then than now. The old folks didn't have as many health problems as we are having and they ate all those forbidden foods. I think it's the fertilizers and chemicals they put in the food now. Seem to me that children were more

healthy in those days than they are now. (Annie Willis, 1989)

The suggestion that the younger generation of Gullah may no longer prepare food strictly from naturally produced sources implies that the Gullah way of producing and preparing food is symbolically significant and a mark of their difference from other cultures. These statements also reflect a concern for the customs and traditions threatened by the influence of urban development in the region. By recalling a past that their foremothers and forefathers created, these women set a context in which the values of their community can be understood and reclaimed for future generations of Gullah.

The women's statements also reveal concern about the expectations of custom and tradition and how these can be accommodated to the demands of present-day family life and employment. Certainly many of the traditional foods eaten by the Gullah must be time-consuming to prepare, and one cannot always prepare them regularly if one has a full-time job or other commitments. How do women cope in these circumstances? Several women employed outside the home admitted that they had made some adjustments. Pat Forest, a 43-year-old woman who is employed full time as a nursing aide in a local health clinic, lives with her husband and four children, who range from 10 to 22 years of age. Because of the demands of her job and her role as primary caregiver in the family, I was not surprised to learn that she prepared red rice by using a precooked tomato-based sauce rather than cooking from scratch. Traditionalists in the community would frown on this type of cooking, however. Some women told me that they often save time by preparing part of the meal the night before serving it or that they might prepare traditional meals only on specific days of the week such as Saturday and Sunday. Some women even said that they simply do not set a time for the main evening meal until it is prepared to their satisfaction. Several also mentioned that they had taught their sons and daughters to take on some of the basic responsibilities of cooking, especially the daily pot of rice.

The ways in which these women manipulate time constraints to accommodate the customary demands of their food practices suggest efforts to uphold the central role of these food practices in the home, but also to exercise the flexibility needed for modern living. Although the women show respect for the culture and even express some guilt about failure to conform fully, their actions suggest that they are walking a fine line (albeit rationalized by time pressure). They are maintaining tradition while adjusting to modern influences that potentially might endanger their tradition.

In common with West African cultures, the Gullah tend to prepare excess amounts of food for a meal in case someone should pay a visit. In West Africa, in fact, it would be embarrassing for a host to prepare or send out for food for unexpected guests.[10] Even under the economic constraints facing many West African societies today, such a tradition is upheld as strongly as possible because it is still viewed as a mark of prestige for both the head of the household and the cook. Although the Gullah do not necessarily view this tradition as a symbol of prestige, some of its elements are common in many of the homes I visited while conducting this study. As Velma Moore explained to me.

> I'm always able to feed another person in my home. People [here] will automatically cook something more just in case a stranger drops in.

As my study proceeded, I knew that the local residents were beginning to open up to me when, after several visits, I was offered food, whether or not it was mealtime.

EFFORTS TO TRANSMIT TRADITIONAL FOOD PRACTICES

Much effort is being made to keep these traditions alive through oral tradition and everyday practice. Observers are pessimistic about what the future holds for a people who now consider themselves as endangered species.[11] One of the leading concerns expressed by residents of these communities is that the survival of this coastal culture is threatened by the rapid economic growth and development of tourist centers in the region. According to Emory Campbell, director of the Penn Center on St. Helena Island, South Carolina:

> The Black native population of these islands is now endangered, and we don't have too much time to protect oysters, fish, and crab. Developers just come in and roll over whoever is there, move them out or roll over them and change their culture, change their way of life, destroy the environment, and therefore the culture has to be changed.

The lack of stable employment opportunities on these islands is also cause for concern, because it has created an imbalance in the age structure; a high percentage of young adults leave for employment elsewhere. Also, it is felt that the drive toward a more materialistic way of life in the region will lead, in the long term, to an array of social problems such as alcoholism, marital conflicts, and youth delinquency.[12]

The task of transmitting cultural traditions to a rapidly declining younger generation of Gullah poses a challenge to those committed to preserving this way of life. Such transmission will be difficult unless the living context of the culture can be preserved.[13] The women I interviewed also expressed this attitude:

> You've got to have culture in order to make your community stable and stay in one place. And so how else can white people come in and say, "Oh, these people down here speak Gullah or Geechee," and want to learn more about your culture, but at the same time they want to buy your land and push you out. How can you come down and visit me in my area, but I'm hanging on by a thread because you want my area. What do you suppose they'll show their friends and talk about? You know, they'll say, "This used to be a Gullah community, a Geechee community, but now they all live there in the heart of Atlanta or someplace else." It's not going to work. You can't move papa from [here], sit him in the middle of Atlanta, and say, "Make your cast net." Who's he going to sell cast net to in the middle of Atlanta?...all of a sudden he'll die. So you can't move the culture and tradition from one area and just plant it in another area...You've got to nurture it here, pass it down, teach children, and so forth. It's a slow process. You've got to know how to do it and you can teach other people how to do it. (Velma Moore, 1991)

Perhaps the most relevant context for understanding knowledge transmission among Gullah women may be African-derived cultural practices that stress motherhood, self-reliance, and autonomy, extended family, and community-centered networks.[14] Each practice is centered in either the home or the community, and the two spheres of activity are mutually reinforcing. Within these domains an alternative framework of identity is constructed and women serve as transmitters of cultural knowledge.

The concept of motherhood illustrates how women use their spheres of activity to transmit cultural traditions. Motherhood among the Gullah is not limited to a biological relationship, but also can embrace other relationships with women termed "other mothers" (women who assist bloodmothers by sharing mothering responsibilities). Other mothers may include grandmothers, sisters, aunts, or cousins who take on child care, emotional support, and even long-term responsibilities for rearing each other's children. According to Jones-Jackson, "It is not unusual for a child [in the Sea Islands] to reach adulthood living not more than a block from the natural parent but

residing with another relative who is perhaps childless or more financially secure."[15] It is also common to see a neighbor helping to prepare a meal next door or being offered a meal without concern that parental permission would be required.

The concept of family extends beyond the nuclear family to include extended and even fictive family ties. Responsibilities and obligations within the family are defined in this context; they facilitate the development of family communities where relatives live close to each other, and promote cooperative values through shared roles and socialization practices. Women of all generations, as mothers and as extended family members, play a critical role in fostering self-reliance and a sense of collective memory in their children of both genders. They do so through the daily preparation and eating of traditional foods and by using informal conversation to teach family history and cultural traditions.

I learned about the use of informal conversation when I attended a funeral at the home of a Gullah family. In the evening, after the funeral ceremonies were finished and most people had left, all the women of the family sat together in the living room with their children at their feet, eating and telling each other family stories. Someone asked about the people in a family photograph. My hostess described the context in which the photo was taken (which happened to be a family meal) and recalled each family member present, including the wife and mother, who was in the kitchen cooking when the photo was taken. Because children are expected to eventually manage their own lives, both sons and daughters are taught the skills of self-reliance through cooking. Parents believe that their children must know these things to survive in the wider culture.

Much of this socialization takes place around the mother or in the family, but much is also learned from trial and error. Velma Moore recalls:

> I learned to cook by trial and error and mama. Nobody teaches you how to cook, not over here. They allow you to play cook in the kitchen and watch them. Tradition always leaned towards girls cooking, but that boy, if he was hungry, he was expected to go in there and fix something for himself. Not that he had to sit there and starve all week until somebody's sister come home. So he learned how to cook, just like his sisters did. If a parent was home and he was home, they'd come up and ask him, "Hey, you was home all day. How come you didn't put on the rice?" or "How come you didn't boil the beans or something?" And so they would ask

him the question that they would ask girls. At least I know
mama did (laugh).

Strong bonds between women are also established through
women-centered networks, which promote cooperative values in child
care and informal economic activities (such as grass-basket weaving
and quilting), in the opportunity to share experiences and ideas and in
fostering the development of positive self-images, self-affirming roles,
and self-reliance as women. The social exchange of goods and services
and the flow of information and ideas that emanate from this type of
networking encourage the development of positive self-images and
community awareness in the children in these communities. While
staying with Gullah families, I often observed exchanging and giving
of food and other goods and services among women and their families,
although many people commented that this practice was declining.
Often when people went fishing or gathered vegetables and pecans,
the women sent these foods to neighbors and friends, especially elderly
individuals or couples who could no longer move around easily.

Preparation and serving of food by Black women in a secular
communion of fellowship "symbolize[s] the spiritual component of
collective survival."[16] Women who prepare food for church activities
play a vital role in helping these community-centered institutions to
become sites of cultural preservation and spiritual fellowship, because
food is an integral part of the ritual activities associated with spiritual
fellowship. During the planning of church functions such as church
anniversaries, weddings, and funerals, women who are known for their
skills in preparing particular dishes are usually asked to prepare foods
such as collard greens, red rice, peas and rice, cornbread, and chicken.

> When we go on a church picnic, we have a little cook-out
> like hot dogs and hamburgers, stuff like that. When we have
> the anniversary of the church, we cook soul food. And we
> have collard greens, and string beans, butter beans, fried
> chicken, some kind of roasts, macaroni and cheese,
> cornbread, and red rice. (Bernice Brown 1989)
> We eat our food every day on St. Helena Island, and we also
> eat it at church anniversaries, weddings and funerals. When
> we raise money to help the church, like women's day, the
> pastor's anniversary, the choir anniversary, we cook our food.
> (Queenie Moore, 1989)

Some women, including a study participant from Wadmalaw
Island, also raise funds for their church by preparing meals for sale in

their homes. Organizing such a party often involved considerable work in preparing traditional dishes such as red rice, fried fish, barbecued pigs' feet, collard greens, and shrimps and okra served with rice. Usually, my informant's friends and relatives helped her to prepare the food. Members of the church congregation and other community members then were expected to show their support by attending the party and paying for the food as they would in a restaurant.

By extending food preparation to embrace the church family, the actions of women, who usually do this work, promote a sense of shared tradition and spiritual identity among church members, especially among youths and those who lack the time or talent to practice these traditions. This activity also reinforces community-centered networks by providing a context for dialogue, mutual mentoring, and spiritual development, especially among women in the community.[17]

CONCLUSION

I have argued here that through regular food preparation and management of feeding in the family and the wider community, African American women in Gullah communities perpetuate cultural identity and group survival. Cultural preservation through food preparation and feeding is a highly conscious act on the part of these women; it is tied closely to their judgments about when to accept, and when to resist, change. Gullah women, therefore, are willing to take shortcuts in cooking when time pressures demand it, but they seem less willing to compromise their feelings about nature and environmental protection or to tamper with the "unique" seasonings they say are a component of true Gullah cooking.

Gullah women devise and transmit alternative ways of understanding their culture by relying on African-derived systems of knowledge, which promote motherhood, women-centered networks, self-reliance, extended family, and community-centeredness. Reliance on these values has enabled Gullah women to resist negative images of their past; they use common but resourceful strategies such as everyday practice, teaching by example, and providing constant recollections of their past through storytelling and other oral traditions. Although present attempts to define and preserve the unique cultural tradition of these communities are threatened seriously by the pace of economic developing in the region, Gullah women have learned from their mothers and grandmothers that the observance and practice of the underlying principles of their traditions are vital to the survival

and preservation of their culture.

[1] J. Holloway, *Africanisms in American Culture*, Indiana University Press, Bloomington, 1990, p. 4; D. Littlefield, *Rice and Slaves: Ethnicity and the Slave Trade in Colonial South Carolina*, Louisiana State University Press, Baton Rouge, 1981; P. Wood, *Black Majority; Negroes in Colonial South Carolina from 1670 through the Stono Rebellion*, Alfred A. Knopf, New York, 1974.

[2] Littlefield, *supra.* ; J. Opala, *The Sierra Leone-Gullah Connection*, USIS, Freetown, 1987; Wood, *supra.*.

[3] M. Washington Creel, "Gullah Attitudes toward Life and Death," *Africanisms in African-American Culture*, Indiana University Press, Bloomington, 1990; Georgia Writers' Project, *Drums and Shadows: Survival Studies among the Georgia Coastal Negroes*, University of Georgia Press, Athens, (1940) 1986; P. Jones-Jackson, *When Roots Die; Endangered Traditions on the Sea Islands*, University of Georgia Press, Athens, 1987; Opala, *supra.*; L. Turner, *Africanisms in the Gullah Dialect*, University of Chicago Press, Chicago, 1949.

[4] Jones-Jackson, *supra.*, p. 17.

[5] See Margaret Washington Creel, *supra.*, and Patricia Jones-Jackson, *supra.* (especially pp. 24-28). A good background to African spiritual philosophy is John Mbiti, *African Religions and Philosophy*, Praeger, New York, 1969.

[6] Formerly enslaved Katie Brown and Shad Hall from Sapelo Island, Georgia, when interviewed by the Federal Writer's Project in the 1930s, vividly described a speical rice cake made with honey that their African Muslim grandmother prepared for the family on particular Muslim fast days (Georgia Writers' project, *supra.* pp. 162, 167). See Thomas Winterbottom, *An Account of the Native Africans in the Neighbourhood of Sierra Leone*, Frank Cass, London, {1803}, 1969, a British physician who worked in Sierra Leone at the end of the eighteenth century who also reported that the Muslims he encountered liked to make cakes of rice and honey.

[7] One may find that even when a meal displays the qualities they claim it must have to be satisfying or filling, it still might not be acceptable to a given people if that food is not their preferred staple.

[8] W. Bascom, "Some Yoruba Ways with Yams," *The Anthropologists Cookbook*, Universe Books, New York, 1977, p. 83; C. G. Friedman, "Africans and African-Americans; An Ethnohistorical View and Symbolic Analysis of Food Habits," *Encounters with American Ethnic Cultures*, University of Alabama Press, Tuscaloosa, 1990, p. 83.

[9] See Charles Joyner, *Down by the Riverside: A South Carolina Slave Community*, University of Illinois Press, Urbana, 1984, p. 96, for a description of how rice was cooked on some slave plantations in South Carolina, given by Goliah, who was enslaved on the plantation of Robert F.W. Allston.

[10] Bascom, *supra.*, p. 52; R. S. Finnegan, *Survey of the Limba People of Northern Sierra Leone*, Her Majesty's Stationery Office, London, 1965, p. 67.

[11] V. Singleton, "We Are an Endangered Species: An Interview with Emory Campbell," *Southern Exposure*, 1982, p. 38.

[12] Singleton, *supra.*, p. 38.

[13] According to Charles Joyner, *supra.*, a folklorist and scholar of Gullah history and culture, cited in R. Nixon, "Cultures in Conflict: Sea Island commmunities are fighting for their survival, stirring new hopes along the coast of South Carolina," *Southern Exposure* {fall}, 1993, 56).

[14] P. Hill Collins, *Black Feminist Thought: Knowledge, Consciousness, and the Politics of Empowerment*, Unwin Hyman, Boston, 1990; F. Steady, *The Black Woman Cross-culturally*, Schenkman, Cambridge, Mass, 1981.

[15] Collins, *supra.*; Steady, *supra.*

[16] Collins, *supra.*, p. 119.

[17] Although I recognize the important contributions of Gullah women in the development of the Black church and in its spiritual leadership and community development activities, they have made this contribution at the expense of holding leadership positions. In the formal authority structure of African American churches, men generally control these positions. Women lack due recognition and status, and they continue to fight to attain a measure of power and influence in many Black churches. At the same time, they have shown different patterns of leadership within the church community by fostering a sense of collective autonomy and "woman consciousness" (C. Gilkes, "Together and In Harness: Women's Traditions in the Sanctified Church," *Black Women in America: Social Science Perspecitves*, University of Chicago Press, Chicago, 1988, p. 228). Like the activities of women who organize voluntary missionary societies, teach Sunday school, raise funds and become prayer band leaders and church mothers, the activities of women who prepare food for church functions show that women use this sphere of influence in the church to foster a sense of shared tradition and spiritual identity in their communities.

Hoppin' John

Kimberly B. Thomas
Wadmalaw Island, S.C.

3/4 of a bag of field peas
3 cups of white rice
water
1/4 - 3/4 lbs of cooked pork, beef, or turkey parts
1 medium or large onion (optional)
1 small or medium bell pepper (optional)
1/2 - 3/4 stick of butter or margarine
salt
pepper
meat seasoning

Soak peas from 30 minutes to 24 hours depending on the length of cooking time that you want to have. The longer they are soaked, the less the cooking time.

Finely chop the onions and bell peppers.

Season the chosen meat with salt, pepper, and meat seasoning and boil. The onions and bell peppers can be added to the boiling meat or put in with the peas.

Allow the meat to boil down to natural juices then add peas to this. You may need to add more salt and pepper to the peas. Season to taste and then cook for 45 minutes to 1 hour. You will know that the peas are done when you can mash one on the side of the pot with a fork without using a great deal of force. Do NOT overcook the peas. They should not be excessively soft.

Wash rice 5 or 6 times in order to remove the excess starch. Then add rice to the meat and peas combination in the pot. Check the water level over the rice. If the water is 1/2 inch or less, you will need to add more water. The water should be no more than 1 inch above the rice. If you find that there is more than 1 inch of water above the rice, add more rice until you only have approximately 1 inch above.

Cover the pot and let it come to a boil (approximately 5 minutes). Stir in the butter or margarine. Turn the fire to a low flame and let cook for 20-25 minutes. You may stir occasionally, but this is not necessary.

Let stand for a minute and then serve hot.

Down Home Bread Pudding

Carolee Holmes Brown
St. Helena Island, S.C.

2 cups bread (torn into little pieces)
1/2 cup raisins
1 cup cooked pears or apples
1/2 block margarine
1/2 cup sugar
1 tsp. vanilla
1 egg
1 cup of milk
cinnamon to taste

Soak bread in water until very moist and then drain. Mix all ingredients together. Stir until entire mixture gels. Then spread everything in a 9 x 9 inch square pan and bake at 350 degrees until top is browned. Cool and serve.

Benne (Sesame) Seed Wafers

A Charleston favorite

2 cups brown sugar
1 cup plain flour
1/2 tsp baking powder
1/4 tsp salt

1 egg beaten
1 stick butter
1 tsp vanilla
1/4 cup toasted
 benne seeds

Cream the butter and sugar, add the egg, then flour sifted with salt and baking powder. Add vanilla and benne seeds. Drop by teaspoon on greased cookie sheet. Bake in moderate oven at 325 degrees. Cook quickly. Allow to cool 1 minute before removing from the pan. The wafer should be almost transparent.

NOTE: Benne seeds are felt to bring good luck.

Lowcountry Boil

Jackie Edwards
Brunswick, GA

Shrimp
Crabs
Corn on the Cob
Potatoes (cut in half or quarters)
Eggs (optional)
Crab Boil Seasoning (use the whole spice version)
Additional seasonings to taste

Boil the crabs in rock salt.
Remove the crab shells ("husks") and clean the insides (optional).
Put the crabs and all other ingredients in an old iron pot and steam it all down together. DO NOT completely boil it.
Serve hot.

Sweet Potato Pone

Catherine Carr
Lady Island, S.C.

2 large sweet potatoes
1/2 cup sugar
2 tbs. maragine, melted
1 cup dark cane sugar
2 eggs, beaten
1 tsp. nutmeg
1/2 tsp. salt

Peel and grate sweet potatoes. Add other ingredients and mix thoroughly. Pour into greased baking dish and cook in slow oven at 300 until done, about 1 hour.

restin' in*

Ihsan Bracy

for ida raspberry

by the time the family arrived back from the funeral she was packed. she sat on the edge of the quilt covered bed to survey her handiwork. there were rows of cardboard boxes, all lined up against the faded flowered papered walls. every item of her life was labeled, categorized and dispensed with. there was a sense of completion, finality. she had neatly emptied out her closets first, then the bureau chest of drawers, one drawer at a time, starting at the bottom. she had been surprised how amazingly simple it had all been, how little effort it had all taken, how quickly it had all been accomplished. all of one's life, wrapped up so easily. she could hear the stirring of the womenfolk downstairs in the kitchen, quietly preparing ever-flowing food, ready for people when they returned. she heard the continual answering of the door with the arrival of the many plates and offers of condolences.

she had not gone to the funeral. had not been invited, as it were. she wondered how it was that her progeny could think that just because she had lived as long as she had that suddenly she wouldn't be able to stand things. she had stood all of them, for all those years. had borne nine children, eleven if you count the two that had died at birth. well really only one had died, in her arms; the other had lain still as they pulled him from her. a beautiful boy, her first child, perfectly formed in every way 'cept for the purple cord wound tight around his neck. he was a deep brown color, dead.

she had neatly folded away all the clothes of her life, except for what she was wearing, the night clothes laid out on her bed and the gold and black dress which hung on the door of the closet. folded and packed all of her clothes, memories still clinging to them each. as she folded she caught trails of memory here, floods of remembrances there. the summer whites had reminded her of over a century of conversations among the womenfolk. births, pregnancies, adulteries, comings and goings whispered from each and every crease. faces. faces that came back without names. names that had been carried along by the wind. wind carried along with the footprints of a country road's dusty life.

* Reprinted from *ibo landing* by Ihsan Bracy, Cool Grove Press, 1998. More about *ibo landing* on website http://www.coollgrove.com

she had neatly folded away all of her clothes, according to their function. summer clothes together, a line of fall, winter, spring coats hanging quietly above shoes that had walked the miles of a lifetime. miles uphill, downhill, wet or dry. snow storm miles, summer shine miles, pregnant miles, carrying in the arms miles, tugged and cried after miles, and the calling, calling, calling of her name, sweet master! folded neat piles of house dresses, given to her over the years and the box full of the ever present white aprons, the uniform of her old age which she had worn dutifully, had taken for a widow's veil. except for church going she had not been seen out of one for more than forty years, or at least as long as anyone's memory.

from her window she noticed the dust rising from the lane and realized the clan had returned. she looked around one last time, inspecting the room for any last item that needed to be attended to. satisfied that her work was done, she started down the stairs, silently assured with the knowledge that she was indeed ready for her journey.

she arrived at the bottom step just as the door swung open and one of her more than twenty-six grand, nineteen great-grand and eleven great great-grandchildren hit the door, tearing at the tie around his neck. the top button of his too starched white collared shirt had torn at him, tormenting him throughout the entire service. she had just sat in her chair when the chorus of

-hi grandma,

echoed through the room.

-go tell your granddaddy i wants to see him,

she said quietly to one of the twins as they passed within earshot. they both ran off together to see who could find their grandfather first, each wanting to be the first to bring her summons.

grand geechee was just stepping from the limousine when he saw his twin grandsons racing toward him.

-great-grandma wants to see you,

they both said in unison. as he walked slowly toward the front porch of

the house he had known all his life he remembered running as a child like he now saw his grandsons do.

he had just come back from burying him, his father, her son. her last remaining child. he could almost see his father standing, leaning on the porch, looking out as he had so often. he had been in favor of telling her but had been dissuaded by the voices of all his sisters worrying that she wouldn't be able to take it. he had argued that she had overseen the coming in and the going out of each and every one of them. the sisters had countered with how they all knew that benjamin had been her favorite, her youngest.

-she gonna take it hard,

had echoed throughout the family. against his better judgment he had sat by as everyone was instructed

-not to tell mama,

convincing themselves that at her age it would be best. as if they couldn't recognize that she had known everything that had happened in each of their lives, always, without anyone having told her most of anything.

she had buried two husbands, now eleven children, and she was as close to the grave as she ever hoped to be. she had lived well past a century, a hundred and twelve or thirteen, waiting for her time, looking toward the release which had been promised to her, which would signal the reward for all her service. she had seen so much of life her eyes were tired of looking. had seen wars, so called spanish wars, world wars, wars in places called korea and vietnam. had seen people ride out on the horse and buggy and come back from the moon. had danced in front of soldiers in gray marching out to a civil war. she had been barefooted, just a dusty dress standing in a dusty road. they had marched out in lines stretching out for most of a day. she had watched the not so many coming back, broken, battered, beaten into ruins, chased by the long line of blue uniforms which signaled her release. she had seen crosses burnt and people hung from trees left to rot. she had lived from slavery to segregation, through segregation to integration, from nigger to negra to negro to colored to black. she was the stuff they spoke of when they said,

-they don't make 'em like they used to.

she was the 'used to' they referred to. she still was well, had her health, she still had her life. she still ran the house, cooked every breakfast and oversaw the cooking of every meal. she walked the half mile down hill every day to the mailbox and back up. she usually strolled down to call on miss mable to sit and pass a little time whenever weather permitted, until miss mable had passed a little more than two years ago.

she had outlived all of her friends and almost everyone she had ever met throughout her life, all the children of her friends and some of their grandchildren. even past the burial of her baby benjamin whom they had put away today. didn't nobody have to tell her that benjamin was gone. she had known it. had seen it all before it happened. she alone had seen the darkness that was closing to engulf the last of the babies she had pushed from her womb. she had been four or five years old when she had seen the soldiers first march and that made her at least old enough to sit on the front pew to mourn the passing of her last child.

she had already said goodbye to benjamin, when he had left the night before last. had pulled him to her, hugged him close in her arms for what she knew would be the last time. what messages she wanted sent on to her loved ones on the other side were tucked softly and carefully behind the folds of his soul. not a heavy weight to carry, just a little message that she would be coming soon.

she had never been sick a day in her life, not even a childhood disease. the doctor had told her she was a medical marvel and that she should leave her body to science. she had paid him no attention because she knew she was leaving her soul to the lord and all that came with it. she had not slept a sunrise, except counting a few rises after early morning births.

she smiled, remembering the look in benjamin's eyes the first time she held him. he had given her the least trouble of all. had been the easiest birth, as if he couldn't wait to jump from her loins to embrace life. maybe that was why she loved him the most. he gave her the least amount of trouble throughout his life too. he had been the child most like her, quiet. always with that sullen look. she remembered the eyes of the first child, the one born still. she suddenly knew that she was

tired, very tired, as tired as she had ever felt. yet at the same time she felt this feeling of being light, excited, like a young girl on her first overnight stay.

grand geechee came into the room.

-no need to hold down your head chile. i knows benjamin done gone. knows
y'all done bury i las' chile, done put he in the ground.
i needs to talk to yous to all of yous. i need to look on ewer one of i
progeny. y'all come on in chere.

she had never called for a meeting of the entire clan before. she answered the eyebrows of surprise that grand geechee raised by sitting back, looking out the window. he understood that she would not speak again until they had all assembled.

after they had all gathered into the living room, she turned her gaze from the tree outside the window and the path of the setting sun. she let it fall on the fruit of her seed. the tree of her life had been fertile and the collection of beauty that she confronted made her feel proud. she knew that both fathers of these children were feeling pride where ever they were at the evidence of their seed and its strength.

she looked at them all. they were a good looking family, ebony colored, to a child. blessed with the same smiles of their grandfathers and the loving eyes and spirits of their grandmothers. they were the proof of her existence, of a life well spent on this earth. she took a moment to look into each pair of eyes and in that space found time to love each and every one of their spirits as she gave them the blessings of her life. she took from each of them as much of their earthly weight as she could carry, quietly cleansing each and every one of them in the process. when this task had been completed she looked out and began in a voice clear with thoughts concise,

-i a strong 'oman, there ain't no need to treat i a chile.
i olda than 'most two, tree or four of yous. i knows benjamin done dead.
seen him go to the bus and buy he a ticket he won't nebwer use.
saw benjamin laid out in he blue suit ewer 'fore him leave this house.

they all looked around. the younger ones surprised. grand geechee just shook his head at the futility of their attempted deceit.

*-saw anna margret in he blue hat with the veil, that mousy look around he
mouth he get whenever he 'bout to cry.*
*-but that ain't 'hy i done called yous chiren together. i a old 'oman. so old
can't 'zactly call i age. i done birthed nine little brown babies and done saw
them tru. now all i babies is down, down in the quiet earth, i job done done.*

she silenced the cries of

-oh mama

with a wave of the hand.

*-now y'all listens to i. i done done, tru. i tired.
i done raised this chere family, done carried y'all this long way,
from slavery times to right chere. i lord done seen i tru
the passin' of i trials and tribuations. now i glory time done come.*

again there began the beginnings of an outcry which she silenced with
one line,

*-i bags done packed, i time done come. i leaving here 'fore mornin' sun done
come... now y'all come on up and give granma hugs and some sugah,*

and with that, she picked up her youngest great great-granddaughter
and enfolded her into her arms.

there was not a sound. the members of the family just looked around at
each other, not knowing exactly what to say or do. the words she had
just spoken remained. not just because of what she had said, but because
each of them realized in their own way how much she had loved them
and they her. for as long as anyone could remember mam mam had
never spoken a word that was not truth. not just that she didn't lie, but
anything that she had ever said always came true. she knew about
benjamin as she had known about her first husband little. knew even
before he went possum hunting that night that the white men would
be hunting him. knew that he wouldn't return. she had tried to stop
him, but he wouldn't listen. after he had gone she had simply taken
out her black mourning shawl, thrown it over her shoulders and had
sat by the window all night and rocked, waiting. she had been sitting
rocking the next morning when they had brought his body home on
the back of his wagon, the rope still knotted around his neck, as it had
been when it discovered that the tree stump which held its other end

had not given as the weight choked the life out of his body. she had always known things. a conjure woman some of her neighbor womenfolk would say, behind her back, when she was out of earshot. even then they were sure to whisper, never hurt to be safe, but as the years had worn on, nobody could remember anyone being anything but helped by her gifts, so they were spoken of less and less, until they were forgotten or the secret had itself gone to the graves with the secret keepers.

as she hugged each of her grand, great-grand and great great-grandchildren she gave them each instructions, final directions and advice. this one was to make sure she stayed away from salt, this one was to leave the sugar alone. this one was to keep his wife from doing too much when her time came and she should name the boy after her father. she told the womenfolk who was to get what box, to see to it that miss so and so was to get this or that, and to please keep so and so away from her room and out of her medicine chest. she told which boxes were marked with the things she had left for each of them. after the dispensation of all her worldly goods was detailed and repeated back to her satisfaction she kissed each of them. then she sat each of the babies on her lap and talked to them one at a time.

when she had finished giving away all her blessings she had nothing left but her smile. slowly she stood and walked to the doorway that led to the stairs and the rooms above. she turned to the eyes within the ebony faces and gave away her final smile.

-now y'all member all 'hat i done taught yous. y'all member to love one 'nother. y'all 'member 'here yous done come from, and 'hat yous done come tru. y'all member that yous is all yous have. cherish each 'nother. 'member that all of y'all is stronger than any one of yous is alone. no, now don't start to cry. hush up that noise, y'all hear?

she said in response to some who were beginning to beg her not to go,

-i done liwed i life, more than. i done tired, now y'all got to let i go. my wisit done tru. now mr. waughn down at trinity know all there is to know about puttin' i away. now i don't want yous fussin' and hollerin' and moanin' ower i and such, y'all hear? listen now, i'm telling yous. it ain't dignify to chastise the lord when he done giwe i so much already. ooouuu!

she stretched,

-i done so tired i hardly can keep i eye open, but i 'clare 'fore the lord i
god, come tomorrow mornin' i's gonna be wadin'
tru the riwer 'cross the distant shore, in i father's house.
the boat man is done come for i and i don't aim to keep him waitin'
not a minute longer. i can almost see the green of the mountains on the
other side. i reward time done come and at last
i's gonna drink from the golden cup a ease.

slowly she turned and ascended the stairs this last time. they could hear her singing ever so softly,

-sweet chariot coming, coming soon, come to carry i home.

after she retired there was a stillness around the house that just couldn't be shaken. finally after a while the great-great-grandchildren slept. one by one so did the great-grandchildren and finally the grand. grand geechee was the last to fall into a fitful sleep. only the youngest of the children slept well that night.

the youngest great-granddaughter was the first to wake, rising with the sun. she tipped into her great-grandmother's room to see if she had indeed left on her journey. as her eyes grew accustomed to the early morning light which rushed through the curtained window she noticed the immaculately clean room. her great grandmother lay there, perfectly still, as still as the boxes alongside the walls, or the fall, winter and spring coats hung quietly above the silent shoes and their silent miles.

she tiptoed up to the bed to peer into the face of tranquility on the body which seemed so shrunken and small underneath the quilted bedspread. she recognized the smile on the face of the body which had just contained the spirit of her great-grandmother. but what she noticed most was the sense of calm, peace and completion on the ageless face. she looked like she was resting. so peaceful. the great-granddaughter realized that indeed she had gone.

she tiptoed down the steps to tell the others that they had better not wait. that they had better fix breakfast this morning for themselves. grandma would not be coming down today. she was restin' in.

december 1992

Destructionment
Treddin' een We Ancestas' Teahs

Marquetta L. Goodwine

The words "development" and "developer" ring hollow within the Sea Islands of the United States of America, and bring on images of family removal and the breakdown and dissolution of cultural ties. In this chain of islands that begin at Georgetown, South Carolina and run down to Amelia Island, Florida, these words have been used as a disguise for a commercialization process that has eroded a cornerstone of America: the Gullah culture.

Home of the Gullah and Geechee people and cultures, the Sea Islands might be regarded as the most purely African of all African American areas in the country. Gullahs were first recognized for their preservation of African culture in America due to the unique language that they speak — Gullah. As Gullahs began to move to the mainland and other areas outside of South Carolina, there sprang up a new name for these branches of their extended family tree: "Geechee."

"Gullahs" and "Geechees" are thought to be an enigma since they have been able to maintain many customs and traditions of their African ancestors in spite of being enslaved and oppressed like many of their mainland counterparts and kinspeople. This group of African Americans was able to retain their extensive cultural linkages largely due to their isolation on the islands in the Atlantic off the coast of what was then "the Carolinas." When Georgia became a state and chattel slavery was begun there, many were brought over and placed on the Georgia coastal islands. Northern Florida also had some island plantations on which Gullahs were enslaved. However, most Gullahs entered Florida as a means of obtaining freedom in maroon colonies in the swamplands and islands there as well as at Gracia Real de Santa Teresa de Mosi or Fort Mosi, a Spanish fort in the city of St. Augustine.

Gullahs and Geechees obtained freedom prior to the reading of the Emancipation Proclamation. After "Big Shoot" sounded the guns for the Civil War, the Euro-Americans in the Sea Islands who considered themselves "planters," held Africans and indigenous Americans captive and considered them "property," left the area "lock, stock, and barrel," unsure of what would happen to them if they remained in this area that would soon be in turmoil.

As the Gullahs and Geechees received word that the Union Forces

had arrived and were releasing them from bondage, many ran to the troops for guidance. As folks on various islands in Georgia and Charleston County, South Carolina learned that the troops' head-quarters were in Beaufort, S.C., in Port Royal and on St. Helena Island, many came by boat and by raft seeking refuge.

Having seen numerous African people coming onto shore in rags or, in some cases, stripped completely naked due to all they had gone through to leave the plantations where they had been enslaved, Union Army General William Tecumseh Sherman issued Special Field Order Number 15 on January 15, 1865. This order was the document which provided the basis for the claim of "40 acres and a mule" being entitled to every African American. However, most who speak about this claim do not realize that the Sea Islands was the area in which these 40 acres were to be apportioned. Special Field Order 15 stated that:

> The islands from Charleston, south, the abandoned rice fields along the rivers for thirty miles back from the sea, and the country bordering the St. John's River, Florida, are reserved and set apart for the settlement of the negroes...

Furthermore, the field order stated:

> At Beaufort, Hilton Head, Savannah, Fernandina, St. Augustine, and Jacksonville, the blacks may remain in their chosen or accustomed vocations, but on the islands, and in the settlements hereafter to be established, no white person whatever, unless military officers and soldiers, detailed for duty, will be permitted to reside; and the sole and exclusive management of affairs will be left to the freed people themselves, subject only to the United States military authority and the acts of Congress....

One might have thought that the "exclusive management of the affairs" on the islands might have been too much to give to a group of people who had just regained their freedom and who had been accustomed to following the orders of others. However, in most of the Sea Islands, Gullahs and Geechees had already implemented their own rules for regulation of their communities. While Euro-Americans had attempted to dwell on most islands, they were prevented from doing so due to a number of environmental conditions, including the temperature and mosquitoes that carried malaria. Gullahs and Geechees appeared to be immune to this disease for the most part.

On many plantations, the African placed as an "overseer" for the other African people was called a "driver," and he sparked hatred at first sight among the Gullah/Geechee people. Given that he would

have to have a certain allegiance to the oppressors, most Gullahs and Geechees shunned the company of drivers because they could not trust them. There were some cases, however, where drivers played a dual role and behaved as if they were in total agreement with all that "massa" said. Then, as soon as "massa's" boat cleared the banks, they would return to their people and share with them whatever they knew from the "oda side."

This effort of masking who one really was and how much one really knew was mastered by Gullahs and Geechees. Due to the fact that people spoke Gullah, and often another African language in addition to English, they were able to communicate what they wanted to a group of Gullahs without many others who might be standing close to them understanding what they said. They could then switch and tell the others in English what they wanted them to hear. This technique was no doubt honed as Gullahs did exchanges at markets and bartered on plantations. This afforded one of the means whereby Gullahs exercised their autonomy even prior to the Civil War.

Many Sea Island plantations in South Carolina operated on a "task system," where each person was assigned an average of one acre to work per day. This acre could be of cotton, indigo, or rice, the cash crops which built the infrastructure of America and England. After "having to" work these fields all day, each person was allotted a quarter task or a half task to work for him or herself. On this plot, edible goods such as corn, tomatoes, cucumbers, watermelons, etc. would be planted. These items, as well as livestock and poultry, became objects of barter to Gullahs and Geechees, which they were allowed to use in exchange for other goods they wanted which Euro-Americans had, such as cloth, sugar, and other imported items.

Many Gullahs and Geechees turned the selling of goods at markets into skills. In Charleston, people can still remember many of the songs that grew out of the merchants' calls as they traveled down streets or stood in the market selling goods. The seawork skills of casting nets, bogging for oysters, catching crabs, etc. as well as their skills in construction and woodwork gave Gullahs and Geechees the means to exchange goods and skills in the markets, and thereby to participate in the money economy. This put money in the pockets of African people which they were later to use to become official property owners of the very land that they had been forced to work to the point that it had become an extension of their very beings.

Although many Gullahs continued to inhabit and work the land on which they had been enslaved, even after the arrival of the Union

Forces, they did not have any official ownership of it, i.e. "dey ain' had nutin pun de papa." They knew within their spirits, however, that this was their home. They had built this area and their descendants had grown out of this soil.

Most Gullahs and Geechees had not even received official word of Special Field Order Number 15 before Andrew Jackson became the President of the United States, and promptly rescinded the order and then issued pardons in an attempt to restore property to the people who had enslaved the Gullahs, Geechees, and their foreparents on this land. However, this did not end the possibility of Gullahs ownership of the land; the people that were considered the official "owners" of the land were no longer in the area. In fact, this was how the Union Forces had been able to justify the confiscation and sale of the property in the Sea Islands in the first place: the "owners" were off seeking refuge with family and friends in the North.

Through a program that was set up by a group of missionaries who came to be called the "Gideonites" along with federal troops, the Gullahs were eventually able to purchase plots of land and to set up their own homes there. Many people now held deeds to land that they had toiled on since their arrival in this country or since birth. This program, called "The Port Royal Experiment," was put in place as an answer to the dilemma of education, shelter, and clothing. This was a means through which the Gullahs were to be able to sustain themselves until they could later be "incorporated into" society.

However, the incorporation of the Gullahs and their descendants into the greater society — Euro-American society as well as that of more assimilated African Americans — has also brought about a fading of their culture. As bridges were built to the islands, there was a flow of people into and out of the region. These bridges were the first major tools of "destructionment" used in the Sea Islands to threaten the survival of Gullah culture. To "develop" something is "to grow or expand" according to *The New Webster's Comprehensive Dictionary of the English Language*. However, the term "destruction" is the direct opposite of this, defined as "the cause of ruin."

The attachment of bridges from the mainland to the islands in the Lowcountry of South Carolina and Georgia as well as the building of resort/vacation/retirement areas has come to be known as "development" and the people that bring this in are called "developers." However, any Gullah or Geechee can point specifically to how these were never placed on the islands for their benefit, and have in fact only brought ruin to their culture, their language, their customs and their family ties.

In 1950, there was not yet a bridge to Hilton Head Island nor most of the other islands in the Sea Island chain. Bridges and causeways connecting one island to the next and small islands to the major islands and the mainland began to spring up throughout the region in the 1940s, as many people still living on the islands can recall. Prior to this, people came to the islands anyway, as had the British and the French, and were taken in by their beauty. One of those who came and changed the entire structure of the islands was Georgia timber magnate, Joseph B. Fraser. Fraser began by simply cutting down timber on Hilton Head Island in South Carolina until his son, Charles, who was a graduate of Yale Law School decided to launch "the development of a series of lavish resort 'plantations' — Sea Pines, Hilton Head, and Honey Horn."[1]

In the Foreword to *Sea Island Roots*,[2] Charles Joyner states that Fraser contended,

> It is a wise thing, for those who need the money, to elect to sell. Every black family that sells a portion of their heritage that was maintained with great struggle and great effort by their parents and grandparents and great-grandparents, and uses a part of that heritage to send a child to engineering school or to boarding school, is making an investment in the future of that family. I wish more of them would do it.

Of course Fraser wished that more of the families would sell their property to him; he and his son were developers, after all, and this enabled them to make greater profits. However, those Gullahs who did were doing exactly as he stated: "selling a portion of their heritage which was maintained with great struggle and effort." They were selling their birthrights and their heritage, the foundation of who they are.

The resort that Fraser and his son built was a success and still exists. It sparked a rapid increase of people wanting to invest in building resorts, which brought the Frasers a good deal of competition on Hilton Head. As "developers" moved in with trucks to fell trees and dig lagoons, they also moved into the Gullah community with a great deal of fast talk and untruths.

There are numerous Gullahs who used to live on Hilton Head but now reside in cities across the United States, who tell stories of how an elderly person in their family was approached with a briefcase full of single dollar bills and how this person was coaxed into selling the family land. In many cases, the elders did not realize that they were being told to give up the only place that they had even known.

Given the way in which Gullahs live on the land — in wide open space without gates, where people can come and use each others land for planting crops and so on — the concept of giving the land to someone else was not in their minds.

The documents that were presented to many people were of course legal documents that even college graduates would require lawyers to review. In many cases, these documents were presented to people who could not read and could only sign their mark at the end of the papers: "X." These Gulllah people did not realize that many times what looked like a lot of money was only stacks of single dollar bills. They also did not know that in the coming weeks, someone would arrive with trucks to tell them that it was time for them to move out so that their home could be destroyed to facilitate their digging. When the houses went down, so did the heritage and the legacy, the memory of midwives birthing generations of babies in the same house in one small room, the laughter and the tears that were brought out as the house was built and each tree or hedge was planted and tended to in the yard. The house would go into the same ground where many Gullah souls were also now residing. These souls would cry out, but due to the intensity of the pain that rendered the moving Gullah numb, the cries were not heard.

After a while, the level of development built up for and enjoyed by those coming in from outside permitted the tax base to be raised too high for many of the Gullahs to continue to hold on to their family plots. Due to the fact that someone else built a resort next to them that was valued at millions of dollars, a person who had been there all his or her life, making enough from the land and sea to cover their taxes, could no longer do so. As a result, many people who could not continue to pay lost their land at tax auctions. Even in recent years, some people's taxes have gone up 300% in a single year as a result of a resort being built adjacent to them.

This process became a means of removal of Gullahs and Geechees from wide property areas in the Sea Islands. When neither of the means mentioned above would work, "development" companies would (and still do) send scouts into the area to try to find "a weak link" in a family chain, in order to offer that person money for their land, or even the choice of swapping the land that they are on for another piece in another area (most likely far from where the person has any ties). If they continue to work on the person, they also try to get this person to sway others in the family

to sell, too. Frequently, in the end, greed takes over and people give up their land for what they thought was a lot — only to find out later that they would no longer even be allowed on the property again because a gate was going up which would only be opened for those with passes and who lived or had official business on this resort "plantation."

What was brought about in the guise of "development" was the initial mode of "destruction" that hit the Gullah and Geechee communities of the Sea Islands. Numerous people were forced to leave their land and go elsewhere, seeking jobs working for other people because they were only given menial jobs in resorts. Further, the resorts had caused the decline of sea life in the waterways, either due to the runoff of the chemicals used to clean the golf courses or the seepage from the congestion of so many septic tanks in a limited area.

In addition, people were unable to continue to maintain other traditional practices and means of survival, such as the making of sweetgrass baskets. In many areas, the sweetgrass was damaged or destroyed as the resorts were built, and as chemicals were used to kill insects and to clean golf courses, tennis courts, etc.. Basketmakers used to gather their sweetgrass from the shorelines; now they have to import it from Florida, either because the grass has been killed or they have no public access point in order to gather it. People are no longer allowed to go to cut sweetgrass in those areas where the landings they once used are now within the gated "communities."

After leaving with their hearts broken, or sometimes not even realizing the value of land ownership as they sought the cities with "streets paved with gold," many Gullahs and Geechees did not return home from the mainland except for funerals. While some continued to pay taxes on property that was left to them, they began to have their children in the cities, and their children knew nothing of their Gullah homeland. They never walked the dusty roads or felt the morning dew, never had their faces laced with the spray of the salt water, never saw the marsh sway as it moved in the wind as their ancestors voices spoke from another realm. They had been removed from their homeland and detached from their heritage.

As a result, often when people died and their children were approached by someone stating that taxes were owed on land in South Carolina or Georgia or Florida, they would not see any reason to pay it. Thus, another piece of heritage was sold to the highest bidder.

In the late 1990s, several "development" companies have sought permits in order to do sand mining on the islands, especially in the

Beaufort County area of South Carolina. The sand in the area is still extremely rich and fertile. Thus, it can be sold for profit. The sand that is dug out leaves a hole which generally fills quickly with water since this is a low water level area. These holes filled with water become a landscaped lake around which "developers" sell plots and pre-fabricated units to be built on these plots. The final item to go up is yet another gate.

There is no concern for the families that have lost children who drowned in these holes. There is no concern for the family homes that are ruined due to collapsing foundations from the land shifts caused by the displacement of the soil. There is no concern that in due course people's water supply will be contaminated from the processes being used and the depth of the digging as well as from runoff from materials being transported which are then cleaned off the roads.

Amid all of the elements that make up this process of "destructionment," Gullah culture has been fighting to stay alive. In the South Carolina Sea Islands themselves, Gullah culture can no longer be found on Seabrook or Kiawah Islands. These islands, that the natives of the area considered a part of Johns Island in the past, are now private resort areas. You have to drive a great distance on Johns Island in order to find the Gullah community there. On the way, you have to pass a number of gates to large pre-fabricated plantation styled houses and you can see the golf courses, tennis courts, and pools of yet another resort area. In Georgetown County, one has to search to find an African American community on the islands now, where once they were in abundance. Most of the people are on the mainland now. Nonetheless, the people still maintain their heritage and are proud of it.

On Hilton Head and Daufauskie Islands, Gullahs can no longer travel through the entire islands like they used to even as recently as 20 years ago. On both islands, they are now off on one side. The remaining areas of the islands have become commercialized with golf and tennis courses and villas and condos. In many cases, the people on these islands have not been able to remain independent business owners because large corporations have come in, set up businesses that sell the same services or goods, and pushed them out.

Mitchellville, once a totally autonomous African American community on Hilton Head which came into being during the Civil War, now is little more than a site for the remnants of buildings. Most African Americans never even get to see this spot because they have to go through the visitors' center's entire tour in order to get on the plantation which was the site of this African American town. This

was one of the first places that people started to leave in order to look for jobs, many returning to places from which they had come during the Civil War. Thus, the city eventually fell.

Sapelo Island in Georgia only has one remaining Gullah community on it — Hog Hammock. There were five, previously. People were pushed out of the other four communities into this single community as ideas came up for other uses of the island. There was no regard for the family histories that had come into being at each plot where people had dwelled. Many fought this displacement, but after a while the fight went on too long; some gave up and left the island entirely. The others that remained make up the Geechees of Hog Hammock.

Most of Sapelo Island is now owned by the State of Georgia. Marine research is being conducted there. Little went into preserving the Gullah or Geechee heritage there until it was realized that this was an element that could attract tourists. The families that reside there have inevitably been led to taking advantage of tourism and have rooming houses, hotels, mule cart tours, gift shops, stores, and more within the heart of this peaceful place.

Many of the people of Sapelo now dwell on the mainland in Brunswick and Darien, Georgia. Some have even gone to Savannah. Many others sought new homes on St. Simon's Island. However, on that island again, the Gullah or Geechee community is only in a couple of small pockets which seem set to have "destructionment" move them out as it continues to surround them on all sides.

American Beach, on Amelia Island in Florida, is a small unincorporated town founded in 1935 by the Afro-American Life Insurance Company. This was the first insurance company of any kind in the state of Florida. Due to the fact that African Americans were not allowed to go to many beaches which were designated "white only," Abraham Lincoln Lewis envisioned making American Beach a retreat for African Americans of all financial levels. The beach grew to have nightclubs, restaurants, a candy store, a motel, and vacation cottages, all of which were owned and operated by African Americans. Many of the homes on American Beach were moved there from the site of Franklintown. Franklintown was a settlement of "freedmen" after the Civil War. The townspeople even moved their church to the beach area. Things continued to flourish and bloom until integration came; then, many people began to support businesses outside of the community. Today the sand dunes of American Beach are being destroyed by developers coming in. One of the main companies that brought the destructionment there was that which Fraser founded on

Hilton Head in South Carolina: Sea Pines, Co.. Except for the unofficial mayor of the beach, MaVynee Betscha, who is the great granddaughter of A. L. Lewis, many of the original families gave up the fight against the encroachment and moved to other areas. The African American community of the small town is barely visible. Yet they still fight to have their story told. They do not want to be forgotten.

Gullahs and Geechees continue to pass on their stories to their children so that they will not be forgotten. The pride and honor can be seen in the eyes of all Gullahs and Geechees that continue to fight to hold on to their home in spite of the continued efforts of multi-millionaires to have laws changed in order to provide them with more sunny paradises in which to play. As any of them recount stories of what the islands were and the families that were there and as they tell you where these people are now, spread out in the world, you can see the spirits of the original Africans that came to be known as Gullahs standing at their side and giving them support to withstand the pain and continue on.

The Gullahs that still live in the Sea Islands and remember the islands before the fifties see them through very different eyes than those who come to live in the resorts. They remember the beauty of the dirt roads and trees all around. They remember the fields that they used to play in, and the landings to the creeks that are now locked away from them by gates and NO TRESPASSING signs.

They remember going down to family cemeteries to be able to visit family graves, clean them up and place new flowers there or other gifts. Now, if they do not have passes, they cannot even enter the plantations on which these graves lie. If they do get beyond the gates, they are likely to have the traffic of golf carts and cars going right by them as they stand with the graves in front of them and villas and clubhouses right over their shoulders on the right and left. They may even find golf balls in the cemetery instead of leaves or pine needles just fallen from trees, while for miles around their eyes can only take in what has been built where once their own culture flourished. The Gullahs and Geechees do not see the islands as the beautiful places in which they grew up. Many of them have to hold back the tears and swallow the pain as they come home from the mainland for a visit or drive to work in Hilton Head and other resorts each day. Those who live on Sapelo and Daufauskie have to travel by ferry to be greeted by sorrow as they go to work for and with people that do not have any knowledge of or concern for the stories that are all around them — the African, Gullah, and Geechee stories.

They can practically hear their ancestors scream out their stories that are buried beneath the pavement. The local Gullah business owners have to struggle to survive among the franchises and hotels and other million dollar businesses on the island. They even have to compete with the tourism bureaus and chambers of commerce to be recognized as these places seek to block them out and hire "imported" or "transplanted" African Americans to act as if they are the "true" Gullahs and Geechees.

Many Gullahs and Geechees can reflect back on the stories of their families – how they survived off the land and the sea for most of their lives and how they were fully self-sufficient. They recall the stories of the docks that they used to fish from or hook their boats to. They remember the beaches where Gullahs used to celebrate even during segregation when they were "not allowed" to be on the other folks' beaches. They remember being able to walk down the road and get anything they needed from a neighbor or family member. Now many of those people have been dispersed around the country and the world just as the husk was blown away in the wind from fanner baskets filled with rice.

Looking out over the various islands, one is still swept away by their captivating beauty. The beauty from the natural foliage and the smiles of the native people calls into question the beauty of congested roads surrounded by pre-fabricated buildings, golf courses, and tennis courts. As for the landscape of the islands that are now among the best known resorts in the world, "beauty is in the eye of the beholder."

There is nothing more beautiful than people knowing who they are and being able to celebrate that knowledge. The loss of land has meant the loss of traditions in more ways than one in the Sea Islands. From all over the African diaspora flung out across America, Gullah are returning to re-evaluate whether the building that has occurred has truly been development or if it has been destruction. In the final analysis, the act of "destructionment" cannot and will not be allowed to continue as people see that when one culture dies, another soon follows.[3]

[1] Patricia Jones-Jackson, *Sea Island Roots*. University of Georgia Press, Athens, Ga, 1987, p. xii.
[2] *Supra.*, p. xiii.
[3] This article contains numerous excerpts from the section on Hilton Head Island in *Gawd Dun Smile Pun We: Beaufort Isles*," volume II in the series, *Gullah/Geechee: Africa's Seeds in the Winds of the Diaspora*, by Marquetta L. Goodwine.

The Ecology of Gullah's Survival[*]

Salikoko S. Mufwene

Gullah, also known as Geechee and Sea Island Creole, is a creole spoken by less than half a million descendants of Africans living in coastal South Carolina and Georgia. Gullah has been claimed to be dying since the end of the late nineteenth century.[1] However, Gullah is pretty much as lively as it was in its beginnings, despite what outsiders may think. In this article, I discuss the kind of ecology that, on the one hand has helped Gullah stay more or less the same since it stabilized apparently in the nineteenth century and, on the other hand, has kept it from becoming more like other varieties of English spoken either by descendants of Europeans or by the educated middle class. I do not, however, claim that Gullah is not endangered. I argue below that it is not endangered by debasilectalization (the loss of features that make it distinct from more prestigious varieties of the language) but by factors that are largely ecological. The ecological factors I invoke are both internal and external to Gullah itself and the community of its speakers. The distinction between the two kinds will not always be clear-cut, and I invoke factors that bear on the fate of Gullah in North America, such as group identity, solidarity, loyalty, variation within the variety, residential patterns, and ability to switch codes.

In the broader picture of North American colonial history, Gullah developed gradually in the direction of basilectalization. This view is consistent with the way the plantation industry developed, starting with smaller and less-segregated homestead communities and extending to larger and more-segregated plantation communities in which Europeans and their descendants and Africans and their descendants interacted less and less. Life expectancy dropped quickly, the labor population kept growing more by importations from Africa and Europe than by birth, and the speech models for the newcomers were often restructured further and further away from the metropolitan and earlier colonial models. Gullah must have basilectalized gradually in the course of the eighteenth century.[2] This process must have continued up to around the abolition of slavery in the mid-nineteenth

[*] Reprinted in abridged form with permission from *American Speech*, Vol. 71, No. 1, 1997.

century.[3] After that period, Gullah must have been as stable as any other new variety of English that developed in North America, although it need not have consolidated concurrently with them. Gullah has been under no more pressure to change than any other nonstandard variety of English in North America.[4]

This essay starts with ecological factors that led the colonial English appropriated by Africans and their descendants in coastal South Carolina and Georgia to diverge into Gullah. Because segregation precluded African and European Americans from socializing routinely across racial boundaries, the restructuring of English into North American varieties was subject to influences that varied in some respects. This situation cleared the way for more, or fewer, divergent developments depending also on the closeness or distance of the initial conditions of contact. African Americans did not preserve an archaic form of English outgrown by European Americans, even though a few relic forms might survive. Varieties just developed concurrently, diverging in some respects but also retaining several common features whose frequencies differ ethnically. In short, segregation fostered the development of separate group identities, including separate language norms even where differences are minimal.

Segregation has not disappeared *de facto*, despite its abolition *de jure*. Thus, the vast majority of African Americans socialize among themselves, just like the vast majority of European Americans and other ethnic groups socialize among themselves.[5] Although they meet at school, at work, and at other public places and institutions, the sense of ethnic identity developed in the African-American community has not favored abandoning features of "the community".[6] Shedding their ethnic identity is typically associated with moving out of "the community," which only very few have been able to do.

Group identity has been an important factor in preserving Gullah. Although those who go to school outside the "community" — especially the few who go to college in the American hinterland — return home not speaking the same way, a significant proportion of them learn to code-switch successfully. The reason for retaining Gullah, as stigmatized as it may be outside the "community," is that, as one Geechee high school student once explained to me, they would not like to be considered snobbish to the peers they left behind.[7] If they spoke Gullah before they left coastal South Carolina or Georgia, people who return, often after long periods of residence in New York and similar cities, typically revert to this vernacular. For them it is one of the ways to identify themselves with home. Some of Gullah's most

basilectal features comes from such speakers, after they have idealized their speech according to a stereotype that is not quite an accurate picture of the variable vernacular spoken by the community members they left behind.

One may wonder also whether group identity is the only reason why Gullah has survived. Identity is an important ecological factor that has also helped other varieties stay alive despite the fact that they are also stigmatized. For instance, South American English as spoken by Southerners of European ancestry has continued to be spoken in the south, its homeland, and does not seem to be endangered at all. So it is with Appalachian and Ozark Englishes and a host of other varieties. Stigmatization can work to extinguish a variety only if the community's sense of identity has been eroded. This is more likely to happen if a noncolonized population has been relocated. Gullah speakers stop speaking their vernacular away from home, especially when they interact with people of different backgrounds; they do not stop speaking it at home.

In addition, geographical and social isolation has contributed to helping Gullah, like other stigmatized varieties, survive outside pressure for change. Pressure to assimilate to majority groups is nonexistent for those who do not venture outside the "community". Despite population movements since WWII, a critical mass of the population has always remained well rooted in coastal South Carolina and Georgia, ensuring continuity. Gullah need not have changed any more, nor faster, than any other language that came in contact with another but whose speakers were not integrated into or assimilated to the other community.

The new white residential communities of coastal Georgia and South Carolina are likewise separate from the traditional, predominantly African-American communities. They are separated not only by highways passing between them but also by stretches of undeveloped land.[8] If the newcomers become more numerous and bring with them socio-economic prestige, they are more likely to impose their outside norm and cause the local variety to erode under the influence of the outside variety. These ecological conditions for change in the local variety have not obtained in the Geechee communities because African Americans and whites on the coast, as elsewhere in North America, do not typically socialize routinely across their ethic boundaries. For instance, one seldom sees them in the same bars or social clubs, and they hardly talk to each other in the grocery store. It is a mistake to expect every stigmatized community to change when it

comes in contact with a less-stigmatized population only geographically but not socially.[9]

Although the newcomers, mostly whites, may have formed a community including some of the local whites, they have usually settled in parts that had not been heavily inhabited and remain separate from where the native Geechee populations have lived. The principal meeting point between the Geechees and the newcomers has typically been the grocery store. Otherwise, their social networks of interaction have remained separate. These ethnographic conditions make it difficult to imagine why anybody would expect the presence of newcomers in the area to influence local speech other than their addition to variation in a way that hardly affects Gullah itself. One may hear more varieties of English now in this part of the United States; but does the addition of the new varieties necessarily lead to the loss of the earlier varieties, particularly if there is little interaction between the Geechees and the newcomers? Do linguistic features spread like cold germs, without intimate interaction between carriers and non-carriers?[10]

As for the presence of tourists, one wonders how many times tourists stop to interact with the local populations in the first place. Much of the presumed interaction between Geechees and tourists in the resorts of South Carolina and Georgia is associated with Geechees who work for the resorts. Typically they are maids and janitors; managerial positions are generally held by whites from other parts of the United States or English-speaking world. Contact has also been associated with the basket ladies who sell their products along the highway or at the market points at the resorts. We may, however, ask ourselves how many times guests stop to talk to maids in hotels and whether the few occasional exchanges of greetings between visitors and service personnel are likely to influence local speech.

As for the basket ladies, first, only a small proportion of the population is engaged in basket weaving. Second, the few markets at the resorts are from a linguistic point of view, reminiscent of those at the Charleston market: the basket ladies, who have little education and are not necessarily fluent in the middle-class variety, use their native vernacular to speak among themselves and use an approximation of the variety spoken in the nearest city to speak to tourists. One is thus reminded of diglossia in many Third World countries, where one variety, often a different language, is used to accommodate the stranger and another is reserved for communication among the locals. We may call it bidialectalism in the case of Gullah; it may be bilingualism

elsewhere. The names for this ability to manipulate more than one system may be different, but the linguistic strategies are of the same kind. The real question is when such alterations are likely to produce change. They do not seem to have had such an effect on Gullah.

On the Sea Islands of South Carolina and Georgia, the location of the vacation resorts is especially interesting. They are typically at the beach, whereas the local residential neighborhoods are not. The highways leading to them hardly cross the residential communities; they bypass them. Few tourists stop to buy baskets on the highway, and the locals need a pass to enter the resorts. Why change should be expected when the tourists are not absorbed in the local communities or vice versa is quite intriguing. I once asked a Geechee working at one of the resorts whether, after work and back home, he ever felt compelled to talk like his patrons during the day. Thinking I was a fool, he asked me what the motivation would be for this shift at home. He wanted to talk like everybody else at home. The reply is also akin to what I learned from a high school senior who would not speak Gullah in my presence but spoke it freely in my absence. Asked why he would not stop speaking it altogether if he was embarrassed to use it in the company of outsiders, he said that he would otherwise be treated as a snob in "the community" and would not have many friends. A speech variety that is generally considered nonprestigious may have prestige for its speakers. Thus, the stigmatized status of a language variety does not seem to automatically augur its death.

There is no documented evidence of unequivocal linguistic influence on the structure of Gullah from tourists or newcomers to the region. The role of the media and the school system seems to have been misinterpreted. Because the locals can watch, listen to, and understand programs on television and the radio, as well as read articles in newspapers, there is no doubt that they have developed interpretive competence in the variety used in the media. It is also true that some of the more educated Geechees can speak some approximation of that variety. Does this mean that such speakers also speak it as their vernacular while continuing to reside in the Geechee community? My field records do not suggest this. I have often observed that those who wanted to conceal their Gullah speech from me would speak it when they were not aware of my presence or forgot that I may be listening or simply did not mind me any more. I have seen people watch television and then turn around to comment on it in a different local variety, either what we call Gullah or something closely related to it. But then we must remember that history does not suggest that there was ever any

time when all members of the community spoke our academic stereotype of Gullah.

One must also wonder why the media would have accomplished in the Geechee community what they have failed to do in the rest of the south, where the majority white population had earlier and greater access to the media. We may also ask ourselves whether our ability to read more highly rated varieties of English, or any other scholarly language, has led us to speak the same written varieties. What motivation would noncolonized native speakers have to shift to a vernacular that is external to their domestic environment?[11]

There are reasons for doubting whether the school system has had the impact attributed to it in the literature on debasilectalization. If anything, it has fostered bidialectalism and/or a form of diglossia. The Oakland School Board's decision to teach standard English as a second language variety to AAVE [African American Vernacular English] speakers is one of the latest pieces of evidence that the school system has not had that generalized impact. Reports that several African-American ministers "slip back" to AAVE when they become emotionally involved in their sermons, or that politicians switch to the vernaculars of their constituencies while visiting among them, suggest that schools do not obliterate vernacular varieties but simply teach alternatives to them that are better accepted in specific ethnographic settings in which the same ministers and politicians are expected not to speak their vernaculars. That white southern English has persisted to date is a clear indication that the effect of the school system has been vastly exaggerated.

In sum, the history of English in North America has been marked with assumptions and expectations that do not seem to be justified. Several questions of language change or linguistic evolution have too often been approached as if the ecology in which a language variety has been used were irrelevant to its fate. In the case of Gullah, land developments have brought newcomers to coastal areas of South Carolina and Georgia, where they have become the majority of the population. Now in the Gullah region glass-wall isolation has replaced geographic isolation. In predicting the pending demise of Gullah, patterns of social interaction have not been taken into account. Persistent neglect of the fact that even speakers of stigmatized varieties have a sense of linguistic identity and loyalty to their culture has too easily led linguists to speculate that Geechees must feel some social pressure to shift to "mainstream" American values. We have simply overlooked that humans have adaptive skills that enable them to alternate between two or more systems, according to some division-of-labor norms that they devise.

Most of the above discussion has explained why the structure of Gullah is not being seriously threatened by the other systems that its speakers have come in contact with. It says nothing against the fact that Gullah may be endangered by the economic system. Immigration of Geechees to cities in South Carolina, Georgia, and outside these states (e.g. New York and Washington), where they are under real pressure to assimilate to the local population and to avoid being stigmatized, reduced the total population of speakers. Not taking into account maid and janitorial service in the neighboring resorts, lack of any kind of industry that would motivate the more economically ambitious young Geechees to remain in the area erodes the reproduction of the language, as the number of potential new speakers may not grow, nor be sustained, in some of the communities.

The depopulation of some islands, such as Cumberland in Georgia and Daufuskie in South Carolina, is also a more serious threat than is the influx of continental Americans to, for instance, Hilton Head in South Carolina or St. Simon in Georgia. In the former case, the Geechees who migrate to the city succumb to fear of stigmatization and adopt the majority's norms. In the latter case, the locals sometimes feel more pressure to assert their own identity and to speak in ways that will continue to distinguish them from the newcomers. This is happening on Hilton Head, where Gullah is attested with more and more basilectal features. The more Gullah seems to be an underground phenomenon, the more resilient it may be to outside pressure. The real threat to this vernacular seems to be potential demographic erosion of its speakers. One of the factors favoring its survival now is the fact that its speakers are not integrated in the population of the more affluent newcomers.

To sum up, what takes place in one community need not be expected to happen in another, regardless of apparent similarities. Differences in ethnographic ecological conditions are likely to produce different outcomes of similar events, in this case migrations of outsiders to island communities. In the case of Gullah, one must distinguish the question of debasilectalization from that of endangerment. Although the former process may contribute to the latter, there is no evidence for it, not any more than in several other nonstandard varieties of English in North America. The *de facto* segregation of ethnic groups, as highlighted especially by residential patterns may have helped foster a sense of linguistic identity that has contributed to the preservation of Gullah's structural features.

However, even if Gullah's death may not be predicted with certainty, Gullah may be endangered. Economic, rather than traditional

sociolinguistic factors, seem to bear most critically on this condition. They will largely determine how much longer Gullah will be spoken, if it is moribund at all.

———————

[1] Rev. John G. Williams, "A Study in Gullah English." *The Charleston (SC) Sunday News*, Columbia, SC., 10 Feb. 1895. Author's ms. in the University of South Carolina Library,

[2] Salikoko S. Mufwene, "On Decreolization: The Case of Gullah." in Marcyliena Morgan, Ed., *Language and the Social Construction of Identity in Creole Situations*. UCLA Center for African-American Studies, Los Angeles, 1994. 63-99.

——1996a. "The Founder Principle in Creole Genesis." *Diachronica* 18: 83-134.

[3] An important factor here is the stabilization and growth of the African-American population by birth rather than by importation or by immigration. On the other hand, the immigration process increased among European Americans, offsetting drastically the general race demographic disproportion but bringing no end to the de jure and later de facto segregation. Thus, marginal, regular or intimate social intercourse between European and African Americans hardly favored generalized influence of European-American English on African-American speech.

[4] I have also become reluctant to disfranchise Gullah—a name used by its speakers— as a creole and therefore a separate language, according to most creolists (e.g. Holm 1988). Nothing in the process called creolization suggests that the end point must be a separate language. Native speakers of Gullah say they speak English, albeit a nonstandard dialect different from other such dialects in North America, which are not mutually intelligible to all speakers. To the extent that all North American varieties of English developed from contact of languages and/or dialects (Mufwene 1996b), there is no particular reason why the appropriation of English as a vernacular by descendants of non-Europeans and its concurrent restructuring should be assumed to produce a separate language. Despite outsiders' claim that Gullah is unintelligible to them, linguists would be better off not patronizing native speakers and indirectly encouraging further disfranchising of the community, especially since the language/dialect distinction is not structurally based.

[5] The relative integration of European Americans holds mostly when they are contrasted with other races. American history yields abundant evidence of distinctions along ethnic lines, e.g. between German, Italian, and Polish Americans, some of which are reflected in the development of ethnic varieties of English among European Americans.

[6] I use *community* between quotes to reflect how African American leaders refer to the African American community, especially the less affluent and typically segregated part of it. Otherwise, the term retains its ordinary meaning in the linguistic literature.

[7] Salikoko S. Mufwene, "Why Study Pidgins and Creoles?" *Journal of Pidgin and Creole Languages* 9:265-76; 1988. "Investigating Gullah: Difficulties in Ensuring 'Authenticity.'" in A. Wayne Glowka and Donald M. Lance, Ed. *Language Variation in North American English Research and Teaching*, New York, 1993. MLA, 178-190.

[8] I comment below on why vacation resorts have not had the impact speculatively attributed to them in the literature.

[9] Incidentally, Wolfram and Schilling-Estes also report the existence of a middle-aged group that represents resistance to the change in progress and loyalty to their ancestral identity. They preserve selectively, but not totally, some features of

the moribund dialect.

[10] Southern English is not disappearing despite the influx of Northerners to the South, although one may identify communities, such as in coastal Florida, where leveling is taking place or where Northern linguistic norms have become prominent. However, such linguistic communities are far from typical in the South. In several southern cities, the local norm has not been displaced, nor is there any good reason for assuming it to be threatened under the present conditions of the coexistence of dialects. Note in fact that children of newcomers assimilate to the local norm, much to the horror of their less-adaptive parents. The outsiders' speech is tolerated, perhaps even admired, but not necessarily emulated; hence it does not threaten the local norm.

[11] I have been told anecdotally that children left alone watching television without interaction with the speaking community have failed to learn the language spoken on this medium. It would thus take more than simple eposure to learn to speak any variety, except of course in cases where one deliberately selects such a medium as the source of linguistic information. Thus a few Africans in countries surrounding Zaire and the Republic of the Congo have learned to speak a little Lingala from the radio and television music programs by sheer determination to understand the music. There are a lot of Zaireans, however, who sing those Lingala songs without understanding much of what the words mean.

Holdin' Pun We Culcha
Sites, Individuals & Organizations Preserving the Gullah & Geechee Heritage

Marquetta L. Goodwine

In 1950, when Georgia timber magnate Joseph B. Fraser and his son Charles began cutting down trees for one business and used the timber to build buildings to start another, no one realized that this would be a precursor to ethnocide. The resorts that they built were only supposed to be recreation areas, getaways, and hideaways for a few to come and enjoy the island view and atmosphere. However, as the trucks rolled out completing the building and the money began to roll in, greed continued. Families were asked, then coerced, then tricked and hoodwinked into letting go of that which their ancestors had fought so hard to obtain and maintain.

The face of Hilton Head Island changed forever in 1956 with the coming of the first bridge attaching it to the mainland. Prior to this time, the island was populated almost entirely by Gullah. By the mid-1970s, there were six gated communities on the island including the Port Royal Plantation which was started by Fraser's timber associates, Fred Hack and Olin McIntosh. By the 1980s, Gullahs were outnumbered by European people at a ratio of 5 to 1.

The rush for recreation has not ended in the Sea Islands. The development now called Fripp Island was started on a barrier island on the other end of Beaufort County in 1963. Unlike Hilton Head, Fripp did not displace any families. 1995 brought a retirement area which even the people of Hilton Head grumbled about: "Del Webb's Sun City Hilton Head." It seems hardly accidental that this place bears the same name as a place of recreation that boomed during the reign of apartheid in South Africa.

To this day, many other "developers" follow Fraser[1] with no regard for the continuation of family ties and the fact that for Gullahs, the land is an extension of themselves. Many people who have bought land have the same mentality: blocking people from visiting a family homestead simply because it is at the tip of the end of their property lines, refusing people access to park on the road in front of their property so they might catch a distant glimpse of a place where they used to play. The gatekeepers will not let people in to visit their own family gravesites.

Battle after battle has taken place in the courts of South Carolina, Georgia, and Florida as Gullah and Geechee Sea Islanders fight to regain their property and to hold on to their rights and the rights of their ancestors whose spirits should be allowed to move about as they once did. The battles in courtrooms, on streets, in county and city council meetings, etc. have not ended. The education of people regarding what the Sea Islands are, what Gullah and Geechee mean,* and what it takes to preserve them has not ended either. This process is present in the work of a number of individual activists and artists, organizations and institutions. In various ways, many people have answered the call of saving and preserving Gullah culture.

Although the history from Georgetown County, South Carolina, down to Amelia Island, Florida, is immense, the aspects that include the stories of African people that built the area have not been properly noted for the most part. However, some of the sites that have become listed on the National Register of Historic Places include:

Historic Beaufort District

This is the township of Beaufort in Beaufort County, South Carolina. Many of the buildings throughout the district were built by people of African descent. However, there are no individual monuments to the builders because they were simply seen as "slave labor." The bust of Civil War hero, Robert Smalls, can be seen within the district. There is also an area called the "Northwest Quadrant" in town, an area which was primarily for Euro-American "plantation owners," where Gullahs were allowed to purchase property.

During Memorial Day weekend, the Henry C. Chambers Waterfront Park is the site of the annual Gullah Festival. The Gullah Festival Committee led by Rosalie Pazant can be contacted at :

Gullah Festival Committee
Post Office Box 83
Beaufort, SC 29901
(803) 525-0628.

Penn Historic District

This 50 acre area is the home of Penn Center, Inc. which once was Penn School, the first trade and agricultural school for "freedmen." The school was founded in 1862 and closed in 1948. However, Penn

* See my article "Destructionment: Treddin' een We Ancestas' Teahs"

Center, Inc. has continued to serve as a meeting place for various Sea Island activities. People can support the York W. Bailey Museum, the Land Use and Development Fund, and the Program for Academic and Cultural Enrichment by contacting:

Penn Center, Inc.
Martin Luther King Drive
Post Office Box 126
St. Helena Island, South Carolina 29920
(803) 838-2432
(803) 838-8545 Fax
E-mail: Penncent@hargray.com

The Penn Club is the organization through which individuals support the on-going work of Penn Center, Inc. There is a membership fee which includes receiving the Penn Pals newsletter. To become a member, write:

Penn Club
Post Office Box 246
St. Helena Island, SC 29920

Daufauskie Island Historic District
Daufauskie Island is the last in the islands that make up Beaufort County, South Carolina. It became famous through the writings of Pat Conroy about his life as a school teacher there. The book and the film about Conroy brought fame and visitors. Many of those visitors opted not to leave, given the congested nature of Hilton Head. They decided to bring golf courses and tennis courts to Daufuskie.

International Paper Realty Corporation of South Carolina bought land from Charles Cauthen and other investors on October 23, 1984 and subsequently built a dock which they named "Haig Point." In that same month, Bluffton Timber and Land Company sold Melrose Plantation to the Melrose Company, a group of fifty investors represented by Jim Coleman, Steve Kiser, and Robert Kolb. Ever since that time, the Gullah community of Daufauskie has had to fight for its rights.

There have been numerous legal cases on Daufauskie in regard to the blocking of public roads so that the Gullahs would not be able to use them. In the fall of 1990, the Gullahs brought suit against the Melrose Company and Cooper River Landing Company, Inc., charging them with trespassing and desecrating the graveyard. Apparently, there was an attempt to build a house on a Gullah cemetery, and a dock was

built that cut off access from the cemetery to the water. (The connection of the resting spirits to water is essential in Gullah burying traditions.)

On January 25, 1991, Judge Thomas Kemmerlin ruled against the "developers" and in favor of the Gullah. Yet, this was only the first step. It was not until several more hearings that in June 1993, the case was settled out of court. The Melrose Reception Center was to be moved to another location and the cemetery was to be restored.

In spite of all this, the Gullahs on the island are currently being prevented from driving their cars down to bury their dead. Although they had an agreement permitting them access to the gravesite and to the beach that is along the same road, the road there has now been blocked and they have been told that there are new owners who do not have to adhere to previous agreements. Yvonne Wilson and many others on the island have been instrumental in continuing to fight for the preservation of Gullah heritage on Daufauskie Island. They continue to host the Daufauskie Day each summer and to preserve the old buildings of the island, including the First Union African Baptist Church which will be 117 years old this year. Yvonne Wilson can be contacted at:

Yvonne Wilson
Post Office Box 20,
Daufauskie Island, SC 29915.

Charleston Historic District

The narrow streets and colorful buildings of the City of Charleston in South Carolina have numerous stories to tell. From Catfish Row to Rainbow Row, there are real people behind the colorful window panes. Many people do not realize that Porgy of *Porgy and Bess* was a real Gullah man from the islands whose family is still there. To get the heart of the Gullah story in the city, you will need to contact Alada Shinault-Small and family to take you through the city, recount the stories for you, then take you over the bridge and onto one of the many islands of the county. Her company, "Living History Tours," can be contacted at (803) 764-1900.

For details on various information on Gullah culture that has been printed as well as to see exhibits, contact:

Avery Research Center
for African American History and Culture
125 Bull Street
Charleston SC 29424
(803) 953-7609

Avery is just up the block from the site of a building which is said to have been the home of Denmark Vesey, a "freedman" who planned a major uprising to take over the city of Charleston. People still wonder what this country would have been like if that had not been foiled.

The Old Slave Mart Museum in Charleston on Chalmers Street has not functioned in many years. It is currently being renovated, and there is a fear that it will not present the history of the various auctions of enslaved Africans that were conducted here as it did in the past.

The Old Slave Mart Museum is often confused with the market place which is in the middle of historic Charleston. This is the location where many people from the islands came to sell their goods in the city. Gullah women can still be found weaving sweetgrass baskets at this marketplace to this day.

The Sea Islands are famous for their sweetgrass baskets; it is this image which most frequently comes to mind when people think of Gullah traditions. The sweetgrass basket tradition has been largely maintained by the women of Mt. Pleasant, South Carolina. If you drive through this town on Highway 17, you will find the women and men sitting on the side of the road weaving baskets at their stands. On November 22, 1997, a marker was finally placed on this highway to honor the sweetgrass basket makers and this Gullah tradition.

The marker is only a short distance north on Highway 17 from the Boone Hall Plantation and the Charles S. Pinkney Historic Site. These two places are significant in that the first, which prides itself on being the "most filmed plantation," is the site of one of only two "slave rows" in this country. There are several brick cabins that remain standing on this plantation just outside the gates of the "big house." During the plantation tour here, just as on many of the others in the Charleston area, visitors are told of the building of the various edifices, but not of the Gullah skilled labor that made the bricks from mud and straw and did the processing of the bricks and the construction work.

Charles S. Pinkney's site is significant in that he witnessed the initial crop of indigo actually take hold in South Carolina. This crop became one of the major cash crops as the dye was used in conjunction with the "long stapled Sea Island cotton" that was being shipped all over the world due to its high quality.

The South Carolina African American Heritage Council has been working to make sure that more sites that focus on the history and heritage of Gullahs and other African Americans are brought to public attention. They can be contacted at:

The South Carolina African American Heritage Council
619 Robyns Glen Drive
Mt. Pleasant SC 29464
(803) 881-5516
(803) 884-7473
(803) 881-7070 (fax)

They are part of a group of organizations called the "Southeast Regional African American Preservation Alliance." The mission of the alliance is "To encourage the preservation of African American history, sites, and culture."

A discussion of the history of Gullahs cannot be complete without a focus on rice, the other cash crop that financed the infrastructure of America and England. If you would like to simply step back in time and learn more about the processing of rice, stop by:

The Rice Museum
638 Front Street
Georgetown, SC
(803) 546-7423

Georgetown County, South Carolina, was a major rice district filled with aristocrats. Today, most of the Gullah community has spread out onto the mainland. There still remains a Gullah community on Sandy Island while others hold on to their property on Atlantic Beach.

Beaulah Priest-White and others have stepped forward to make sure that the Gullahs of Pawley's Island can continue to remain there amid rapid resort encroachments. They have worked to build affordable housing, have job training, and leadership development within the community. They can be contacted at:

Five Rivers Community Development Corporation
Post Office Draw 1279
Georgetown, SC 29442-1279
(803) 527-4596/3035
(803) 527-3878 Fax
E-mail: fiveriverscdc@mailcity.com

There are people within the community that provide tours as well. You can visit a number of old churches and pass by and through plantations that were the home of many Gullahs.

Heading south toward Charleston on Highway 17, there is a small town called McClelanville which also has the sweetgrass basket heritage and the rice plantation history. After passing through this, Mt. Pleasant, and the city of Charleston, one will hit the turnoff for the major islands of Charleston County which are home to Gullah people – Johns, Wadmalaw, Seabrook, Edisto, and James Islands.

The people of these islands have fought for years to keep their property and to keep their culture alive. As is the case in George-town County, they witnessed the coming of resorts and retirement areas that would surround them. In the 1970's, Kiawah Island became the second resort in Charleston County. It followed on the tail of Seabrook Island. There was no community input in the sale of the island. Had there been, there would still be nothing but Gullahs on that island to this day.

The people of Johns and the neighboring islands are very close knit. There are a number of organizations that oversee the things that go on in and will affect that Gullah community. The people of the "Moving Star Hall" Congregation on Johns Island have become famous for keeping Gullah spiritual traditions alive. Members of this church and activists like A.B. Jenkins can recount stories of the days of old as they sit now to plan for a continued future of their people on the island. To contact the organizations of John's Island, write to:

John's Island Rural Housing
3624 Maybank Highway
John's Island SC 29455
(803) 559-3359

A person can even stay on Edisto Island in what was once a rice plantation. Historic buildings such as the Point of Pines Slave Cabin and the Hutchinson House are only a short drive away. Contact:

Edisto Beach State Park
8377 State Cabin Road
Edisto Island, SC 29438
(803) 869-2756/2156

With all of these sites, as well as Battery Wagner on Morris Island giving tribute to the 54 Massachusetts Colored Infantry, there are nonetheless a number of places in which Gullahs made history which are not recognized in the manner that they should be.

A prime example of this is the site of the Stono River Rebellion which took place in 1739. Some 20 plus Angolans played drums, waved flags and marched toward freedom in Florida, killing many of those that were involved in their enslavement en route. In the small town of Rantoweles, S.C., there is a marker that is extremely difficult for anyone to locate. The story of the Stono Rebellion is still not even taught on any major scale in any of the counties of South Carolina.

Beaufort County, South Carolina, has only recently begun to focus more on the rich Gullah history that remains there. The tourism board has started to focus on it, mostly in order to capitalize on it. There has been no major push to preserve it; rather, they have brought in newcomers of African descent, promoting them as "authentic" Gullahs. Small things such as the photographic display at the Henry C. Chambers Waterfront Park have been erected as a result of the persistence of Gullahs in the area to proudly continue to celebrate their heritage.

There have been other markers that have been placed in Beaufort such as the one at Camp Saxton on the Naval Hospital Base in the Port Royal area. This marker was spearheaded by the Penn Michigan Support Group out of Detroit. They were essential in starting a tradition of having the Emancipation Proclamation read at this site every January 1st since the marker was erected. This was the original site at which this was done in the Sea Islands.

A few miles away, there is also a marker at the Technical College of the Lowcountry campus. This is the campus of Mather School which was a boarding school for African American students that was started during Reconstruction. The school was very similar to Penn School on St. Helena Island in terms of what it taught. The missionaries there also worked with orphans of the area for many years until the school could no longer remain independent.

The other major marker to people of African descent in Beaufort is in front of the Cope Building (which will soon house the museum) at Penn Center, Inc. This marker has Penn School history on one side and the story of Charlotte Forten, the first African American instructor there, on the other side.

St. Helena Island

St. Helena Island, South Carolina, is one of the last islands on which there is a major viable Gullah community. Many of the other islands have the Gullahs off on one side or sandwiched between gated communities. St. Helena is the only place in South Carolina which

still has three of the original "praise houses" still standing. These were small white edifices in which Gullahs met (and still meet) to deal with community business, to give testimony and take part in rituals. The "shout" tradition sprang forth from here. The polyrhythmic handclaps of Gullahs and the special cadence of the songs which are now called "spirituals" all grew up from beneath the floorboards of the "praise houses."

There are churches amidst the numerous communities through-out St. Helena Island that can tell many stories of enslavement, the Civil War, the Port Royal Experiment, Reconstruction, and the Civil Rights era. This was the island on which Martin Luther King, Jr., the Southern Christian Leadership Conference (SCLC), and the Student Non-Violent Coordinating Committee (SNCC) met to do major planning during the Civil Rights Movement. Training sessions were held here. Dr. King used this as a place of retreat. In honor of Dr. King, the area called "the Green" at Corner was renamed the Martin Luther King, Jr. Memorial Park. It has been renovated by the park committee which continues to maintain it.

It is no wonder that St. Helena Island was the first location in Beaufort County, and one of the first in South Carolina for a chapter of the National Association for the Advancement of Colored People. This chapter is currently spear-headed by Michael Rivers of Seaside Road. They continue to be a part of and to focus on the various needs of the St. Helena Island Gullah community. The organization can be contacted at:

NAACP-St. Helena Chapter
Attn: Michael Rivers
234 Seaside Road
St. Helena Island, SC 29920

Amid all the oak covered trees, just down the road from the Penn Historic District and up the road from the historic Chapel of Ease, lie two small cottages painted white with blue window panes as is Gullah tradition. They are "Hunnuh Home: Gullah/Geechee Sea Island Center." At this location, people can pick up handmade Gullah crafts such as quilts, nets and sweetgrass baskets. Most weekends, they can also obtain a homemade Gullah meal such as gumbo and fried fish while sitting down to do research in the archives. For those that are just passing through, they can make this their first stop in order to have a conducted tour or pick up information on authentic Gullah

businesses to support on any island in the Sea Island chain. They can find out what institutions and organizations to assist in seeking to support the preservation of Gullah and Geechee cultures. For more details on activities at "Hunnuh Home" contact:

Gullah/Geechee Sea Island Coalition-Homebase
Post Office Box 1207
St. Helena Island, SC 29920
(888) TRY-ISLE.
E-mail: GullGeeCo@aol.com

The Northeast Division of the Gullah/Geechee Sea Island Coalition is filled with many Gullahs and Geechees in urban environments. They always welcome more assistance in their programs and projects. They can be contacted at:

Gullah-Geechee Sea Island Coalition - Northeast
Post Office Box 40-0199,
Brooklyn, NY 11240-0199
(212) 439-1026.

The Coalition also assists people in locating places to stay when they are coming to the Sea Island. One of the locations for those who love the outdoors is:

Hunting Island State Park
2555 Sea Island Parkway
Hunting Island, SC 29920
(803) 838-2011

This park is not only for camping. It is also a wildlife preserve and a beach. There is a picturesque visitor's center that tells the history of the island and the herbs and creatures there.

The wildlife in the Lowcountry of South Carolina has a number of advocates. There is always a voice for the creatures there.However, outside of the churches, the Gullah community has had to fight to have its voice heard. WVGB Radio Station of Beaufort, SC, which is run by the Galloway Family has been such a voice for many years now. They make sure that the community is informed of positive things that are happening as well as political issues that need to be dealt with. They can be contacted at:

WVGB Radio Station
806 Monson Street
Beaufort, SC 29902
(803) 524-4700 or fax (803) 524-1329.

In 1997, Beaufort County was enmeshed in discussions about and battles against development on top of gravesites as well as sand mines. Several "development" companies have submitted permits in order to begin building on areas where graveyards exist as well as to begin digging sand mines throughout the county. The sand mine that has received the most attention is the first one on which public hearings were held in August, 1997. In the heart of a peaceful residential community where children and elders walk the roads, Brickyard Holdings, Inc. wants to dig a hole approximately 47 feet deep which would cause a number of dangers to the stabilization of the Hopes and John Fripp areas of St. Helena Island as well as to the health of the people there. This island is one of the last islands among the chain of the Sea Islands where a viable Gullah community still exists. The destruction of the area for the financial gain of a few investors in one company would also endanger a major area deep with African, African American, and American history.

One of the on-air personalities of WVGB is also a local entrepreneur and activist who decided to make sure that the Gullah had a print media that recognized the issues pertaining to the African American community of the Lowcountry. Thus, Jabari Moteski began the "Gullah Sentinel" bi-weekly newspaper in September of 1997. This paper can be contacted at:

Gullah Sentinel
1010 Charles Street
Beaufort, SC 29902
(803) 982-0500 or (803) 982-0285 Fax

As one enters Hilton Head Island, there is another wildlife preserve. People there such as Thomas Barnwell have decided to make sure that members of the Gullah community also have a place in which to dwell. Thus, he has set up affordable housing and maintained it by hand for many years. Thomas Barnwell can be contacted at:

Thomas Barnwell
P.O. B. 21057
Hilton Head, SC 29925

(803) 681-3575
(803) 689-5087 Fax

A number of other activists and entrepreneurs have formed the Native Islander Business and Community Association. This group sponsors the Native Islander Gullah Celebration every weekend in February annually. The organization also has a revolving loan fund which has begun to assist many Gullah businesses on Hilton Head and in the surrounding area. In order to find out more about becoming a member of the association, write to:

NIBCAA
Post Office Box 23452
Hilton Head Island, SC 29925
(803) 689-9317

During the Native Islander Gullah Celebration, the association makes sure that people have an opportunity to support the various Gullah businesses and to tour Mitchelleville, which was a totally autonomous Gullah community. The remains of the township are within one of the gated communities.

These gated communities often bear the word "plantation" in their name despite the often painful reminder of what this word means to people of African descent. Indeed, the name foreshadows what they encounter once they pass through the gates: minimum wage jobs, and oppressive remarks and conditions in many cases. It is no wonder that many of the people that work on places such as Hilton Head do not go to some nearby historic areas on their day off. One place in particular would be the Hofwyl-Broadfield Plantation in Georgia. Here people can still see rice being harvested as it was many generations ago. For details, contact:

Hofwyl-Broadfield Plantation
5556 US Hwy 17 N,
Brunswick, GA 31525
(912) 264-7533.

On Hilton Head, Dataw (built by Alcoa Aluminum in 1990), Fripp, Harbor (built up from a sand dune in 1990), and Daufauskie Islands, a lot has changed throughout the generations. People are not allowed to enter the gated communities (which used to be where they sat and played

and worked and raised families) to see the historic areas, markers, or gravesites there unless special permission is granted or special tours are conducted by their visitors' centers. Interestingly enough, the islands of Georgia have not gotten this restrictive yet (for the most part).

In 1912, Sapelo Island was bought by Howard E. Coffin, chief engineer of the Hudson Motorcar Company in Detroit, Michigan. He obtained it from Thomas Spaulding who was a cotton and sugar plantation owner who had enslaved approximately 400 Geechees to work his crops. In 1934, tobacco heir Richard J. Reynolds of Winston-Salem, North Carolina, purchased Sapelo from Coffin. In 1954, he donated the buildings of the island to the University of Georgia for a marine research laboratory. Shortly thereafter, Reynolds had the Geechees that occupied five communities on the island move into one community so that he could have a hunting and wildlife preserve. Once again, more thought was given to wildlife than to human beings and their history and traditions.

Some of the Geechees held out as long as they could in their own communities, but eventually things got harder and harder and some left the island altogether. Others that still remained set down new roots beside the Geechees already in Hog Hammock Community. If one goes to Hog Hammock today and wants to know the sites and scenes of the island, they can begin with a mule tour, stop by some shops and get local crafts, and then settle in for the night in one of the local boarding facilities including the "Weekender." The people of Hog Hammock may be few in number, but they are not short on pride. They continue to fight for their land and to maintain their culture. In order to support their efforts, get in touch with activists and natives Cornelia Bailey or Ben Hall at:

Sapelo Island Cultural and Revitalization Society
Post Office Box 1
Sapelo, Georgia 31327
(912) 485-2126

Sapelo is still not connected to the mainland. Thus, it holds its natural character and beauty. Nearby Jekyll Island, which was the last drop off point for a "slave ship" cargo of Africans, is now a resort island lacking the landscape of Sapelo.

St. Simon's Island, on which many of Sapelo's people now live, is totally different. This island has a number of "slave cabins" still standing with markers to denote them as such. However, one would

pass by the markers repeatedly looking for the buildings since they have now been renovated and are used as stores. A person has to stop and stare to realize what they were.

By the same token, the ruins of the hospital which was for enslaved Africans on the Retreat Plantation is not quickly noticed between the golf courses. Howard Coffin, who is credited with starting the golf course here, also began the resort which is now "Sea Island" just up the road from St. Simon's.

Neptune Park is the site of the Sea Island Festival which was started by the Georgia Sea Island Singers, Frankie and Doug Quimby. The park is named after Neptune Small, who was enslaved by the King Family at the Retreat Plantation. He apparently was so faithful that while accompanying a member of the King family who served in the Confederate Army to war, he braved the line of fire to rescue the man's body when he fell, then took the body back home. His reward was a tract of land where the park is now.

Past the Harrington Community where a number of Geechees still maintain their homes is the First African Church. Up the road from there is the location of a monument which was placed there by Robert Sengstache Abbott who was born in 1868, the child of freedmen. After being raised in Savannah, Georgia, he went to Chicago with only 50 cents in his pocket. He was able to somehow begin the *Chicago Defender* which was one of the nation's first "Black" newspapers. In the 1930s, Abbott came back to St. Simon's area to erect a monument to his father, Thomas Abbott and his two aunts, Celia Abbott and Mary Abbott Finnick. The monument is at the site of Fort Frederica.

The Sea Island community is now beginning to come together as a Coalition instead of attempting to continue to fight the "powers that be" as fragmented groups from one island to the next. This type of organization is necessary in order for the Gullah community to have our own self-interest promoted as well as to have our culture preserved. We must tell our own stories and govern our own community as our foreparents did. We know that 'empty sak cyan stan upright 'lone.' Thus, the community must and is coming together to hold up all ends and to hold pun we culcha.

[1] For more on the early development started by Fraser, see my article, "Destructionment: Treddin' een We Ancestas' Teahs," in this anthology.

Excavating Gullah Seeds
Guidelines for Conducting Research on the Gullah

Marquetta L. Goodwine

By the winter of 1861, Big Shoot had taken place and the war had begun. My people were looking to this new set of buckras that had arrived in the Sea Islands to finally return their freedom to them. However, the soliders' primary intent was to carry out military strategies which had been planned in order to help "turn the tide" of the war and capture a major area. They didn't know what to do with these thousands of Africans populating the area. What was to be done with this "contraband"? The Union forces needed to have cotton to sell in order to finance the war effort, but the cotton could not be sold if it was not harvested. Realizing that they no longer had to do back-breaking work in cotton fields for anyone, the Africans were either at home in their cabins and yards or leaving, seeking freedom. This was the time that had been prayed for; this was their time of Jubilee, for which blood had been spilled and rituals performed. How were the Unionists going to get the cotton from the fields to the northern markets and to England? They definitely knew nothing of working the fields and given that these Africans were no longer "slaves," they could not force them to work for them either. The dilemma was to be resolved through what is now called "The Port Royal Experiment."

The Port Royal Experiment essentially was a plan to have the newly freed African people continue to do work in the fields. In return they were to have food, shelter, clothing, and extremely low pay. They were also to be afforded three months of education per year. The irony of what was being described in The Port Royal Experiment is the fact that many Gullahs and Geechees had already been living under basically the same system. Many plantations in the Sea Islands and the South Carolina Lowcountry operated on what was called a "task system." This provided each individual with an acre of land or slightly more which he or she had to work each day. Once that task was completed, the individual generally had a quarter or half task of their own to work. From that, he or she fed the family and even had goods to barter with or take to markets. Thus, Gullahs and Geechees could make money which went into their own pockets. Also, many Gullahs and Geechees were skilled in various seawork — shrimping, crabbing, fishing, boat making, net making, sailing, etc. — and were able to make

money from these skills either by selling certain items or by being "rented out" to other plantations where in some cases they were able to keep a few coins from what was paid to their "owners." As far as clothing went, they were provided with garments once or twice a year by those who enslaved them. There were also seamstresses on the plantations that would make various items. The old clothing that could no longer be repaired later provided the pieces that made up the quilts which kept entire families warm during cold fall and winter nights in the wooden shacks that the folks called "home."

The system of education of Gullahs and Geechees was an underground system, since numerous laws were put into place in the Lowcountry and throughout the South to prevent the education of "negroes." New laws were added to the books at any time that African people carried out an uprising or rebellion or even when plans of one were revealed. Thus, for the most part, the education of African people had become illegal long before 1861. Therefore, those that continued to educate Africans did so in private and the Africans knew not to vocalize the fact they could read, write, and/or count.

This legacy of secrecy has become a regular part of the thread that weaves together the lives of Gullah and Geechee people. This legacy of secrecy has been a means of survival and preservation for many years. However, as we approach the new millenium, Gullahs and Geechees are beginning to speak out more about the land, the language, and the heritage that they have held on to and intend to continue to hold on to.

From the time that the first ships entered the ports of Santa Elena and the harbors that surround what is now Charleston, South Carolina, the African people that were to become known as Gullahs and Geechees had their gifts and talents exploited. They were used to clear the land that was the home of indigenous American people, who would not cooperate with the Europeans in being moved from their own home. They were used to plant crops and build homes for people that enslaved them, people who attempted to break their will and their ways. They were told that they were ignorant and backwards — despite the fact that they had been specifically chosen to be brought from their homeland for their expertise in cultivating the lucrative crops that the enslavers were unable to produce themselves. They were brought over to navigate waterways to transport the goods and people. They developed irrigation systems for fields for rice to flourish. Yet they were told that they were ignorant, backwards and lazy.

After the guns sounded to begin the Civil War and the Euro-American plantation owners and enslavers fled the Sea Islands and

the Lowcountry, a new group of people came with another plan to further exploit the talents of the Gullahs and Geechees living there. From the time of The Port Royal Experiment and on into Reconstruction, many more people came to the Sea Islands under the guise of helping the people, yet somehow seemed to leave having only helped themselves. During the late 1800's and throughout the 1900's, a number of individuals began to recognize the unique ways, language, and songs of Gullahs and Geechees in the Sea Islands. Some began to collect stories and songs to share with their friends for purposes of entertainment. When they began to realize that this unique cultural material could make them money, they broadened their practice and consistently removed the resources of the Gullah and Geechee communities without giving the people anything in return.

This exploitive practice has continued in the Sea Islands and has been perpetuated in a large part through many institutions of higher learning. Students and scholars come into the region to "study" the people and then take out of the community everything from people's personal effects to songs, photographs, stories (which people thought were being shared in a private conversation), and more. There has been no regard for what the people will feel about these things going out to other people, especially when the stories and other words are embellished by the person doing the "studying." Also, when the person "studying" takes it upon him- or herself to interpret what the Gullahs and Geechees mean by their words and actions rather than going to the people and simply asking them to explain, this indicates a lack of respect for those people who had been generous enough to share the information with them.

As technology has increased, there have been tape recorders and cameras brought in to the islands and more material removed, even when people were unaware that this was going to happen. With the onslaught of films, the level of exploitation has increased and continues to rise. A number of films based on the history and heritage of the Gullahs and Geechees of the Sea Islands have been made. Ironically, the documentaries and the films based on facts have not received as much publicity as some fiction films which have not done justice to the Gullah and Geechee community. No one asks whether filmmakers have a responsibility to give something back to the community through which they have gained fame and fortune, nor does anyone ask the same of the students and scholars that go on to publish their works about the Sea Islands, whether accurate or inaccurate. Most of all, no one asks the Gullah and Geechee people if we want this type of exposure, whether this information is true, or if it has helped us.

What is unknown and unseen because we cont.
secrecy and being polite is that there are so many of us
being approached in regard to our culture based o.
information that people have obtained through fiction t.
people, our ancestors and our community. We are tirec
defend ourselves concerning the supposed analysis of Gulla.
has been and is still being promoted within academic arena ριe
that have no connection to our community other than having come in for
a few days, weeks or months to do research and to "study" us.

We are especially tired of knowing that the media and the
mainstream are continuing to promote people who are said to have done
so much for the Gullah heritage and community when these people have
not and do not speak on behalf of the community. Our ancestors continue
to cry out that we must speak up, that we must stand up as they did,
and hold on to our culture and our heritage. We cannot allow people to
continue to simply believe in that which is sold to them as a representation
of our people, which has not been condoned by or accepted by our
community. We have not seen a dime of the money that has been made
from most films or books done about Gullah and Geechee culture re-
enter the Gullah and Geechee communities. Some has gone back into
the surrounding resorts, insofar as the writers and filmmakers go there
or live there. However, no money has come back to help in the
preservation of the language and the customs. Nor have any funds
been contributed to a land use and preservation fund to assist Gullahs
and Geechees to remain on the land out of which these cultures grew.

Many people continue to ask what they can do to assist with the
Sea Islands and before the members of the communities there can
answer, they take it upon themselves to do what they want. Many
would say, "This is the American way." However, the Gullah com-
munity has always been something other than American. Various
people have come to the Sea Islands because they heard a little about
the uniqueness of the culture and felt that they could capitalize on it.
Some have even used a distant family tie to the area as justification for
coming in like a thief in the night, and the public does not hold them
accountable for the theft of culture and the destruction of heritage. No
one stops to ask: "Have you really helped the people there? Did they
want your help? Would they welcome you back if you came there
again now that your work has been seen?" If these questions were to
be asked and answered honestly, one would likely find that in many
cases, Gullahs and Geechees would have preferred to have less publicity
through the dissemination of incorrect information. This has only
encouraged the proliferation of more myths about the area. This in

has increased tourism, which has benefited those who build resorts or run tourist bureaus, but has not assisted the Gullahs and Geechees that built the communities and are fighting to preserve and remain in them. Gullahs and Geechees have come to be a less inviting group of people, a group that converses less and less with those that are not Gullahs and Geechees because they see that many still think that they are backward and ignorant. People think that they can continue to come in under the guise of assisting when they are coming to remove the last of the heritage that remains and to benefit from it individually while watching a community die. However, just as Gullahs and Geechees managed to survive all these decades through code switching, private practices and customs, and their faith in the higher power, they will continue to survive in the next millenium and beyond. Gullahs and Geechees will no longer stand by "wid out crackin' wi teet'" and allow individuals to come in and absorb the blood, sweat, and tears of our foreparents and ring them out into a sewer. We will not allow people to come in and excavate the seeds of our heritage and put them on display for grant money, awards, for the purpose of putting the excavator's name up in lights.

We need others from every community around the world to stop and think about why they are supporting and promoting people that have no serious connection to our community. We need non-Gullahs and Geechees to communicate with us when anything comes out about our community in order to find out what we think of it and whether or not this is for all of us or for one individual or one company. We are continuing to plant seeds and to harvest the preservation and survival of the Gullah community. Thus, the shovels of the excavators have to be broken if we are to continue to remain on solid ground. When digging, dig for TRUTH.

The following guidlines are provided for people who wish to establish a sincere and mutually beneficial relationship with the Gullah.

GUIDELINES FOR RESEARCHING THE GULLAH COMMUNITY

1. Respect the fact that this is a "living culture" and that the people have a right to choose whether or not to be studied. In order for them to make a clear decision in this regard, the aim of the study should be communicated as clearly as possible at the very beginning of contact with the community.

2. Contact institutions and/or organizations which can connect you

with a Sea Island mentor or mentors in order to present information with a proper perspective.

3. Couple all documented research and analysis of the culture with information obtained by discussion with Gullah community members and mentor(s). The family members of those that are deceased that will be represented in the document, film or other final product should be included in this discussion as well.

4. Do not attempt to speak Gullah to native speakers as a means of trying to be accepted.

5. Do not push people to begin to speak Gullah to you or in your presence.

6. Do not attempt to force your way into the Gullah community or to superimpose the ways of your own community on the Gullah people.

7. Follow through on your word with the people that are assisting you. Always put something positive and beneficial back into the community. Also, make sure that the community has seen the completed project. One secure point of deposit for copies of all materials produced on the Gullah community which is accessible to all in the community is the Gullah/Geechee Sea Island Coalition Archive. You can and should deposit a copy of the completed work and possible notes by mailing it to:

Gullah/Geechee Sea Island Coalition - Homebase,
Post Office Box 1207,
St. Helena Island, S.C. 29920

or

Gullah/Geechee Sea Island Coalition - Northeast
Post Office Box 40-0199
Brooklyn, NY 11240-0199

United Nations Declaration on the Rights of Persons Belonging to National or Ethnic, Religious and Linguistic Minorities (1992)

The General Assembly,

Reaffirming that one of the basic aims of the United Nations, as proclaimed in its Charter, is to promote and encourage respect for human rights and for fundamental freedoms for all, without distinction as to race, sex, language or religion,

Reaffirming faith in fundamental human rights, in the dignity and worth of the human person, in the equal rights of men and women and of nations large and small,

Desiring to promote the realization of principles contained in the *Charter of the United Nations*, the *Universal Declaration of Human Rights*, the *Convention on the Prevention and Punishment of the Crime of Genocide*, the *International Convention on the Elimination of All Forms of Racial Discrimination*, the *International Covenant on Civil and Political Rights*, the *International Covenant on Economic, Social and Cultural Rights*, the *Declaration on the Elimination of All Forms of Intolerance and of Discrimination Based on Religion or Belief*, and the *Convention on the Rights of the Child*, as well as other relevant international instruments that have been adopted at the universal or regional level and those concluded between individual States Members of the United Nations,

Inspired by the provisions of article 27 of the *International Covenant on Civil and Political Rights* concerning the rights of persons belonging to ethnic, religious or linguistic minorities,

Considering that the promotion and protection of the rights of persons belonging to national or ethnic, religious and linguistic minorities contribute to the political and social stability of States in which they live,

Emphasizing that the constant promotion and realization of the rights of persons belonging to national or ethnic, religious and linguistic minorities, as an integral part of the development of society as a whole and within a democratic framework based on the rule of law, would contribute to the strengthening of friendship and cooperation among peoples and States,

Considering that the United Nations has an important role to play regarding the protection of minorities,

Bearing in mind the work done so far within the United Nations system, in particular the Commission on Human Rights, the Sub-Commission on Prevention of Discrimination and Protection of Minorities as well as the bodies established pursuant to the International Covenants on Human Rights and other relevant international human rights instruments on promoting and protecting the rights of persons belonging to national or ethnic, religious and linguistic minorities,

Taking into account the important work which is carried out by intergovernmental and non-governmental organizations in protecting minorities and in promoting the rights of persons belonging to national or ethnic, religious and linguistic minorities,

Recognizing the need to ensure even more effective implementation of international instruments with regard to the rights of persons belonging to national or ethnic, religious and linguistic minorities,

Proclaims this *Declaration on the Rights of Persons Belonging to National or Ethnic, Religious and Linguistic Minorities:*

Article 1

1. States shall protect the existence and the national or ethnic, cultural, religious and linguistic identity of minorities within their respective territories, and shall encourage conditions for the promotion of that identity.
2. States shall adopt appropriate legislative and other measures to achieve those ends.

Article 2

1. Persons belonging to national or ethnic, religious and linguistic minorities (hereinafter referred to as persons belonging to minorities) have the right to enjoy their own culture, to profess and practise their own religion, and to use their own language, in private and in public, freely and without interference or any form of discrimination.
2. Persons belonging to minorities have the right to participate effectively in cultural, religious, social, economic and public life.
3. Persons belonging to minorities have the right to participate effectively in decisions on the national and, where appropriate, regional level concerning the minority to which they belong or the regions in which they live, in a manner not incompatible with national legislation.
4. Persons belonging to minorities have the right to establish and maintain their own associations.
5. Persons belonging to minorities have the right to establish and maintain, without any discrimination, free and peaceful contacts with other members of their group, with persons belonging to other minorities, as well as contacts across frontiers with citizens of other States to whom they are related by national or ethnic, religious or linguistic ties.

Article 3

1. Persons belonging to minorities may exercise their rights including those as set forth in this Declaration individually as well as in community with other members of their group, without any discrimination.
2. No disadvantage shall result for any person belonging to a minority as the consequence of the exercise or non-exercise of the rights as set forth in this Declaration.

Article 4

1. States shall take measures where required to ensure that persons belonging to minorities may exercise fully and effectively all their human rights and fundamental freedoms without any discrimination and in full equality before the law.
2. States shall take measures to create favourable conditions to enable persons belonging to minorities to express their characteristics and to develop their culture, language, religion, traditions and customs, except where specific practices are in violation of national law and contrary to international standards.
3. States should take appropriate measures so that, wherever possible, persons belonging to minorities have adequate opportunities to learn their mother tongue or to have instruction in their mother tongue.
4. States should, where appropriate, take measures in the field of education, in order to encourage knowledge of the history, traditions, language and culture of the minorities existing within their territory. Persons belonging to minorities should have adequate opportunities to gain knowledge of the society as a whole.
5. States should consider appropriate measures so that persons belonging to minorities may participate fully in the economic progress and development in their country.

Article 5

1. National policies and programmes shall be planned and implemented with due regard for the legitimate interests of persons belonging to minorities.
2. Programmes of cooperation and assistance among States should be planned and implemented with due regard for the legitimate interests of persons belonging to minorities.

Article 6

States should cooperate on questions relating to persons belonging to minorities, including exchange of information and experiences, in order to promote mutual understanding and confidence.

Article 7

States should cooperate in order to promote respect for the rights as set forth in this Declaration.

Article 8

1. Nothing in this Declaration shall prevent the fulfilment of international obligations of States in relation to persons belonging to minorities. In particular, States shall fulfill in good faith the obligations and commitments they have assumed under international treaties and agreements to which they are parties.
2. The exercise of the rights as set forth in this Declaration shall not prejudice the enjoyment by all persons of universally recognized human rights and fundamental freedoms.
3. Measures taken by States in order to ensure the effective enjoyment of the rights as set forth in this Declaration shall not *prima facie* be considered contrary to the principle of equality contained in the *Universal Declaration of Human Rights*.
4. Nothing in this Declaration may be construed as permitting any activity contrary to the purposes and principles of the United Nations, including sovereign equality, territorial integrity and political independence of States.

Article 9

The organs and specialized agencies of the United Nations system shall contribute to the full realization of the rights and principles as set forth in this Declaration, within their respective fields of competence.

Contributors

Josephine Beoku-Betts is Assistant Professor in the Department of Sociology at the University of Georgia, Athens. Prof. Beoku-Betts roots are in Sierra Leone, West Africa.

Ihsan Bracy is author of *Ibo Landing,* stories of three generations of the author's family of Gullah and Geechee descent from the Sea Islands of South Carolina. He lives in New York, and has recently been nominated to the New Harlem Renaissance Writers Guild.

Leroy Campbell is an artist whose work is displayed in corporations, universities and private collections, as well as on television and in movies. His Neckbone art is sold in contemporary art galleries internationally. Leroy Campbell hails from Charleston and presently lives in New York above his 'Spiritual Rhythms Gallery' (see "De Ones Ya'll Kno' 'Bout").

Virginia Mixson Geraty has been awarded an honorary Doctor of Laws by the College of Charleston for her work with the Gullah language. She has served as Gullah translator for the BBC's Summer Institute of Linguistics, and for Charleston Adventure and Catch the Song, SETV., as well as Gullah Instructor at the College of Charleston. One of the world's premiere Gullah historians and lifelong Lowcountry native, she is author of *Bittle en' T'ing, Maum Chrish Chaa'stun,* and *Gullah For You,* a lexicon of the Gullah language.

Marquetta L. Goodwine is Founder of the Gullah/Geechee Sea Islands Coalition. Author, folklorist, performer and Gullah historian, Ms. Goodwine defines herself as an "art-ivist." She completed her higher education at Fordham and Columbia Universities, after leaving the Sea Islands, where she comes from two proud Gullah families of St. Helena, Polowana and Dataw Islands in South Carolina (*see* "De Ones Ya'll Kno' 'Bout").

Jonathan Green is an artist whose work has been featured in major traveling exhibitions, solo presentations, and group shows. Trained at The School of The Art Institute of Chicago, Jonathan Green has been honored with numerous awards and commissions from art-sponsoring institutions, human service organizations, and national, state and local humanities councils, including an Honorary Doctorate Degree in Fine Art from the University of South Carolina (*see* "De Ones Ya'll Kno' 'Bout").

Y.N. Kly is Professor of Social Work and Human Justice specializing in International Law, founder of an international NGO in consultative status with the UN, author of numerous titles on international minority rights, and two-time winner of the prestigious Outstanding Book Award from the Gustavus Myers Center for the Study of Human Rights.

Salikoko S. Mufwene is Chair of theDepartment of Linguistics at the University of Chicago and the author of numerous articles on the Gullah language.

Joseph Pinckney is a Hilton Head Island, South Carolina, historical artist renowned among art lovers as "the Norman Rockwell of the Lowcountry". A South Carolina Hall of Fame inductee, he received his formal training in New York City, and has had his artwork displayed all over the United States, including the Smithsonian Institution. He is the only artist who has devoted his life to capturing on canvas the images of how ordinary people lived in the Lowcountry prior to its development as a resort area (see "De Ones Ya'll Kno' 'Bout").

William S. Pollitzer is Professor Emeritus in Physical Anthropology at the University of Chapel Hill, Chapel Hill, N.C. He is a past president of the American Association of Physical Anthropologists and of the Human Biology Association, and a former editor of the *American Journal of Physical Anthropology*.

Bernard E. Powers, Jr. is Professor of History at the College of Charleston, and author of *Black Charlestonians: A Social History 1822-1885*, selected by *Choice* magazine as one of the Outstanding Academic Books for 1995. Dr. Powers is President of the Advisory Board of the Avery Research Center for African American History and Culture.

Contributors of Reflections on the Gullah heritage:

Cornelia Bailey *Bentina Chisolm*
MaVynee Betscha *Dorothy Ferebee*
Samuel R. Brown, Jr. *Joe Frazier*
Samuel R. Brown, Sr. *Marquetta L. Goodwine*
Thomas J. Brown *Kitty Green*
Josie Burwell *Mary Goodwine Johnson*
 Joseph Mustipher

Contributors of recipes:
Kimberly B. Thomas *Jackie Edwards*
Carolee Holmes Brown *Catherine Carr*